The Artist's Guide to

DRAWING THE CLOTHED FIGURE

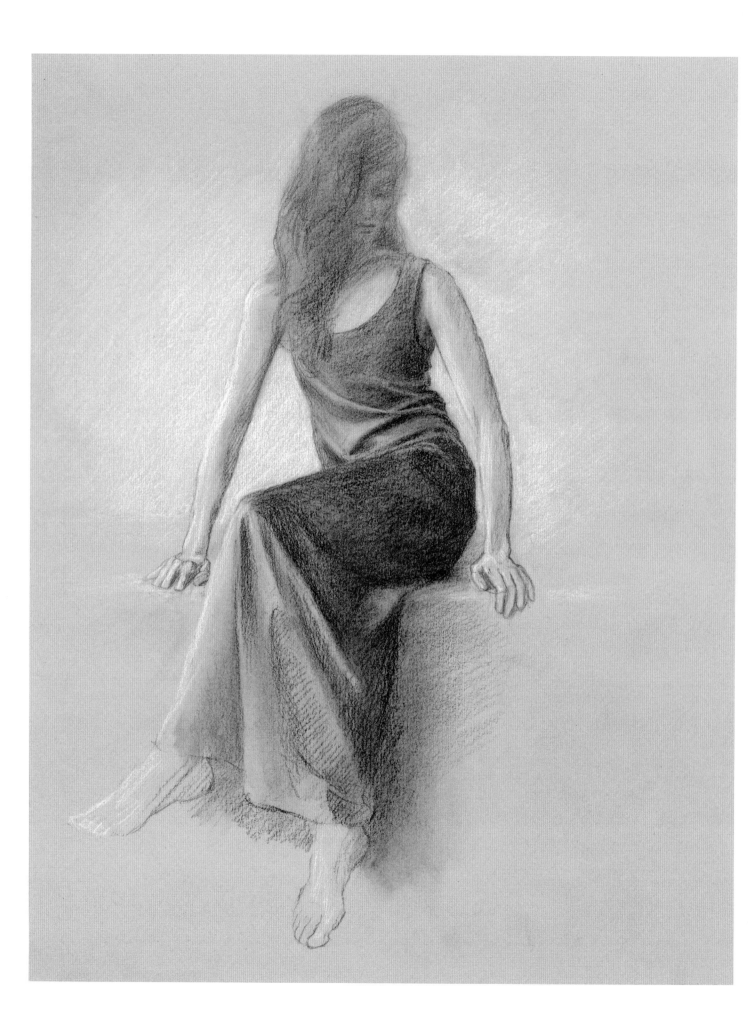

The Artist's Guide to

DRAWING THE CLOTHED FIGURE

A Complete Resource *on*
Rendering Clothing *and* Drapery

Michael Massen

WATSON-GUPTILL PUBLICATIONS / NEW YORK

For my mother

Published in the United States by Watson-Guptill
Publications, an imprint of the Crown Publishing Group,
a division of Random House, Inc., New York.

www.crownpublishing.com
www.watsonguptill.com

WATSON-GUPTILL is a registered trademark and the WG
and Horse designs are registered trademarks of Random
House, Inc.

Library of Congress Cataloging-in-Publication Data

Massen, Michael.
 Artist's guide to drawing the clothed figure / Michael
Massen. — 1st ed.
 p. cm.
 Includes index.
 ISBN 978-0-8230-0119-4
 1. Drapery in art. 2. Figure drawing-Technique. I. Title.
 NC775.M37 2011
 743.4--dc22
 2010048019

The quotation from Leonardo da Vinci that appears on
page 48 is from Jean Paul Richter, trans., *The Notebooks
of Leonardo da Vinci*, vol. 1 (1888), page 272.

Printed in China
Jacket and interior design by Jenny Kraemer
Jacket art by Michael Massen

10 9 8 7 6 5 4 3 2 1

First Edition

ACKNOWLEDGMENTS

My sincere gratitude goes to the many people who made this book possible.

I'd especially like to thank Candace Raney and the other wonderful professionals at Watson-Guptill, including Autumn Kindelspire and Jenny Kraemer, who made this project a reality.

Many thanks, as well, to James Waller for his careful, considerate, and unflagging efforts in editing the manuscript.

I am grateful to Amla Sangvhi for her advice and guidance in my researching and securing the outside illustrations; Rob Schaffer for reviewing and correcting my understanding of the scientific concepts in the work; and my friends and fellow artists Debra Goertz and John Brown for their feedback and encouragement when the project was little more than a hope and an outline.

Special thanks go to the professional models and friends who gave so much time and energy posing for the illustrations, among whom I count John Forkner, Laura Mae Noble, Emily Roberts, Amy Russ, Renée Veneziale, and Izaskun Zabala.

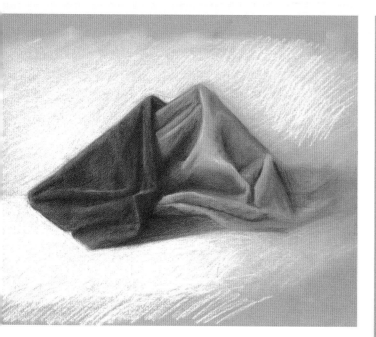

CONTENTS

INTRODUCTION

Since the Fall, our natural state has been clothed. Those who eschew, to one degree or another, the protection, modesty, and adornment that clothing affords are exceptions to the rule. For the most part, the wearing of clothing seems to be a human norm.

While the nude has been the source of some of Western art's greatest masterpieces, if it can be agreed that all artists, at least to some degree, express the world that surrounds them, then their ability to represent the clothed figure—which they encounter daily—should be considered at least as important as their skill in rendering the nude. It is the purpose of this book to assist them in that effort.

Historically, artists wishing to represent the nude figure have studied artistic anatomy—the analysis of the forms, proportions, and physiodynamics manifested in the body's visible characteristics. This book can likewise be thought of as a sort of artistic anatomy of drapery—a study of the factors that cause drapery to appear as it does.

As the various forms of the human body—its depressions and projections, concavities and planes—are explained by the bones, muscles, tendons, and organs that lie beneath the skin, so, too, do the folds and gathers of clothing owe their form to underlying causes. Though a beginner might think so, folds do not appear haphazardly. On the contrary, cloth, being a pliant material, is shaped by the forces that act on it. The trick to representing drapery well, in whichever artistic medium, is to recognize the consistent behavior of cloth as it responds to those forces.

Although different kinds of cloth may have their own "personalities," cloth, in all its variations, behaves in a consistent way, assuming consistent and replicable forms. These folds are volumetric, even though most cloth is meager in thickness. They occupy space.

In drawing these volumes, it is important not to confuse the patterns of shadow created by light as it falls upon these folds for the material itself. They are only a side effect of its structure.

Understanding this structure of cloth gives the artist advantages similar to those gained by studying the anatomy of the figure. First, understanding how drapery "works" enables the artist to convincingly represent it. As has long been noted in academic practice—and has been wonderfully expressed by Robert Beverly Hale in *Drawing Lessons from the Great Masters* (1966)—artists cannot convincingly portray what they see without first understanding what it is that they are looking at. Beginners are often frustrated when depicting drapery, seeing it only as an incoherent tangle of lights and darks. Ignorant of its principles and bewildered by its transitory and inessential details, they either content themselves with a crude, "muddy" representation of clothing or desperately try to precisely imitate what appears before them. Even some experienced artists, who otherwise show a solid command of traditional representation, have trouble with drapery. The mistakes they make are apparent to the educated eye, and even the untrained eye may be able to discern a lack of the solidity and surety of form that come from a more informed understanding of the subject.

Second, understanding the mechanics of drapery allows the artist to more convincingly render what is *not* before his or her eyes—imaginary figures, figures in imaginary states of motion, or figures of fantastical proportion. This skill is of particular advantage to comic book or fashion illustrators, who must continually clothe figures of implausible proportions in a plausible manner.

Third, and to my mind most important, an understanding and mastery of depicting drapery allow an artist the freedom to bend, twist, modify, or even abandon the basic principles in whatever way will best serve his or her artistic needs. Artists who understand drapery know how to emphasize the shapes that improve an artwork's composition, narrative, and spirit—and how to de-emphasize those shapes that detract from the overall impact of the work. An artist who has completely absorbed these fundamentals, like a dancer who has memorized all the steps of a piece, will then be free to follow his or her creative impulses without being diverted by the labor of figuring out each component part.

This book's purpose is to ease the challenge of representing the draped figure, not to provide a complete course in drawing. In the pages that follow, I assume that the reader already has some familiarity with the core skills of draftsmanship—perspective, mark-making, an understanding of light and shadow, and so on—as well as a basic competency in figure drawing. The stronger these skills are, the easier it will be to apply them to the rendering of drapery. Indeed, drapery conforms so closely to the framework of the nude figure that

the addition of a few simple lines to a well-constructed figure drawing may be all that is necessary to produce a satisfactory representation of a clothed person.

About the Illustrations

In preparing the drawings for this book, I have relied on the contribution of very talented and dedicated figure models. All of them have wonderful, unique physical features, but I have purposely avoided models whose body types were outside the average proportions, hoping that users of the book will extend the principles that these drawings illustrate to the specificities of the figures in their own works.

I have also opted to present generic examples of typical contemporary clothing. Fashion, by definition, is always changing. I suspect that future readers will find that the particular clothes in which these models are dressed seem antique, perhaps even ridiculous. But because the rendering of the garments is based on natural principles, I hope that the book will prove useful for many years to come.

About the Sidebars

Scattered throughout the book are sidebar features highlighting the work of some masters of depicting drapery. The artists I have chosen represent only a small sampling of the superlative draftspersons who excelled not only in the drawing of the figure but also of the clothes that cover it.

All these artists share two somewhat contradictory qualities: a deep understanding of the mechanics of drapery and the ability to abandon those same

principles, when necessary, to create a personal expression rather than a dutiful copy of what was in front of them.

The analytical drawing that accompanies each of these master drawings is meant to explain the basic concepts inherent in the work. It should not be interpreted as some sort of preparatory stage in the history of the drawing's creation.

One word of advice as you look at these master drawings: In the end, a bravura imitation of even the greatest artist will be found wanting compared to a genuine artistic expression. There is nothing wrong with copying from the masters; in fact, it has been a core tenet of artistic education for centuries. But if you wish to learn the style of a particular artist, remember to strive to copy his or her *intention*, not his or her *result*. Only by doing so will you ever come close to reproducing a similar end product.

Better still, strive to learn from the artists whom you admire those techniques that will enhance your *own* capabilities. Study, most of all, from nature, which, carefully observed, will reveal to you those principles that will always remain true. In doing so, you will equip yourself with the strongest possible set of tools for your own endeavors.

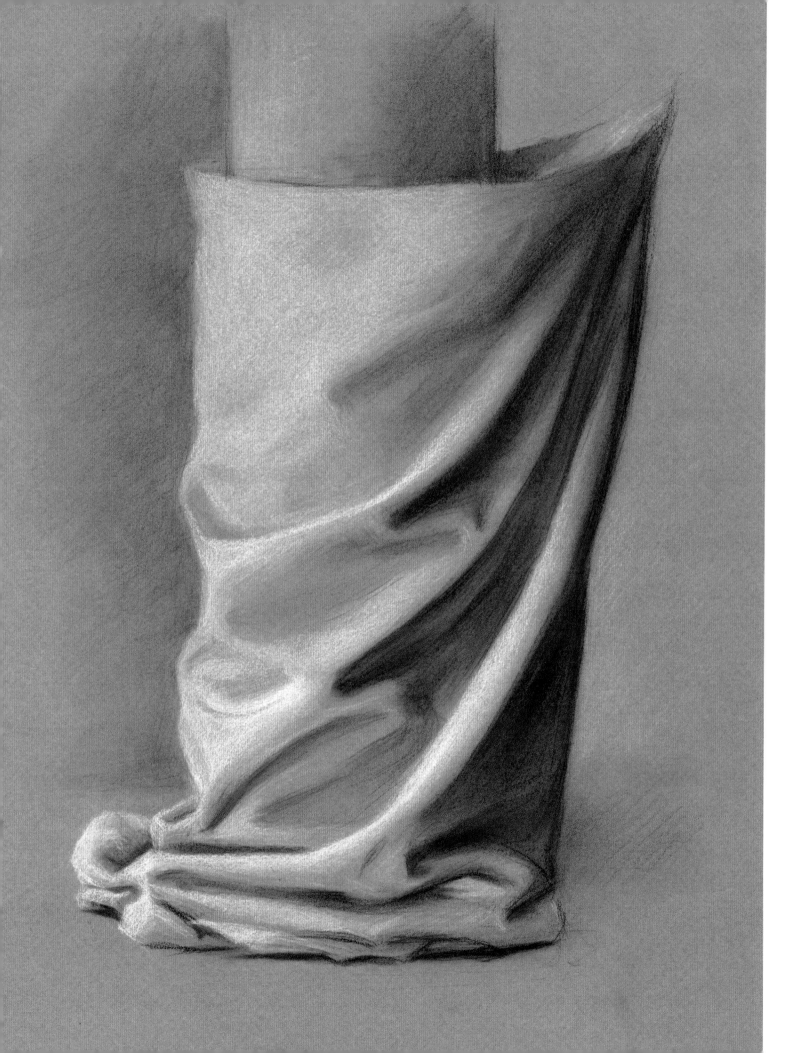

THE ANATOMY OF FOLDS

Drawing drapery can be challenging. An arrangement might consist of just a few folds, or it might involve a complex group of cloths twisting and falling over one another. As with drawing anything else, however, drawing drapery is easier if you can break a complex pattern down into more simply conceptualized elements: A human body, for example, is easier to draw if broken down into its component parts—the head, the arms, the trunk, and the legs.

The structure of drapery, however, is very different from that of human or animal anatomy. Whereas a body's composition is more or less finite, the form of cloth may be altered in limitless ways.

Luckily, the basic components of drapery are easier to grasp than those of the human body. Human bodies are thick in some places and thin in others, and they have muscles and joints that move in many different ways. By contrast, cloth is usually composed of the same material, of the same thickness, throughout, so the core building block of drapery, the fold, is more or less always the same—a plane in one direction adjoining a plane in another. Thus, even when facing the task of representing a complex arrangement of drapery, you can feel assured that, at base, it can be understood by simple concepts.

These basics cannot address every detail and permutation that you come across, but if you strive to keep them in mind as you draw, they will lend harmony and believability to your finished work. As with good figure drawing, you should treat details and accidental formations as just that. If you allow your broadest conceptions to be bold and sure, you will soon find that the details of your picture—if you choose to include them at all—will easily fall into their proper place.

Gravity

Picture a roll of fabric unspooling. Once it hits the ground plane, a length of the cloth will travel a certain distance in one direction. Then it will double back over itself and travel in the other direction until it reaches a point the same horizontal distance away from the vertical wall of the descending cloth, but on the opposite side. This simple phenomenon forms the basis of every fold that we will study in this book. As the cloth unspools, this action continues, back and forth. Observing the cloth from the side, as in figure 1.1, we can see the result of this back-and-forth movement in the zigzagging appearance of the cloth's edge.

As a roll of cloth unspools, the causal force is the pull of gravity. As gravity exerts a vertical pull, the folds that result are horizontal. When drawing cloth, remember that gravity affects the entirety of the material at all times. Whether it is a cloth lying on the ground or a coat draped across the shoulders of a figure, gravity pulls at it equally at every point. So when you draw drapery, remember to depict gravity as the chief actor, consistently drawing the cloth downward. Even in cases of extreme movement, or in unusual environments such as under water or in outer space, gravity, or its absence, must still be considered, even if it is temporarily overcome by another force.

But there is another way of thinking about gravity. As physicists tell us, we can think of gravitational force as moving in the opposite direction. In figure 1.1, the action depicted could be conceived of as the floor coming up from beneath to strike the loose edge of the cloth. If you push upward on the loose edge of your sleeve, you will see a similar result. Wherever you apply force to a cloth you should expect to see it being compressed in a direction that is perpendicular to the force. And likewise, wherever you see a series of compressed folds, you should be on the lookout for that compression's source.

When studying drapery, keep this principle in mind: Folds generally form *perpendicularly* to the direction of the compressive force, not parallel to it. To put it in other words, folds are usually formed by a push, not by a pull. This is true even of the unspooling cloth in figure 1.1. Because we speak of gravity's "pull," you may be tempted to believe that there is no "push" there. But remember that we are equally free to consider it from the opposite viewpoint—as a case of the ground hitting the cloth, exerting a pushing force from below that forms the folds. Without such a collision, the cloth would hang straight down, continuing to be pulled toward the center of the planet.

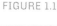

FIGURE 1.1

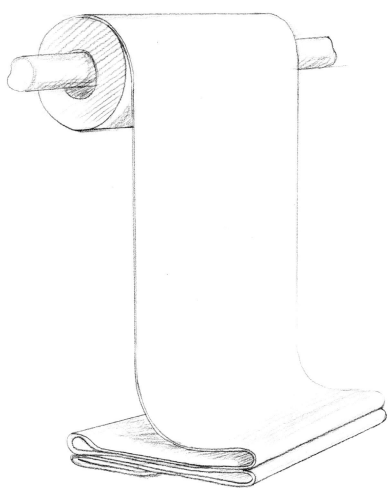

◀ A roll of cloth unspooling. Note the wave shape formed by the edge facing the viewer.

Compression vs. Tension

Although folds are almost always formed by compression, not by tension, the subject can be confusing. Look at figure 1.2, which shows two hands pulling at either edge of a cloth, and notice the series of folds that appears between the two hands, running in the same direction of the pulling force. This is what most people would expect to see. But if you try pulling on a handkerchief or napkin yourself in the same manner, you will find that these horizontal folds are, in actuality, *not* caused by the pulling action of the hands but by the pushing of your thumbs and fingers into the cloth. When the cloth is manually stretched, the force is not distributed evenly throughout the whole area of the cloth, and so these horizontal folds stand out in sharp relief.

If, however, you were to pull the cloth using a pair of straight, flat clamps, as in figure 1.3, you would find that no horizontal folds appear, no matter how hard you pull. This is because, absent the influence of the fingers and thumb, the cloth is being pulled in one flat plane.

The appearance of folds in a cloth that is being pulled also depends on the direction of the weave of the cloth. If the cloth's weave is in the same direction as the pulling force, then, no matter how forceful

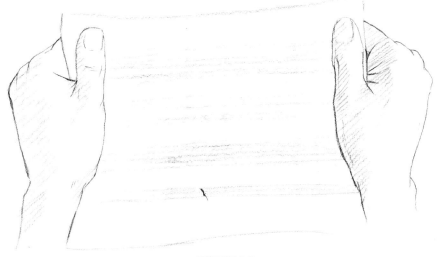

FIGURE 1.2

◀ Two hands pulling a cloth in the direction of the weave.

▼ Two clamps pulling a cloth in the direction of the weave.

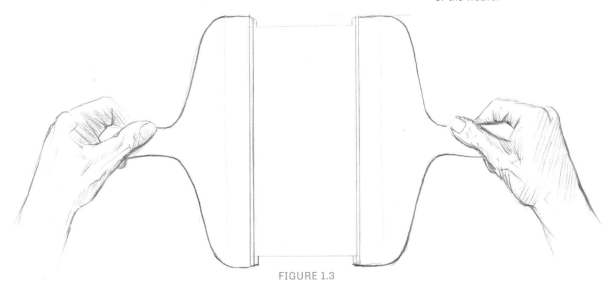

FIGURE 1.3

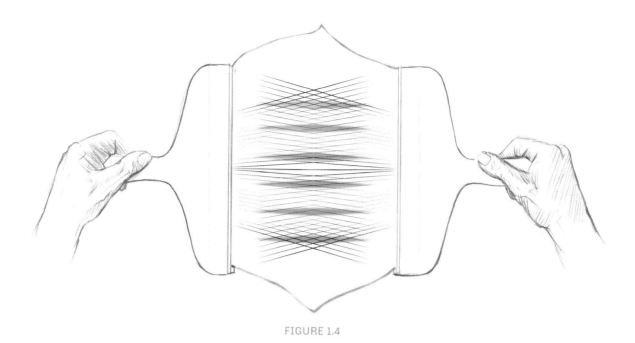

FIGURE 1.4

▲ Two clamps pulling a cloth obliquely to the direction of the weave.

the pulling action, no folds appear. If, however, the cloth is pulled in a direction oblique to the weave of the cloth, a distinct set of small folds will appear, running in the same direction as the pull, as you can see in figure 1.4. This is because the reaches of the threads that are far from the clamps are now being compelled in a horizontal direction. If the top and bottom of the cloth were pulled as well, the cloth would be stretched tight, and the folds would disappear altogether.

So it can generally be said that while a pulling action *can* produce folds in the direction of the pull, the appearance of folds is actually dependent on variable factors, which, besides the direction of the weave of the cloth, might also include the looseness of the weave and the abundance of material relative to the force. Therefore, when drawing cloth it is better to focus on the forces of compression acting on it rather than the forces of tension. When you see a set of pronounced folds, be more attentive to the pushing action, perpendicular to the folds, than to the pulling motion that emphasizes them or distorts the cloth in that direction.

Resistance

As stated above, gravity is the main force acting on cloth, pulling it downward at all points. But most cloth that we observe is resting on something. When a piece of cloth is suspended, part of it is resting on an object, but the remainder of the cloth, with nothing but the air to offer it resistance, continues to be pulled down.

Because cloth is supple, it will conform, at least to some degree, to the surface of the resistant object. But if the cloth extends beyond the edge of that object, gravity will continue to pull it downward, causing the cloth to fold or bend along that edge—that is to say, along the limit of the supporting plane.

▶ Cloth draped over a cylinder.

The more complex the shape of the supporting object, the more complicated we can expect the resulting folds in the drapery to be. But for now, let's take a look at some simple objects to observe how gravity and resistance act on cloth. As you look at figures 1.5–1.7, assume that the force of gravity is coming from the bottom of each drawing, where the ground plane is conventionally implied, and that it is pulling in that same direction. In all these cases, the drapery bends and falls along the edges of the forms, since beyond these edges there is nothing the cloth can rest on.

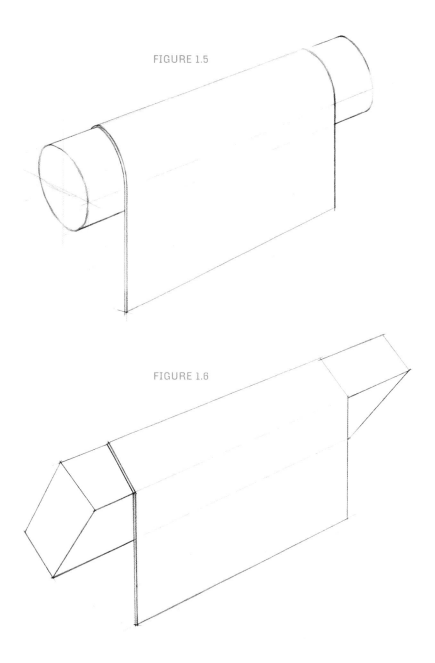

FIGURE 1.5

FIGURE 1.6

▶ Cloth draped over a rectangular solid.

FIGURE 1.7

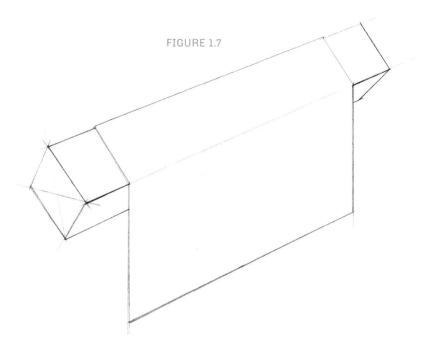

▲ Cloth draped over a square-sectioned solid.

Bear in mind that, while the cloth conforms to the shape of the top surface of any of these forms, the fall of the cloth is indifferent to whatever form the bottom surface of the objects takes. Once the cloth leaves the support of the object, only the air and gravity will affect it. In each example, the drapery—"uninformed" about whether it is resting on a cylinder, a rectangular solid, or a square-sectioned rectangular solid—behaves the same way once gravity regains its control beyond the edge of the form.

The setup of each of these drawings is purposely simple. Each of the solid forms has an edge that is smooth, straight, and parallel to the ground. The cloth therefore falls evenly over the edge, creating a single, unmodulated fold. In subsequent sections, we will see how additional factors, such as tilting the forms or adding irregularities to the edges, will modify the result.

Monodirectional Folds

By looking at the simplified setups in figures 1.8 and 1.9, we can see how a series of even, parallel folds will result from a perpendicular (sideways) compressive force.

The formations depicted in these illustrations probably seem familiar: Figure 1.8 might be a shower curtain, suspended at one edge to form a vertical plane. The material has been compressed by a force moving horizontally through it, as when someone pushes a shower curtain to the side. Figure 1.9 could be a napkin lying on a table. A horizontal force has impacted this form, as well, but this time across the whole breadth of the cloth. True, gravity is also pulling down on the cloth from a vertical direction, but let's leave that out of

our observations for now and merely take note of how a theoretical force moving in a single direction, and evenly across the breadth of the cloth, will produce such a series of parallel folds.

Structure of a Single Fold

In figures 1.8 and 1.9, you should see an echo of figure 1.1. In that first drawing, of an unspooling cloth folding upon itself, the force of compression was the vertical force of gravity pulling down/pushing up. In figures 1.8 and 1.9, the force of compression is moving sideways, but it produces a similar result regarding the

structure of each fold. Let's examine the structure common to all the individual folds in these drawings.

In figures 1.8 and 1.9, just as in figure 1.1, the points of the folds where the cloth changes direction do not take the form of sharp angles but are instead rounded. A section drawing of any of these arrangements would look like the sine-wave profile depicted in figure 1.10. Artists refer to the rounded edge where the fold turns direction as the *ridge* of the fold.

▼ Vertical waves, created by a horizontal force, in a vertically suspended cloth.

▼ Horizontal waves, created by a force perpendicular to them, in a horizontal cloth.

▼ The profile of a typical sine wave. Note the rounded peaks at the top and bottom of each form.

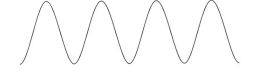

FIGURE 1.10

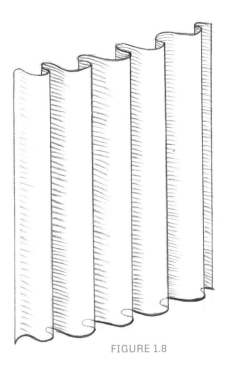

FIGURE 1.8

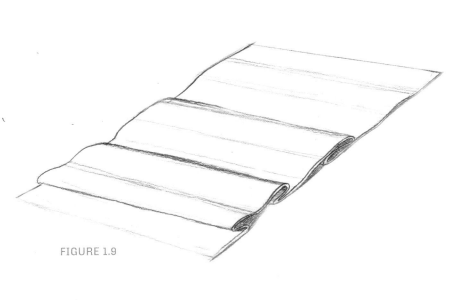

FIGURE 1.9

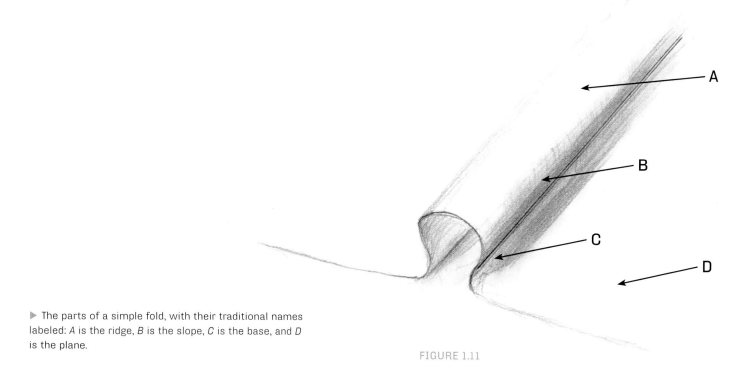

▶ The parts of a simple fold, with their traditional names labeled: *A* is the ridge, *B* is the slope, *C* is the base, and *D* is the plane.

FIGURE 1.11

▼ Close-up of the peak of a fold in cross-section. Note the rounded ridge at *A*.

FIGURE 1.12

Figure 1.11 shows a single, simple fold. Note how its component parts relate to the sine-wave pattern depicted in figure 1.10. The "ridge" is marked as *A*. The flatter, broader plane (*B*) that leads from it is traditionally called the "slope." It, in turn, leads to the lower ridge of the fold (*C*), which in art parlance is traditionally called the "base."

The base, in turn, connects to another slope, unless it comes to rest upon some supporting surface, in which case it extends into a flattened area (*D*) called the "plane." There will be more discussion of both the base and the plane later in this chapter.

If you go back and look closely at figure 1.1, you will notice that the ridges of the compressed cloth ridges are not only curved, but they also swell a bit, causing cylindrical forms to develop beyond the angle of each fold. Figure 1.12, a section drawing of a fold, also shows this swelling. This slight bulge is caused by the internal resistance of the cloth—a topic that we will explore in greater depth on page 48.

Monodirectional Folds in Tubes

Now let's look at what happens when a force compresses a cloth that is tubular in form—that is, a cloth whose edges are joined to form a cylinder. There are two possibilities, depending on which direction the force is moving in. The first is illustrated in figure 1.13; here, the compressing force is moving in the same direction as the long axis of the tube. The folds, naturally, form perpendicularly to the direction of the force, and run *transversely* (crosswise) to

the length of the cloth tube, like the folds of a concertina accordion. By contrast, in figure 1.14, the force of compression is moving in a direction opposite that of the cloth tube's long axis, causing the waves to run *longitudinally*, or parallel to the long axis of the tube. Note how in each case, the back-and-forth wave pattern is the same. In either situation, the folds—looked at in section—still run from crest, to slope, to base and repeat again from there.

In drawings like these, the places where the folds turn are expressed as lines. But you should remember that these lines do not represent sharp edges; rather, they merely mark the areas where the continuous, curving forms of the folds turn away from the light or from the viewer. Folds should always be understood as multifaceted, three-dimensional forms.

▼ Horizontal waves, created by a vertical force, in a vertical tube of cloth.

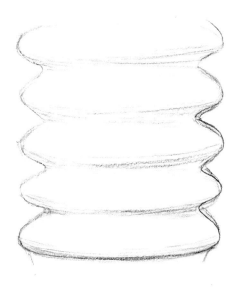

FIGURE 1.13

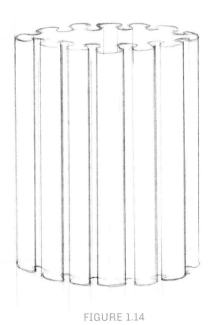

◀ Vertical waves, created by a horizontal force, in a vertical tube of cloth.

FIGURE 1.14

LEONARDO

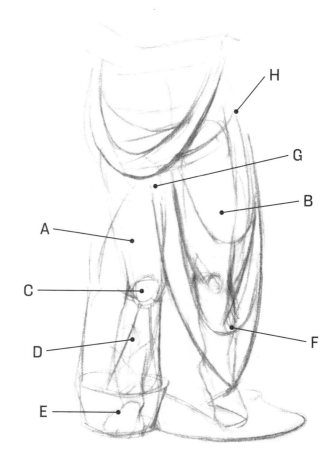

Leonardo da Vinci's drapery studies are widely considered to be among the most beautiful ever produced. As Leonardo was both a scientist and an artist, his work reflects a determination both to understand the mechanics of the natural world and to use that understanding to depict it in the highest aesthetic terms. Leonardo assiduously researched both the structure of folds and how light plays on them.

Certain passages in Giorgio Vasari's *Lives of the Artists* (1550) suggest that this study was done from an arrangement of drapery on a dummy form, not a living model. Nonetheless, one can clearly make out the implied wrapping of the cloth about two upright leg forms, at *A* and *B*. Indeed, at point *C*, the relief of the figure's right knee distends the cloth, clearly "showing through." A conical formation, *D*, descends from this same right knee, expanding into a compression band as it hits the ground at *E* and collapsing, in between, into a zigzag pattern.

The cylindrical length of cloth surrounding the left leg at *F*, suspended on one side over the figure's right thigh at *G* and, on the other, from the left hip, *H*, falls in a descending cascade of folds between the two.

Notice how Leonardo, in his treatment of the folds, runs a highlight across the length of the ridges of the satiny material, thereby capturing their stiffness and shine. Note, too, his careful attention to the direction and size of the sloping planes and to how they interlock with and reinforce each other.

▶ Leonardo da Vinci (1452–1519), *Drapery Study for a Standing Figure Seen from the Front.* Tempera and white on canvas, 13 x 24 inches (34 x 60 cm), c. 1478–80. Gabinetto dei Disegni e Stampe, Uffizi, Florence, Italy/ The Bridgeman Art Library

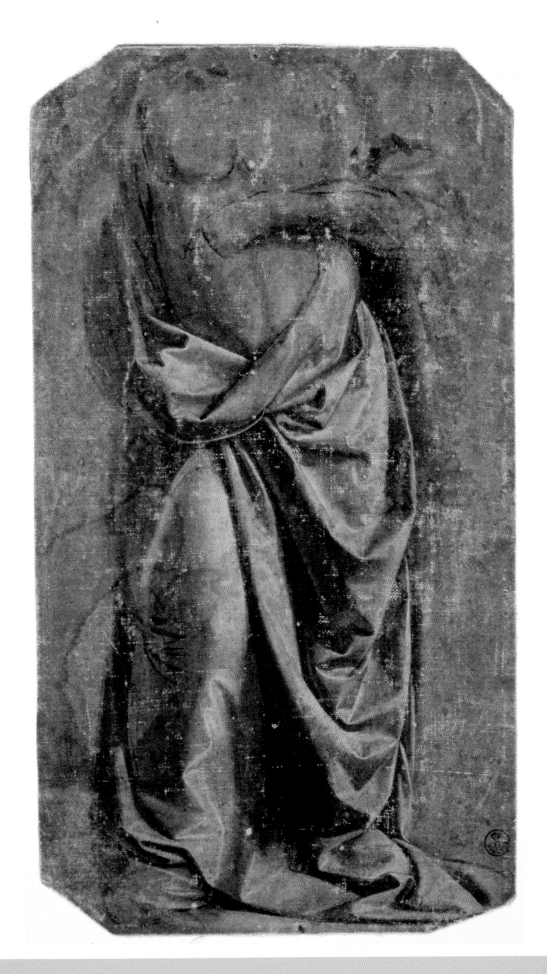

Intersecting Folds

Unlike those that we have just studied, most of the fold patterns that we see in real life are produced by several interacting forces, not by a single force. What results arise? Let's start to answer that question by looking at some simple scenarios.

Figure 1.15 shows a cloth with a series of parallel folds—like those that we saw in figure 1.8—draped over a square-sectioned solid. In figure 1.16, a cloth with a parallel series of vertical folds is draped over a cylinder.

The order in which the forces acting on the cloth occurred doesn't matter. The drape in figure 1.16, for example, may have been pushed from the side before it was laid over the cylinder, or vice versa. (Or both things may have happened at the same time.) In fact, all folds represent reactions to an acting force *after the fact*. The folds you see in a cloth are essentially a visual record of the forces that *have* acted upon it.

In both figure 1.15 and figure 1.16, notice two things: (1) that the folds take on a greater complexity where two directions of force intersect—in this case, at the lateral edge of the block or cylinder, where the sideways force of compression intersects with the vertical pull of gravity, and (2) that along this line of intersection, these folds adopt a particular configuration, which is magnified in figure 1.17. This pyramidal structure, with rounded concave sides and rounded convex edges, forms the basis of all the fold structures that we will examine in the following sections.

▶ Intersection of a series of transverse waves with the edge of a block.

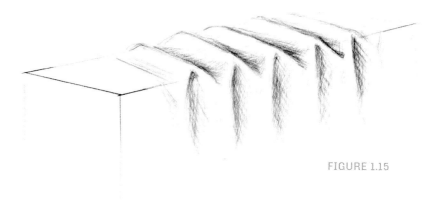

FIGURE 1.15

▶ Cloth with a series of transverse waves draped over a cylinder.

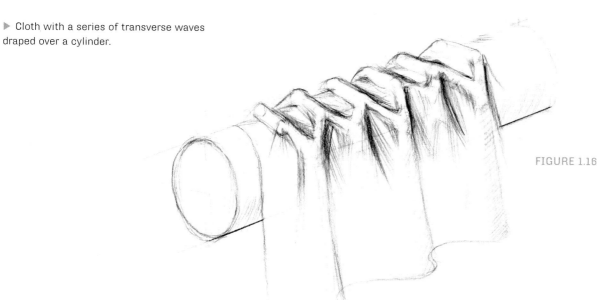

FIGURE 1.16

FIGURE 1.17

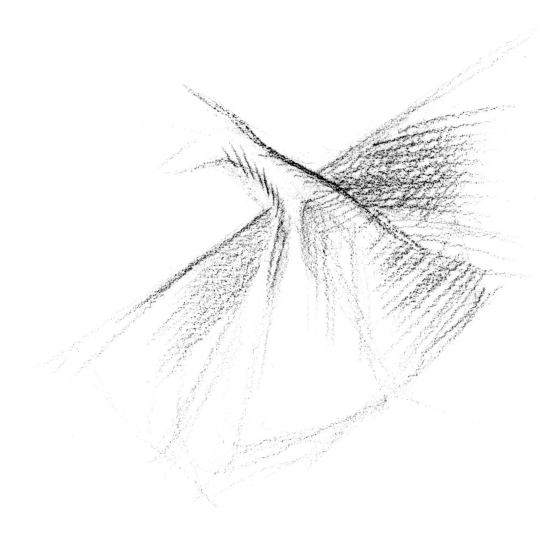

▲ Detailed view of the structure that appears
when two folds intersect.

Compression Patterns in Folds

To better understand the structure of intersecting folds in cloth, let us consider a more abstract, graphic representation of wave patterns. From our examination of simple folds, we know that a series of such folds consists of a ridge, followed by a slope, followed by another ridge, and so on. Now, suppose that such a rhythm, as graphically pictured in figure 1.18, were to intersect with a similar pattern running in a perpendicular direction, as shown in figure 1.19. What would happen?

When the low parts of the second wave pattern hit those of the first, they go doubly low, resulting in a further depression. Likewise, where the peaks of the second hit the peaks of the first, those points are augmented, rising doubly high. When a high point intersects with a low point, they tend to neutralize each other and remain at the level where the cloth would be at rest, as do the places where the midpoints of the folds meet.

In figure 1.20, we have graphically combined the vertical and horizontal wave patterns. The result is a series of doubly dark low points checkerboarded with doubly light high points. The gray areas that form among them are characteristically diamond shaped.

Physicists call this an *interference* pattern, referring to the high points as *nodes* and the low points as *antinodes*. Although artists don't generally use these terms, the phenomenon is very familiar, since the same thing that happens abstractly in wave forms happens in cloth. Understanding the formal structure of this nodal/antinodal pattern is critical to learning how to draw it with accuracy.

Now, have a careful look at figure 1.21, which is a simplified rendering of the structure of an interference pattern made manifest in folds—or a *compression pattern*, as it will be referred to from here on.

A few things are going on here. First,

just as in the abstract graphic representation in figure 1.20, we see a number of high points, or nodes. Similarly, we see an array of low points, or antinodes, interspersed among them. The nodes and antinodes are connected to each other by a series of relatively broad planes. In this rendering, the planes have been drawn as completely flat, though they are rarely so in real life. These planes are, of course, equivalent to the slopes that we looked at earlier.

The whole pattern interlocks as a series of interconnected pyramids. Note how the area bordered by the blue rule forms a "positive" pyramid, projecting toward us, with a node at its apex. The area bordered by the green rule describes its inverse, a "negative" pyramid, receding from our point of view.

Four ridges intersect at the summit of each pyramidal structure, as do the points of the four triangular planes that those ridges border. Here, at the apex, the four

FIGURE 1.18

▲ Graphic representation of vertical waves.

FIGURE 1.19

▲ Graphic representation of horizontal waves.

FIGURE 1.20

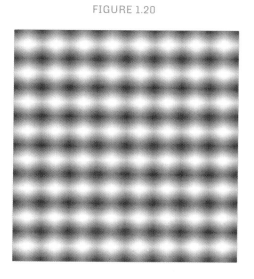

▲ The pattern produced when the patterns in figures 1.18 and 1.19 are combined.

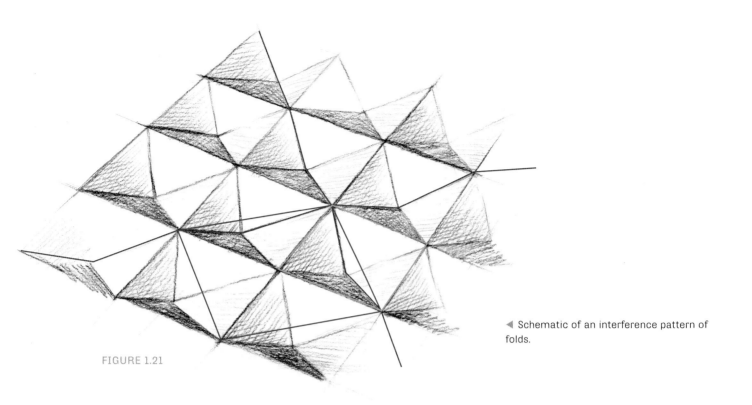

FIGURE 1.21

◀ Schematic of an interference pattern of folds.

FIGURE 1.22

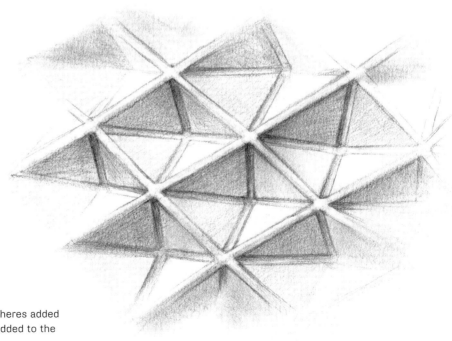

▶ Schematic of an interference pattern with spheres added to the nodes and antinodes and half-cylinders added to the crests and troughs.

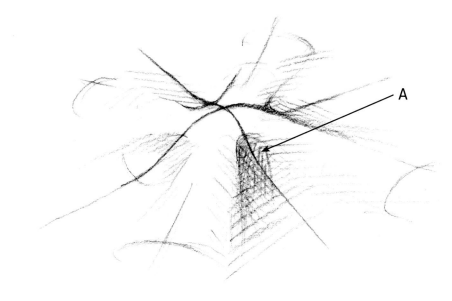

FIGURE 1.23

▶ Close-up of a node formed by two intersecting folds. Note the "eye" (*A*) of the fold and the intersecting ridges.

FIGURE 1.24

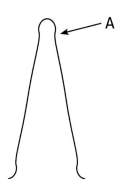

▲ Close-up of the peak of a fold in cross-section. Notice the slight indentation at point *A*, which is the site of the "eye" of the fold.

ridges of the intersecting folds join together. The apex, of course, is equivalent to the node that we looked at before, and we likewise find its inverse at each antinode, which is the apex of a receding pyramid.

In real cloth, these apexes—positive and negative—are rounded, not pointed. Although, as we will see later, the shape of the node or antinode is not exactly spherical, marking the nodes and antinodes with circles is an easy way to quickly establish the locations of the junctures of the planes of the folds in cloth and to indicate their characteristic undulations. In figure 1.22, the pattern that appeared in figure 1.21 has been refined by adding a set of spheres to the nodes and antinodes and a set of half-cylinders, either projecting or depressed, along the length of each "positive" or "negative" ridge. Notice how this simple modification already gives the drawing the feeling of an actual piece of cloth.

Now, as a general rule, the fold patterns

in cloth look the same from whichever side you view them. It follows that if you were to look at this compression pattern from the other side, you would expect it to appear generally the same. The main difference would be that the high points, or nodes, would become the low points, or antinodes, and vice versa. The planes of the slopes would still be the same, however. Essentially, they do double duty, serving simultaneously as the walls of both the projecting and the receding pyramids.

As in figure drawing, where conceptualizing the masses that make up the body is far more important than trying to capture the abstract character of an outline, your drawing will benefit from understanding the direction and position of these internal planes. Correctly describing them will create a more convincing rendering of drapery than trying to copy the "lines" of the troughs and crests that mark the planes' intersection. If you can capture the

major planes of the folds—their relative positions, their sizes and shapes, and the fall of light upon them—you will find that the crests and troughs essentially "draw themselves" with little effort.

Returning to figure 1.21, notice the way that, starting from any point on the form and moving either vertically or horizontally, we can trace a zigzag pattern, as demonstrated by either of the red lines in the drawing. This phenomenon reveals the back-and-forth forces active in the pattern—that is, a set of folds in one direction compounded by a set of folds in another.

Let's take note of another aspect of a fold's structure. Just beyond the node, where it first meets the "negative ridge" (or the fold line planes), you will notice a distinctive depression, as shown in figure 1.23. To better understand this, again consider a cross section of the cloth (figure 1.24). As you can see, the material forms a looping, softened angle at the peak of the fold and then curves back in against itself slightly. Traditionally, artists have referred to this area where the cloth indents as the *eye* of the fold.

As rounded swellings in the negative planes that border it begin to arise, the end of this depression becomes squeezed between them into a pointed "tail," facing away from the node, as seen in figure 1.25. Therefore, the eye takes on a teardrop shape, with its rounded end directed toward the node and its tail disappearing into the slope. Depending on the particular material, the eye of the fold can be subtle and soft or pronounced and sharply defined. Learn to look for its presence even when you don't immediately perceive it.

An Easy Graphic Model for Compression Patterns

As shown in figure 1.26, an easy way to demarcate a compression pattern is with a series of cross forms, each like the letter *X*. For every pyramidal unit within the pattern, the node will appear at the intersection of the cross, and the ridges will appear along the letter's strokes. It helps if you keep your letter form "outlined," rather than filled with solid black. One letter *X*, of course, leads into another, and the whole pattern may be drawn as a grid.

▼ At the bottom of this illustration, the intersecting ridges of the folds are marked with a simple X. At the top, they have been more thoroughly modeled with gray tones.

FIGURE 1.25

FIGURE 1.26

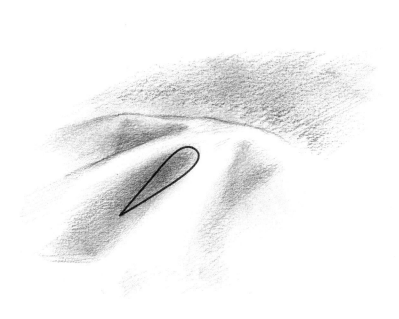

▲ Notice the internal teardrop shape, marked in red, that is formed by the planes of the "eye."

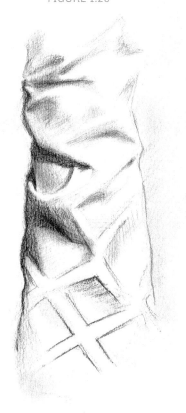

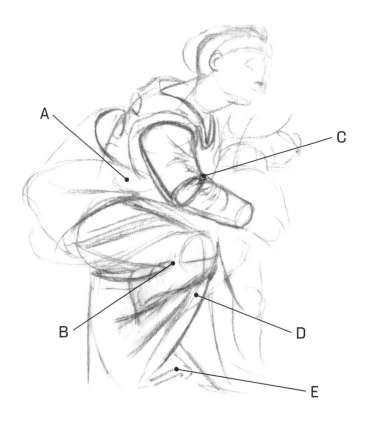

Raphael is considered one of the greatest draftsmen ever to have lived. His drawings—of the draped figure as much as of the nude—are renowned for their grace, balance, and clarity.

As with many other artists, Raphael's practice was to draw a nude study first and then to draw the clothing over it. It was common for him to change the direction and nature of the fold patterns on a particular figure to harmonize with the rest of the composition.

In this depiction of the Virgin, the Madonna is draped in a number of layers of garments. Nonetheless, we can distinguish some of the major dynamics at play:

If we regard her dress as a single tube connected to a tube for each sleeve, we can see the effect of the sharp bends in these tubes at the waist (*A*), the right knee (*B*), and the right elbow (*C*). Note how compression patterns form at each of these junctures, with their most pronounced creases situated between the squeezing limbs.

The Virgin's skirt suspends from the knee in a conical formation at *D* and is itself compressed against the ground in a zigzagging movement at *E*.

▶ Raphael (1483–1520), *The Virgin and Child.* Silverpoint heightened with white bodycolor on a slate gray preparation, 5 x 6⅜ inches (12.8 x 16.1 cm), c. 1512. © Ashmolean Museum, University of Oxford

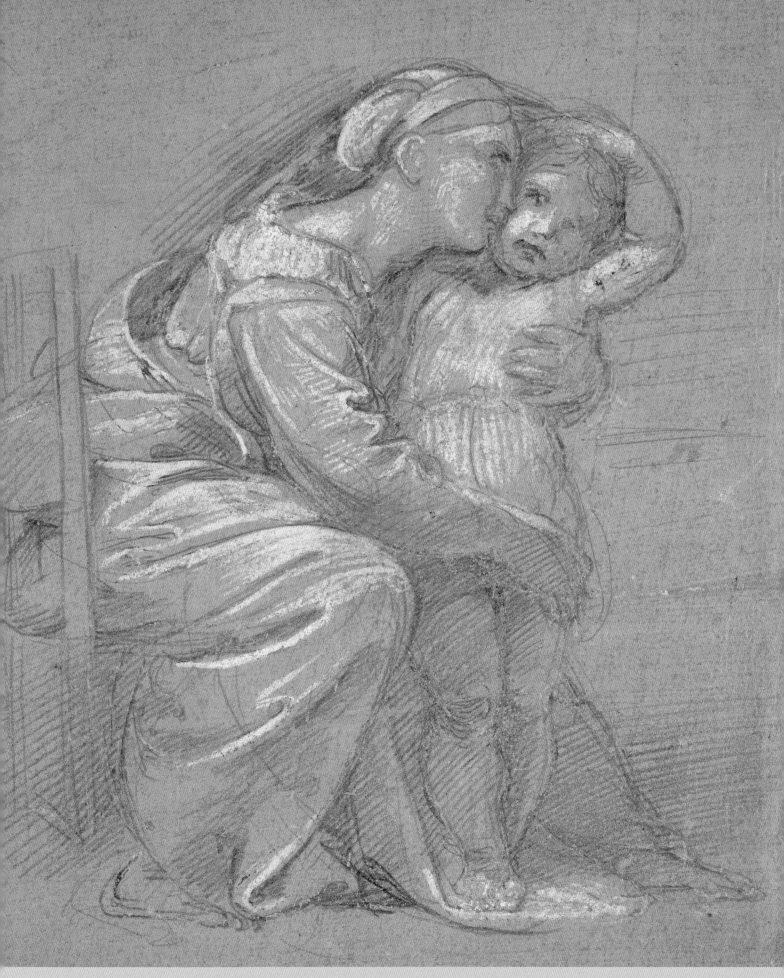

A Conical Model for Compression Patterns

Figure 1.27 introduces another method for describing the intersection of two folds in a compression pattern. You can conceptualize this area as the intersection of eight half-cones, (bisected lengthwise). Just as the "positive" and "negative" pyramids of our pyramidal conceptualization projected and receded, in this conical representation four of the half-cones project toward the viewer, and, evenly distributed among them, the other four recede. As before, a rounded node caps the center point.

Of course, you are free to use whichever model works best for you in describing fold patterns or to invent your own. Because the slope of the fold is usually neither perfectly straight nor very curved, but somewhere in between, sometimes it will be more useful to conceive of the folds in your drawing as a grid of X shapes, as in figure 1.22, and sometimes as the intersections of cones, as in figure 1.27. Or you could even use both models within a single drawing to describe different folds.

When you draw drapery, be aware that the eyes of the folds and the bases, or "fold lines," that lead from them will usually appear to be the darkest parts of the fold, since, as they recede from our point of view, they are also typically receding from the light source.

Because the eyes are always adjacent to the nodal points, they can be used to accurately establish the position of the fold's salient points. Nonetheless, when drawing drapery it is better not to over-rely on them. The better you understand the *complete* structure of the matrix of folds—how all the nodes, antinodes and connecting planes, edges, and folds inter-relate—and the more you incorporate all these parts in your rendering, the stronger your drawing will become.

▼ An alternate method of visualizing a nodal point, using cones instead of flat planes. One of the "eyes" is indicated at *E*, which itself follows the form of a "negative" cone.

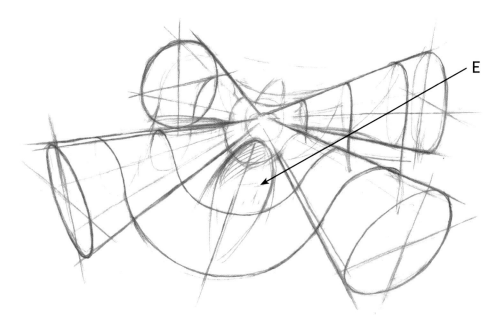

E

FIGURE 1.27

Compression Patterns in Tubes

While compression patterns will appear in almost any study you make of drapery, it may be most useful to analyze the pattern that we most typically encounter in clothing. Take a careful look at figure 1.28, which shows a simple tube of cloth encircling an upright cylinder and hitting the ground plane. Once again, the pattern that we see is the result of forces compressing the cloth in two directions: One set of folds is directed longitudinally, while the other is directed transversely. When the forces (and the folds) collide, we arrive at this result, which is typical of what we commonly see, for example, in the cuff of a pant leg or the bunching of a shirtsleeve. The causal forces are evident in the red lines in the drawing, which trace the form's horizontal and vertical contours.

Figure 1.29 shows another interpretation of a classic compression pattern in a tube of material. As in figure 1.22, the ridges have been drawn as simple half-cylinders, uniting at rounded nodal points. Their "negative" counterparts have been drawn as hollowed, or recessed, half-cylinders. In between, the slopes are drawn as flat planes.

I call this particular array "classic" because the nodes and antinodes are evenly spaced, both in the transverse direction (that is, around the circumference of the tube) and in their depth (that is, their distance from its central axis). Also, there are eight points—four nodes and four antinodes—in each given "ring." In a form like this, which we assume is composed of a uniform material, we would expect the nodes and antinodes to be evenly spaced, as they are here. But, although there could be any number of nodes and antinodes, it is very common to find this pattern, with a ring of nodes facing front, back, left, and right, while the rings of nodes above and below it are set at 45-degree angles.

▼ A simplified model for representing the compression folds in a tube.

FIGURE 1.28

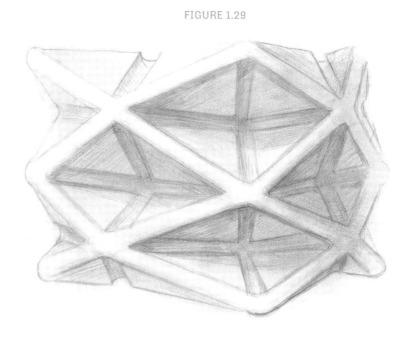

FIGURE 1.29

▲ A compression pattern in a tube of cloth. Notice the compounded sine waves—one running transversely, the other longitudinally—indicated by the red lines.

FIGURE 1.30

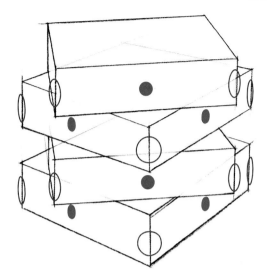 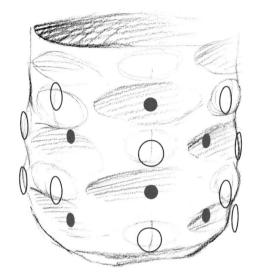

▲ Placement of nodes and antinodes. The stacked square blocks at left provide a useful tool for determining the proper positioning of the nodes (marked in red) and antinodes (marked in blue) in a compressed cloth tube (right).

One way to help capture this repeating pattern of eight equally spaced nodes and antinodes is to draw a set of square blocks stacked atop one another, with every other block rotated 45 degrees, as in figure 1.30. Designating the corners of the blocks as nodes and the midpoints between them (on the sides of the blocks) as antinodes establishes their correct positions in the adjoining rendering. Note how, in both these drawings, the nodes and antinodes (or corners and midpoints of the blocks) align vertically.

Naturally, all the drawings we've looked at so far represent abstractions from reality. In real life, we would expect to see such waves compressed into more complex forms by yet other forces, notably gravity. Such complexities will be explored in the following pages, but, for now, it's useful to establish the basic pattern onto which variations may be applied.

Compression Bands

In clothing, compression bands—short distances where the cloth bunches, increases in diameter, and adopts the form of a classic compression pattern—are commonplace. As we will see in subsequent chapters, they tend to manifest themselves wherever a tube of cloth comes to rest on its long axis or is compressed by a joint, or where its actual diameter increases. These expanded cuffs of material may not be evenly compressed throughout their diameter, and so they often appear tapered or wedgelike in profile.

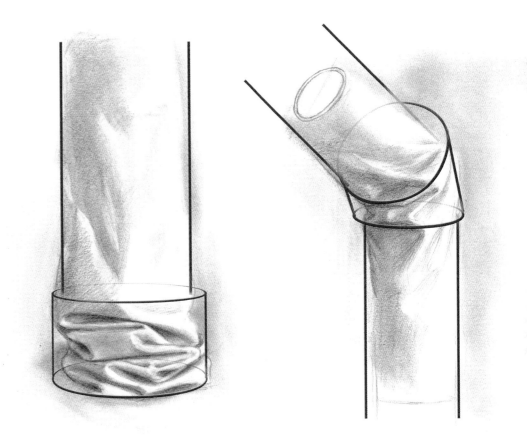

▶ Compression bands. On the left, the pressing of the cloth upon the ground plane results in a collection of folds. These create an expanded volume of material, or "compression band." At right, the cloth is more tightly compacted where the cylinder it surrounds is bent. The resulting compression band is wedgelike in profile.

Variations in Compression Patterns

So far, we have looked at compression patterns as they would be found in an abstracted, idealized setup. While it is paramount to good drawing to understand the structure of this basic array, one is not likely to encounter anything so idealized in real life. A great variety of forces can act upon a cloth, and the resulting formations will vary greatly.

Spacing of Folds

If you look again at figure 1.1—the drawing of cloth hitting the ground plane—you will notice that the nearer the folds are to the ground, the closer together they are. It's easier to understand why this is so if you consider the action in reverse: If you were to up push against the cloth from below (or from whatever direction), the impact will be stronger closer to your pushing action and will diminish farther away. This principle is graphically described in figure 1.31.

Look at any piece of drapery—perhaps the clothing you're wearing right now—and notice the changes that occur in the spacing of its folds. Wherever there is greater stress upon the cloth, the distances

FIGURE 1.31

▲ The folds nearest the compressing force, represented by the red arrow, are larger and more closely spaced than those farther away.

▼ A drape suspended between two anchors. Note how much closer together the planes of the fold are at *A* than at *B*.

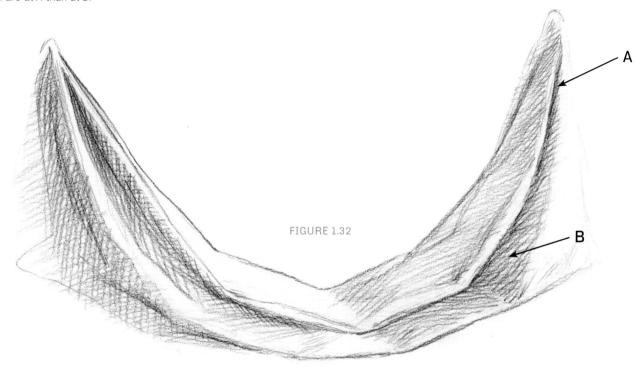

FIGURE 1.32

A

B

FIGURE 1.33

between the folds decrease, and the folds have a greater height and depth than they do farther away, where they soften into gentler ripples.

Let's look at a common example of how the spacing of folds changes—one that we will study more carefully later in this chapter. In figure 1.32, we see a sheet hanging between two supports. Note how the distance between the folds in the sheet becomes wider as it drops farther from the anchors. At the anchors, the weight of the cloth compresses it upon itself. At the bottom, the folds of this suspended swath of cloth can expand freely. With less compressive force present, there will be fewer folds within the same relative distance.

We find the same phenomenon at play in figure 1.33, in which the compressive force of the ground "pushing" against a simple, vertically oriented cloth tube is more pronounced where the tube hits

the ground plane. The transverse folds—those going around the cylinder, perpendicular to the upward force of the ground plane—are more closely spaced at the bottom than at the top of the tube. Or we could describe this in an opposite way, saying that the weight added by each successive fold of cloth causes the pile to compress more as it nears the floor. Note, however, that the positions of the nodes that demarcate the *longitudinal* folds—those running up and down, parallel to the directional axis of the cylinder—are relatively unchanged from how they appeared in figure 1.28.

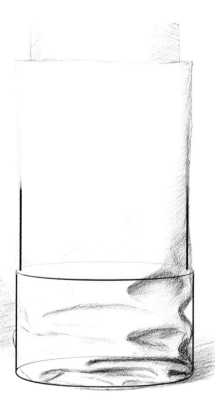

▶ A tube of cloth compressed against the ground plane. The greater amount of force at the bottom results in a greater frequency of folds.

Amplitude

In scientific parlance, the *amplitude* of a wave is the height of its peak or the depth of its trough. In the examples we just looked at, changes in amplitude are connected to changes in wavelength. The shorter the wavelength—that is, the *greater* the frequency, or the *more* folds per given distance—the greater the amplitude. This principle is a little easier to understand in the case of the cloth tube. We know that the circumference of the tube, at any given horizontal level, is fixed; the cloth is generally not going to stretch much. So if one end of the cloth is pushed in a longitudinal direction, the amount of material that would normally extend along a given distance would now be forced to zigzag within a shorter one. That material, if measured along its back-and-forth path, would be the same length as when the cloth was stretched out straight. So the compressed weave of cloth, having to be displaced somewhere, forms waves of maximum amplitude.

Fading

The opposite of a compression effect is one in which waves relax or diminish. If we throw a stone into a still pool of water, we know that the waves become smaller the farther they are from the source that created them. They don't necessarily stop; they just diminish to insignificance, eventually becoming imperceptible. The same happens in cloth. Forces create fold patterns in the material, but at some distance the folds fade away to the point of invisibility—or they actually stop, as in figure 1.34.

Sometimes, this fading occurs over a very short distance. Be aware of this. The basic pattern has not disappeared or mutated into a random formation; it has just become less visible. Train your eyes to look for the continuation of wave patterns even when they become faint. Doing so will enable you to give the proper direction and proportion to the folds in your drawings of drapery.

FIGURE 1.34

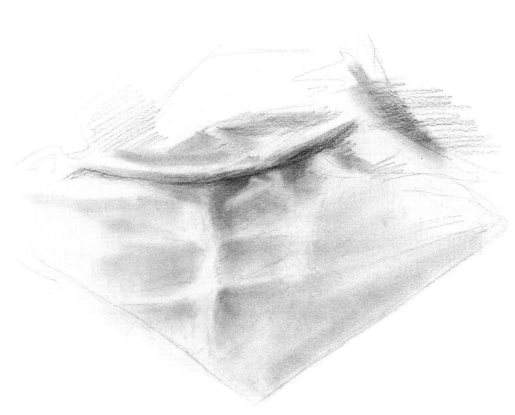

▲ A compression pattern can fade out, sometimes unevenly.

The compression patterns that we've looked at so far have all been depicted as one series of folds running perfectly perpendicularly into a second set. In these cases, one of these sets is caused by the force of gravity. Since gravity pulls vertically these folds are drawn horizontally. The other set of folds, formed by a horizontal force, is drawn vertically.

But patterns of folds can be more complex than this. A force can act on cloth from any direction, and the waves it generates may intersect *obliquely* with those produced by another force. In figure 1.35, the diamond pattern we observed in the "classic" configuration is still there, but now it's skewed slightly.

Notice how easy it is to ascertain the directions of the originating forces from these folds and to predict where the next plane formation would be in the series. In your own drawings, your awareness of the compressive forces can lead you to discover the form of smaller folds, which at first may be barely visible, and to see how to relate all your folds to each other within the context of a series.

Admittedly, the setup depicted in figure 1.35 is abstracted and idealized. Such simple patterns are rare in real life. Forces acting on a cloth usually create more complex patterns, which we will look at in the sections that follow. It is, however, common to find a series of vertical waves running in the same direction as the pull of gravity and opposing horizontal waves that we know are due to gravity. Why is this so common? There are two reasons.

◀ Obliquely intersecting folds. Note the main direction of one set of folds, indicated with red lines, and the second, indicated by blue lines.

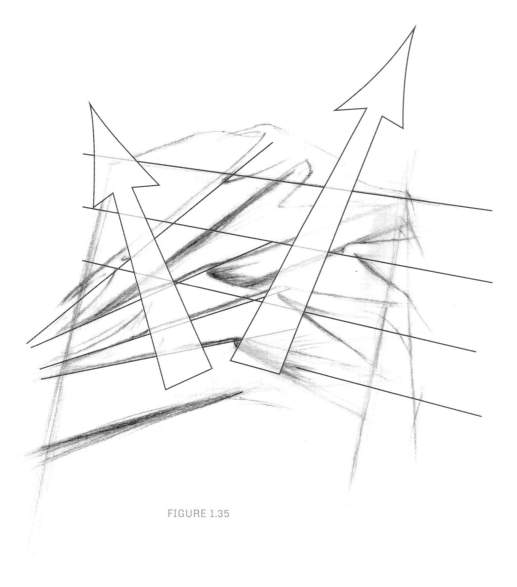

FIGURE 1.35

FIGURE 1.36

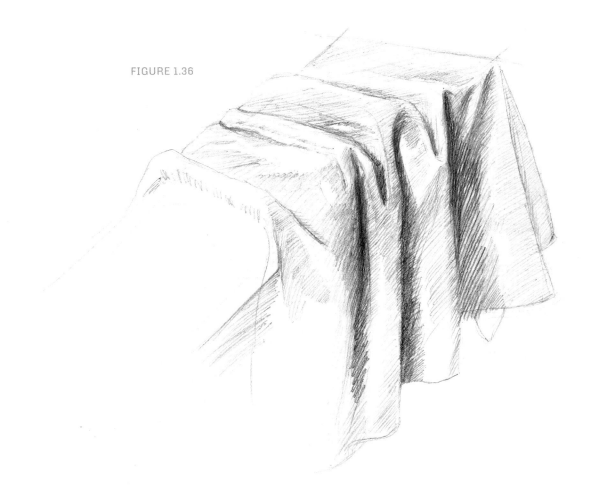

The first has to do with force mechanics. If you push a rubber ball downward against the floor, you expect it to bulge out at the sides, perpendicularly to the direction of the force you are exerting. The same thing happens in cloth. When gravity pulls down on it, a displacing force is also generated that travels in a sideways direction. In many cases, however, the cloth runs into an obstruction. Unlike the rubber ball, which easily displaces the air that surrounds it, the cloth, in essence, "has nowhere to go." Therefore, it buckles back and forth within its own limits. This is especially clear in the case of the self-terminating tube that we use in our classic compression pattern. Because it circles around to join itself, these lateral forces cause it to undulate in an even series of vertical folds about its circumference. The

result is the pattern of even, interlocking diamonds that we studied earlier.

The second reason that we often find purely vertical waves intersecting with the horizontal ones formed by gravity is that the manufactured objects in our world are generally fabricated along vertical and horizontal axes. A shower curtain, brushed to the side, usually hangs suspended off of a horizontal bar. A tablecloth, pushed to one side, rests upon a horizontal table.

But because we humans rarely hold ourselves still upon rigid, perpendicular axes, it is important to study how folds form on inclined supports. Figure 1.36 shows folds hanging from an inclined block; note how similar the formation is to those we saw in figures 1.15 and 1.16, except that here, the fold pattern is now more angular.

▲ Laterally compressed folds hanging from a block inclined at an angle.

INGRES

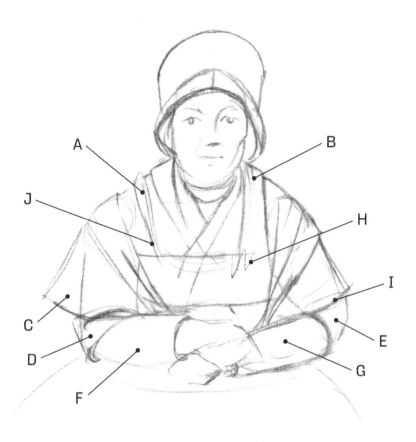

A professor at, and later the head of, the French École des Beaux-Arts, Jean-Auguste-Dominique Ingres was both a master draftsman and a teacher who insisted on good drawing from his charges.

In this drawing, typical of Ingres's style, his mother's face is modeled to a tight degree of finish, while the rest of the figure is captured in brief but extremely precise line work. Despite the austerity of Ingres's mark-making, the structure of the model's pose and of the layers of clothing that cover her form come through with remarkable clarity.

Note the vertical compressions between the model's neck and shoulders at *A* and *B*. Her outer robe, seemingly composed of a stiff material, extends into a conical form, *C*, as it hangs from the point of her right shoulder.

The pinching of the sleeves at the inside bends of the elbows results in the wedge-shaped compression bands that appear from underneath the outer dress at *D* and *E*. This pattern continues into the partially compressed sleeves over the forearms at *F* and *G*. With an uncanny ability, Ingres was able to express these fold patterns by running quick lines separating the lit from the shadowed areas. Note some remarkable instances of these zigzagging lines at *H* and *I*.

Also pay attention to the subtle way that the underlying forms govern the character of the line work. For example, notice how the few lines that appear on the sitter's chest either terminate or change direction at the change of plane, from upward to frontward, that happens along line *J*.

▶ Jean-Auguste-Dominique Ingres (1780–1867), *Madame Ingres Mère*. Graphite on paper, 19 x 24 inches (48.8 x 60 cm), 1814. Credit: Madame Ingres Mère (1758–1817) 1814 (graphite on paper) (b/w photo) by Jean-Auguste-Dominique Ingres (1780–1867), Musée Ingres, Montauban, France/ Giraudon/ The Bridgeman Art Library

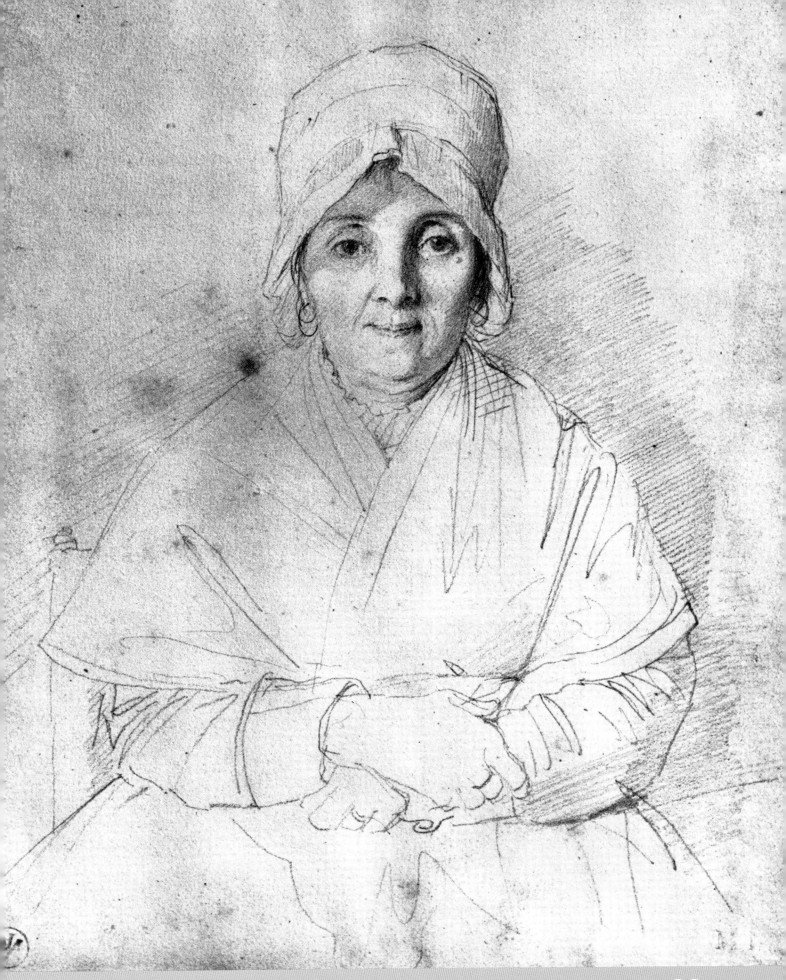

Twisting

A common variation on the classic compression pattern occurs when the cloth tube is twisted. The horizontal rings of nodes and antinodes stay at the same horizontal level, but they gradually rotate about the tube's long axis, as shown in figure 1.37. No longer are the nodes and antinodes stacked straight above one another (as was the case in figures 1.28–1.30 and 1.33). In a sense, we are adding a third dimension of force to our dynamic. The basic compression pattern is the result of forces intersecting along an x-axis and a y-axis. Now, a turning force is added along a z-axis. This type of situation occurs frequently in clothing, which is often attached to a relatively stationary part of the body at one end and a rotating limb at the other.

▼ A twisted compression band. In a "classic" compression pattern, the nodes marked in the same color would stack vertically above one another. In a twisted compression band, they instead rotate about the central axis of the tube. The fold pattern underlying the finished drawing at right has been simplified as a series of stacked blocks, at the left.

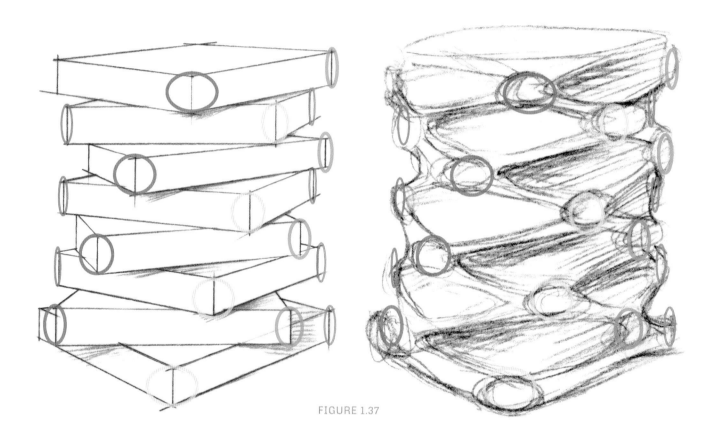

FIGURE 1.37

Elongation

So far, we have characterized nodes and antinodes as circles or simple vaultlike structures—the products of the intersection of two ridges. Often, however, these forms become elongated along one of the pattern's dominant directions. When this happens, the node and the antinode become more like tubes than spheres, and the resulting pattern appears to be formed of interlocking hexagons rather than diamonds, as can be seen in figures 1.38 and 1.39.

Of all the variations on the basic compression configuration, this one presents the most significant change in form. It tends to appear when one of the intersecting forces is significantly stronger than the other. It is also commonly found as a transition between a compression pattern, which is the product of two intersecting forces, and simple parallel folds, such as we saw in figure 1.8.

▶ Elongation. The elongation of two nodes gives a hexagonal appearance to what would otherwise be a diamond-shaped unit within a compression pattern.

FIGURE 1.38

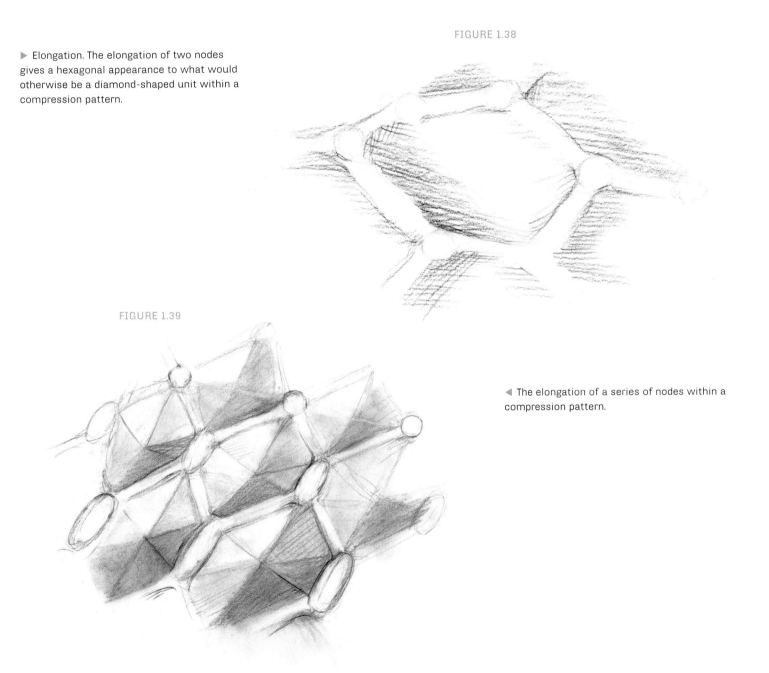

FIGURE 1.39

◀ The elongation of a series of nodes within a compression pattern.

Branching

Another exception to the basic formation often happens in conjunction with the elongation that we just looked at. It appears when an evenly spaced series of folds intersects with a series of folds that gradually become more closely spaced. When this happens, the folds in the first group will often "splinter" into a greater number of nodes and antinodes as the opposing fold pattern that it runs into becomes more compact.

But this transition is not random. It follows as a variation of the standard compression pattern, where one ridge splits into two, and each of these splits into two more, and so on. The resulting configuration roughly resembles the branching of a tree, as shown in figure 1.40. Or, following the transitions from the reverse direction, four ridges merge into two, and two into one. Of course, it is not simply the ridges, or "branches," that fork; the pyramids of

the basic pattern follow along, their planes and angles consistently interlocking with each other as before.

It is common to find elongation appearing in conjunction with this branching. When this happens, it is useful to visualize the resulting pattern as a trunk forking into two branches, each of which begets another trunk, which in turn forks into two branches, and so on, as shown in figure 1.41.

FIGURE 1.40

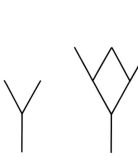
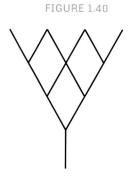

▶ A single unit of a compression pattern (shown at far left with its ridges represented as a Y) can "branch" into more and more units (at right).

FIGURE 1.41

▶ Branching and elongation. Here, the same branching phenomenon as represented in figure 1.40 is occurring—but with elongated nodes, so the units appear hexagonal.

Pop-Outs

Sometimes, especially in very flexible materials, a pyramid within a compression pattern will "pop out" in the opposite direction, as shown in figure 1.42. It may at first be difficult to make sense of this phenomenon, since it looks as if only half of the basic pattern is appearing—a large V terminating abruptly at its apex rather than the X that usually demarcates a node.

Once again, look for the larger pattern, and the origin of the pop-out will soon make sense. You will notice how its shape holds roughly double the volume of its neighboring pyramidal forms. That is because the material that had been doubled upon itself is now expanding into one direction.

Remember that the pattern of folds on one side of a cloth mirrors that on the other; on both sides, the basic array is composed of "negative" as well as "positive" pyramids, meaning that a pop-out may occur in either direction. That is, a pyramid may collapse into itself, creating an indentation that recedes from the viewer.

FIGURE 1.42

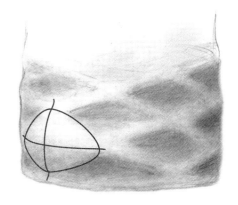

▲ A pop-out. Notice the area circled in red, which in a standard pattern would be recessed.

Bells

Last, let's look at a variation on a standard compression pattern that is closely related to the fading phenomenon we've already discussed. As you can see in figure 1.43, a ridge of the basic formation will sometimes terminate abruptly as it meets a solid form. The resulting shape resembles a bell, with the apex of its dome colliding with the solid form and its mouth either blending into the rest of the compression pattern or gradually fading out. As with the pop-out, the bell formation is usually encountered in very flexible materials. As explained before, the rest of the compression pattern may continue on an imperceptible level, with the suppleness of the fabric absorbing any further visible deformation.

 ▶ A bell.

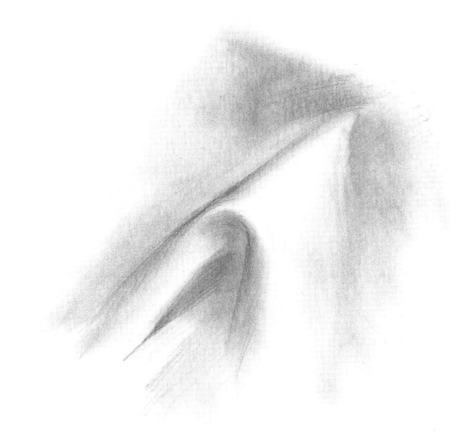

FIGURE 1.43

Plane Breaks

Something you should note, if you haven't already, is how the nodes and antinodes of a fold pattern align along the edge of a form, as you can see if you go back to figures 1.15 and 1.16. This is easy to understand if, instead of thinking of the cloth running over the edge of the block (or cylinder), you think of the block running into the cloth. From the point of view of physics, they amount to the same thing.

So if, as in figure 1.7, you imagine the edge of the block wedging into the cloth, you expect a sharp fold to form along that path, which it does. When this fold intersects with the vertical folds (in this case, caused by an arbitrary force), the result is our customary series of nodes and antinodes—the telltale sign of one series of folds colliding with another. And one distinct row of these nodes will align along the block's edge.

Again, it is useful to understand this phenomenon and its cause in both a "forward" and a "backward" sense: Where you find a series of nodal points, look for the plane break that caused it. Where you know a plane break to exist, expect to find a series of nodal and antinodal points. From this you can derive the placement of corresponding eyes, ridges, slopes, and so on that make up the entire compression pattern. In the following three chapters, we will be exploring in depth the effect of the human body's edges and planes upon clothes and the patterns that ensue.

FIGURE 1.44

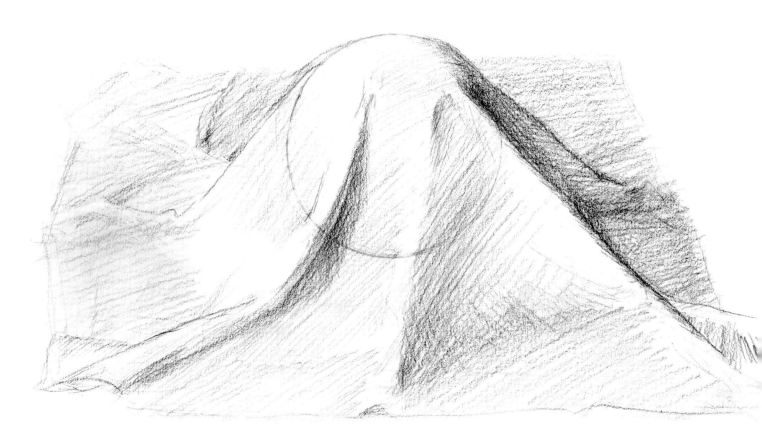

Suppleness

Up till now, we have been looking at abstracted, idealized depictions of patterns that cloth will take on under the application of force. At this point, however, we need to recognize the potentially strong influence of a property found in most pliant materials—their *suppleness*. By suppleness, we mean the greater or lesser degree to which the material itself tends to become deformed. Suppleness is not the same as pliability, which has to do with the degree and ways in which cloth will bend. Instead, suppleness involves the ability of the material itself to shrink or stretch. Most cloth has this ability, since it is composed of soft threads that are woven together, allowing for a fair amount of mobility within the fabric of the material.

To restate a point made earlier: Gravity is the force that is most active on a cloth, pulling on it at all times and at all points. The object on which a cloth rests provides resistance to this pull, and the cloth, to some degree or other, will conform to the object beneath, molding itself to its contours. In more supple cloths, the supporting object tends to "show through" more clearly, as you can see in figure 1.44, which depicts a cloth draped on a ball.

The difference in behavior between a suppler and a stiffer material is illustrated in figure 1.45, where we see the different character of the two cloths revealed: The suppler cloth has a greater tendency to "bend" before it "breaks"—that is, undergoes a break in plane. This is also true of wet cloth. Even when drawing very stiff drapery, however, it is paramount to express the form of the underlying forms through the cloth. This principle should always be regarded: Folds should never cut into the form of the object on which the cloth rests but always remain outside of it.

▼ Section drawings of two cloths draped over spheres. The suppler cloth, at left, conforms more closely to the sphere's surface at the bottom phases of the folds. At right, the stiffer cloth tends to break into flat planes.

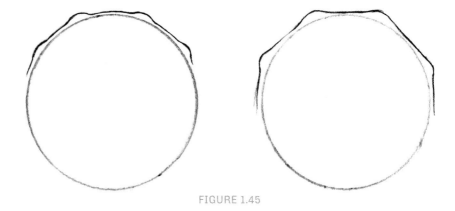

FIGURE 1.45

◀ A soft cloth draped over a ball. The sphere of the ball, shown in outline, projects its shape through the cloth. So, too, does the flat surface of the ground plane surrounding the ball.

FIGURE 1.46

Until now, we have considered compression patterns in the abstract, assuming that the receding, or "negative," phase of any fold or pyramidal formation in a compression pattern mirrors the "positive" phase apparent on the viewer's side. But all drapery at some point rests on some surface, and that surface will to some degree influence the form of the folds with which it comes into direct contact. In figure 1.46, where a supple cloth rests upon a half-sphere resting on a flat plane, the bottommost phases of its folds flatten out, conforming themselves to these supporting surfaces.

The more supple a material is, the more closely it will conform itself to the contour of an impacting surface. The force with which the material is applied to the surface also affects how closely the cloth conforms. For example, the depths of the folds of a cloth that is thrown forcefully onto the floor will be shallower and flatter than those of a cloth that gently falls to the same surface. Similarly, when a cloth is stretched tightly around an object, the shape of that object has a greater influence on the material's form.

▲ In this illustration of a supple cloth covering a half-sphere resting on a table, note how the various surfaces easily "show through."

Tautness

This phenomenon can be clearly seen in the folds of taut or tightly fitted garments. In such cases, the "negative" phases of the fold patterns conform themselves more fully to the body, and we see only the "top" section of what would otherwise be a complete fold pattern. Wherever there is a depression in the body's form, however, the folds appear more fully in both their projecting and receding phases and therefore become more prominent.

▶ Note how the "negative phases" of the compression pattern in the midsection of the cloth disappear as they come into contact with the form of the cylinder, around the area of the red line.

FIGURE 1.47

Internal Resistance, or "Expansiveness"

So far, we have primarily looked at how external force acts upon cloth, compressing it into folds. But there is another important factor to keep in mind when depicting drapery: Cloth also possesses an internal resistance to any force acting on it. We can call this the *expansiveness* of the material—the property of cloth that, for example, keeps it from crumpling absolutely flat against the floor when pulled down by gravity. This property is always inherent, to some degree or other, in fabric, and it is usually uniform throughout the material's expanse. And it is always active. In his notebooks, Leonardo da Vinci wrote very little on the subject of drapery, but what he did write is typically profound and to the point.

> *Every thing by nature tends to remain at rest. Drapery, being of equal density and thickness on its wrong side and on its right, has a tendency to lie flat; therefore when you give it a fold or plait forcing it out of its flatness note well the result of the constraint in the part where it is most confined; and the part which is farthest from this constraint you will see relapses most into the natural state; that is to say lies free and flowing.*

In this passage, Leonardo is not referring merely to the principles we saw at play in our study of compression patterns—how, for example, the "slope" planes broaden and flatten as they move away from the "eyes," which are the most compressed parts of the fold formation. It seems that he is also referring to a phenomenon we see at play in figure 1.48, which revisits the

"shower curtain" setup of figure 1.8.

In figure 1.48, notice how the folds in the cloth broaden as they travel down the curtain. At the top, where the cloth has been deliberately squeezed together, the folds of cloth are closer together and deeper (of greater amplitude). Toward the bottom, where the compressive force acting high up on the curtain is not as firmly felt, the expansive forces within the cloth take back over, broadening and dissipating the folds of the cloth back toward its original state.

This gives the series of folds a conical formation—one outward, or "solid," cone followed by one inward, or "hollow," one. If the expansive force in the cloth were weaker, or if the compressive force acting on it were more uniform throughout its height, the folds would appear as a simple undulation, as in figure 1.8.

Let's look at this phenomenon again in another simple, familiar setup: the tablecloth spread over a table depicted in figure 1.49. Pay particular attention to what is happening at the corners: Here, we find the same solid-cone/hollow-cone pattern that we just noted. Using the previous case (of the shower curtain) as a guide, we can infer that the corner folds are more forcefully compressed at the top and that the internal expansiveness of the cloth pushes it out into broader, rounder folds as it descends away from the level of the tabletop.

The cloth at the corners is not pushed together by an arbitrary force but by the weight of the cloth itself, where it overhangs the sides. As the cloth at each corner is compressed between the expanses of cloth at the table's sides, it is forced into a series of vertical folds clustered about the corner points.

In the example pictured in figure 1.50, where the overhanging sides of the tablecloth are short, the material's expansive force pushes the conical forms at the corners out into even broader, bell-like shapes. (If the expansive force of the cloth were strong enough, the stiff material would overhang the edges of the table with no folds at all.)

Look for these conical formations wherever an expanse of cloth overhangs any two intersecting edges. You will almost always find folds descending from this point. But it its important to remember, as we see in the next section, that it is not the point that generates these folds but the compressive force of the overhanging cloth.

FIGURE 1.48

▲ Expansiveness. Notice how the folds of the curtain, compressed at the top, broaden into more circular profiles below.

▶ A tablecloth draped over a tabletop. Note the conical forms that hang from the corners.

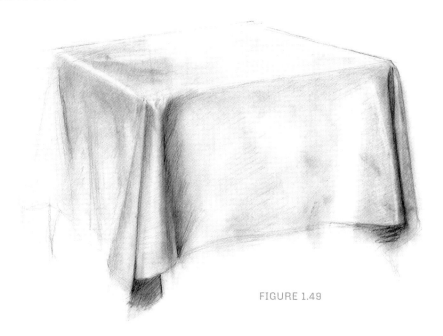

FIGURE 1.49

▶ Schematic of a tablecloth with a small degree of overhang and a moderate amount of expansiveness to the material. Note the broadness of the conical forms at the corners.

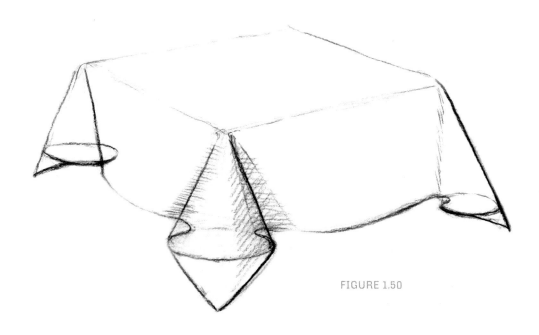

FIGURE 1.50

FIGURE 1.51 FIGURE 1.52

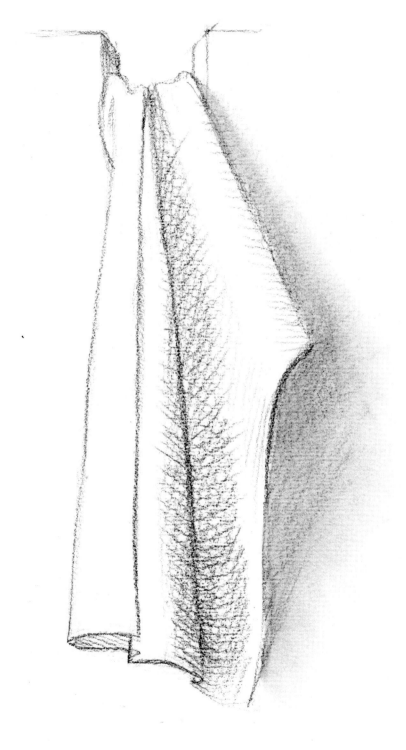

▲ Cloth descending from a hook, traditionally called a "point" of suspension.

▲ Cloth descending from a notch. Note how the fold lines, while close together at the top, still do not meet.

Suspension

Historically, much has been made of the phenomenon we just examined—the tendency of cloth to form folds at the limiting corner of a plane. The deepest part of the folds—the dark "fold lines"—tend to converge on (or, seen from the opposite direction, diverge from) these areas. These areas are traditionally called "points of suspension." Typical examples are illustrated in figure 1.51 (a hook) and figure 1.52 (a notch).

But this term, "point of suspension," is a double misnomer. First, as we have noted from the beginning of this chapter, it is not so much the *suspension* (that is, the "pulling" of the cloth) but rather the *compression* (the "pushing" of the sides of the cloth against each other) that gives rise to the folds. Second, these so-called points are not points at all. Isolated points do not really exist in three-dimensional space. In actuality, they are small *areas* of compression, areas in which an expanse of cloth has been squeezed together. So while you may choose to draw the various folds of cloth in figure 1.52 as all converging toward one another at the notch, a close observation of that area reveals that they always remain separate from one another. Keeping this in mind will have a subtle but distinct impact on the lines you choose to depict such a situation, whether the cloth is being compressed by a notch, a clasp, or a hand.

Catenary Curves

Picture a length of rope hanging freely between two anchors. Unless it is stretched taut, it will sag somewhat in the middle, forming a distinctive curve. This curve, called a *catenary curve* (from the Latin word *catena*, meaning "chain"), describes the shape adopted by a chain, rope, or other flexible cable that, anchored between two points, bends under its own weight. Such a curve takes the form of a U, with the curve turning more rapidly at the U's bottom and more gently at the sides.

Figure 1.53 shows several catenary curves. The arc of a catenary curve can be calculated by using a mathematical equation, but, of course, you don't have to work out a complex formula every time you wish to draw one. You should, however, learn to get a feeling for catenary curves—how they look, how quickly they turn, etc.—because they express the hang of fabric so well.

Catenary curves take form when there is an equal amount of weight on every point of the suspended item, as is the case with a freely hanging rope or chain. If a suspended cloth forms a catenary curve, we assume that there is an equal amount of fabric along the whole length of the arc; if there were more fabric on one side than on the other, the curve would naturally skew in that direction.

Let's look again at the drawing of a cloth suspended between two anchors, repeated here as figure 1.54. The catenary curves in figure 1.53 were generated mathematically. But, allowing for the perspective at play in figure 1.54, notice how closely the hang of the fabric follows the

▼ Catenary curves.

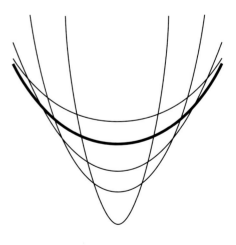

FIGURE 1.53

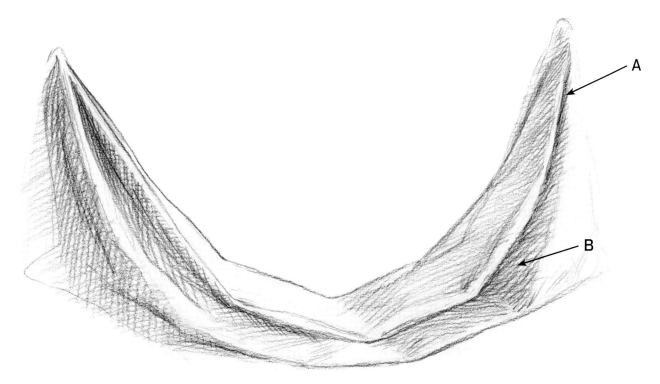

FIGURE 1.54

▲ A drape suspended between two anchors.

path of the more boldly outlined catenary curve in figure 1.53.

Cloth, of course, does not behave exactly like a chain or a rope. Only very supple fabrics will bend into smooth curves. Most fabrics, and especially stiff ones, divide themselves into facets that, in their sum, follow a curved path. And where these planes intersect with each other, you will, of course, find nodal points, however subtle. This is precisely what we see in figure 1.54: The long folds that run from one end of the cloth to the other were formed as the cloth was compressed and attached to the anchors. Because the length of cloth between the anchors is freely suspended—with no ground plane supporting it from beneath—it hangs along a path generally defined by a catenary curve, albeit broken along its length into a series of smaller, flatter, adjoining planes. Note the nodal points that form along its edges, where the longitudinal, side-to-side folds intersect with the front-to-back folds that limit these smaller planes.

Loops

Figure 1.55 shows a loop of rope that's been draped over a cylinder. The rope forms a catenary curve on either side. The lengths of freely hanging rope don't know or care that they are hanging from a cylinder. They could just as well be suspended from a rectangular block or any other form. Once the rope becomes freehanging, it will predictably assume this type of form. And so will a fold of cloth, assuming, once again, that there is a uniform amount of cloth extending beyond this fold. If you think of a skirt hanging upon the thigh of a seated figure, you will immediately recognize some practical applications of this formulation.

With this in mind, let's return to our consideration of a tablecloth. We can fairly accurately conceptualize the folds that appear within the side panels of fabric as a large loop of overhanging rope, as shown in figure 1.56. If we add the conical forms that appear at the tablecloth's corners to these looping folds at the sides, we arrive at the simplified but convincing rendering that appears in figure 1.57. Note that these U-shaped folds usually do not run all the way from one corner to the other (though they sometimes get very close).

▼ A loop of rope draped over a cylinder. Looping folds in cloth will behave in a similar way.

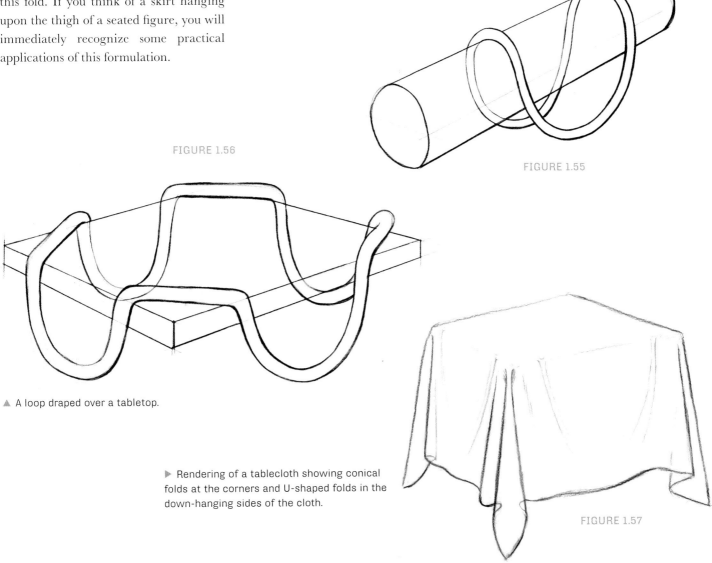

FIGURE 1.56

FIGURE 1.55

▲ A loop draped over a tabletop.

▶ Rendering of a tablecloth showing conical folds at the corners and U-shaped folds in the down-hanging sides of the cloth.

FIGURE 1.57

We have been looking at loops suspended from two level points—that is, from two anchors that are both the same distance from the ground plane. But what would happen if we were to tip the cylinder or tabletop on which the loop rests? We would then be dealing with catenary curves suspended from two *unequal* points, where one point of suspension is higher than the other.

It is very useful to know that a *section* of a catenary curve is still a catenary curve.

As is shown in figure 1.58, the rope hanging from points *A* and *C* takes the identical path as would a longer rope hanging from points *A* and *B*.

And so if we drape a loop over a cylinder that is tilted at an angle, as in figure 1.59, the loop that hangs down on either side follows the section of a catenary curve. This same curve would be observable in a piece of folded drapery laid across an identical cylinder, as in figure 1.60. And, of course, the same phenomenon would be

observable if the surface were an inclined block, as in figure 1.61. Bear in mind how easily cylinders or blocks like these could be used to describe parts of the body—a forearm, upper arm, shin, thigh, or torso.

Once again, the aim is to become familiar enough with the shape of these formations to recognize them when they appear or to create them in a realistic manner when drawing imaginary figures.

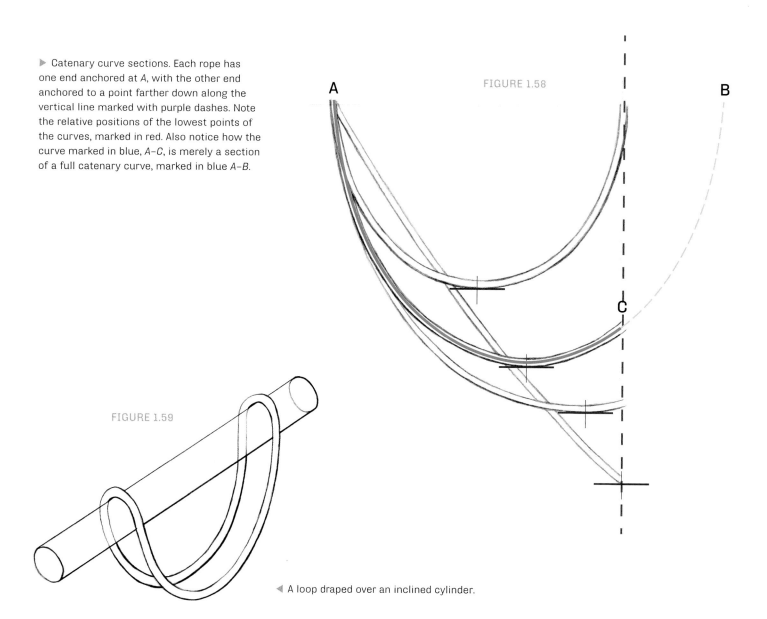

▶ Catenary curve sections. Each rope has one end anchored at *A*, with the other end anchored to a point farther down along the vertical line marked with purple dashes. Note the relative positions of the lowest points of the curves, marked in red. Also notice how the curve marked in blue, *A–C*, is merely a section of a full catenary curve, marked in blue *A–B*.

FIGURE 1.58

FIGURE 1.59

◀ A loop draped over an inclined cylinder.

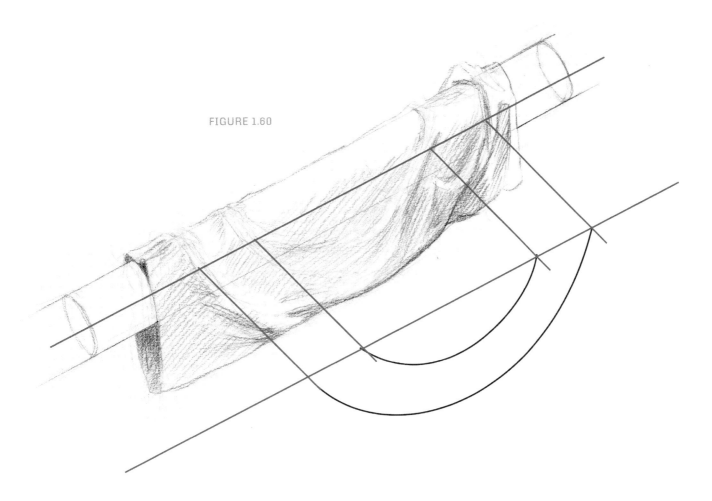

FIGURE 1.60

▲ Two folds describing catenary curves in the folds are visible in the rendering of a cloth draped over an inclined cylinder. Separated from the rendered drawing and marked in red, the curves stand out more clearly.

▼ A loop draped over an inclined block.

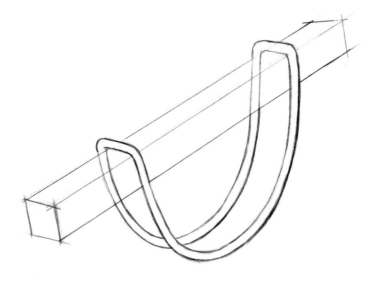

FIGURE 1.61

Lessons from the Masters

DEGAS

Although generally considered an Impressionist, Edgar Degas, throughout his oeuvre, retained a commitment to and a unique mastery of the drawing principles he had first learned at the French Academy. With his grounding in Classicism and his drive to experiment with new means of formal expression, Degas's work links traditionalism with Modernism.

The content of Degas's work reflects a similar progression. Originally drawn to the traditional subjects of history and portraits, Degas later painted the personages he saw about him in late-nineteenth-century Paris—laundresses, café performers, and so on. These people wore Industrial Age dress that is far closer to our own than are the togas and drapes of antiquity, and

Degas depicted them with what was at the time considered an avant-garde degree of naturalism.

In this illustration, notice how the looping fold *A*, which is suspended from and formed by the concavity of the shoulder blades, becomes further disrupted as the right shoulder blade draws back upon the body at *B*.

At *C* and *D*, Degas depicts the compression bands that typically form between the model's arms and her body. Notice how, although the stiff material of the model's outer cap sleeve produces a conelike form (*E*), suspended from the shoulder, the pull of gravity produces an additional fold loop within it (*F*), which hangs nearly vertically from the shoulder point.

The undulations that form the vertical

folds of the skirt originate as they leave the sidemost points of the hips and the buttocks (*G–J*). These then become subject to the compression of the ground plane, which results in traceable series of horizontal rings, as at *K*, where the nodes of the fold pattern lie.

Finally, note how at *L*, where the suspended folds hit the ground, the structure is identical to that we see in figure 1.65 (page 60).

▶ Edgar Degas (1834–1917), *Woman, back view, wearing a long dress*. Pencil on paper, 14 x 9 inches (35.4 x 22.9 cm), date unknown. Réunion des Musées Nationaux Art Resource, NY.
photo © RMN–Thierry Le Mage



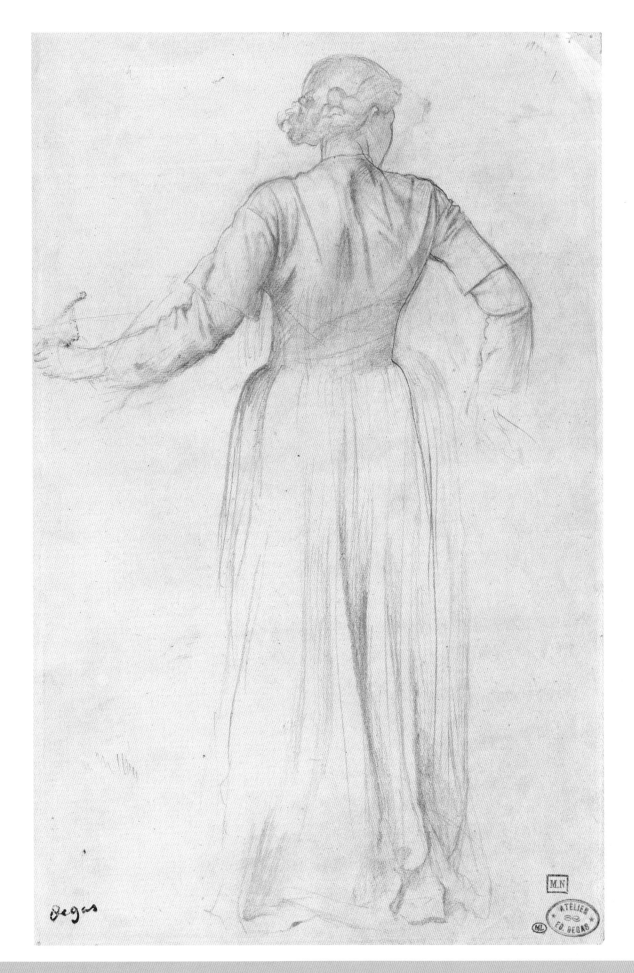

Degas

Compound Formations

The arrangements that we have looked at up to this point have been very simple. Cloth can, of course, be folded, twisted, and knotted into a limitless variety of configurations, and it would be impossible to try to identify and represent all of them within these pages. We can, however, study a representative set of common patterns that occur when two or more of the previously studied formations come into play. In later chapters, we'll see where and when these instances arise in the clothed figure.

Suspension and Compression

If a cloth suspended from a hook (as we saw in figure 1.51) were to collide with the ground plane, we might end up with a formation similar to that pictured in figure 1.62. At the top, the cloth folds into the positive and negative half-cones that we expect, with a large, "positively" projecting cone at the center line. The compression pattern that forms at the bottom works its way right up through the middle

of the cone, fading away as it gets farther from the base.

The result in figure 1.63 is different. Once again, a "positive" cone projects from the supporting anchor. But this time the compression on this cone results in the type of zigzagging pattern that we saw in our very first illustration—the drawing of the unspooling cloth. The cone becomes flattened out in the process. The triangular planes that form within it interlock with the greater compression pattern that pervades the rest of the cloth.

FIGURE 1.62

▲ Cloth hitting the ground, with the conical form folding into a zigzag pattern.

FIGURE 1.63

▲ Cloth hitting the ground, forming an even compression pattern throughout the conical form.

Figure 1.64 depicts two vertical cylinders encircled by tubes of cloth. Each cylinder has a hook that catches the cloth on one side. In both cases, the compression band is constricted even further where it is caught on the hook attached to the cylinder. On the opposite side from the hook, the fold pattern is more spread out, top to bottom. This gives a tapered appearance to the compression band from the side view. In the drawing at the right, the material is suppler. The rings of the compression band take on the character of a catenary curve when seen in profile.

▼ Two cylinders surrounded by tubes of cloth. The cloth at the left is stiffer than the cloth at the right, which is more supple.

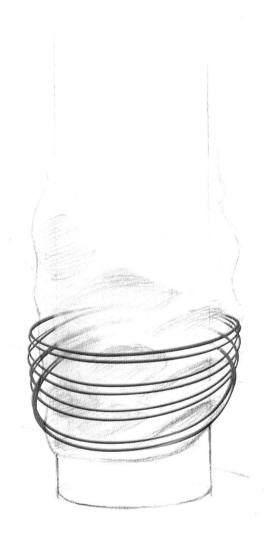

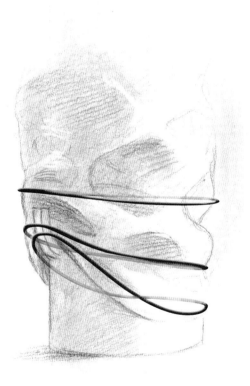

FIGURE 1.64

Classic Drape against an Upright Plane

Figure 1.65 shows a classic drapery configuration: an expanse of cloth supported by two anchors and hanging against a vertical wall. This setup has been traditionally used to model a typical behavior of drapery—and with good reason. If you think of the way a shirt hangs on its wearer's back or chest, you will recognize its utility.

Figure 1.65 is, of course, a variation of the setup that we looked at in figure 1.32, on page 34. But several additional factors are at play here. First, at either side, there is a compound formation like the one seen in figure 1.63. On the left, you see a central vertical fold bordered by two projecting half-cones; the fold line is the narrow opening into a receding half-cone. On the right, the opposite occurs: A projecting cone dominates the vertical forms immediately below the suspending anchor. And both of these suspended formations are compressed at bottom, where they are flattened into a series of zigzagging folds. (Do note that the arrangement did not *have* to

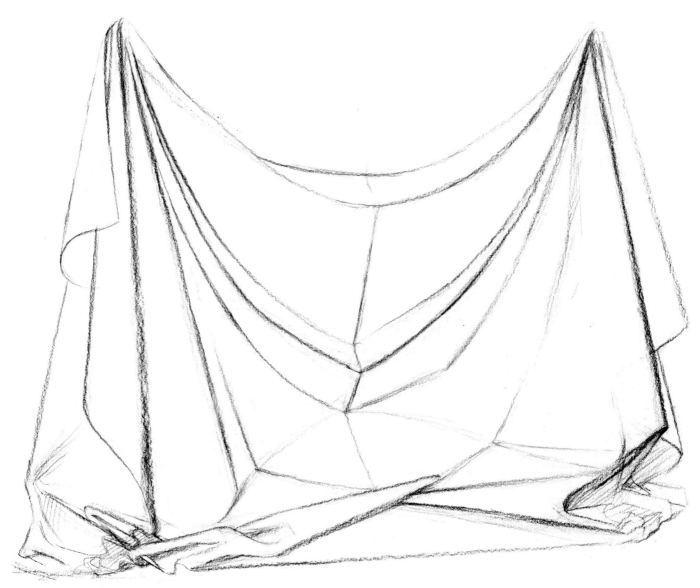

FIGURE 1.65

be this way. This is simply the way the cloth fell in this particular case. A projecting cone flanked by receding cones might just as easily have appeared on the left, right, or on both sides.

In the middle section, we see the dynamic that we first saw in figure 1.32. Here, however, the hanging cloth is not only compressed at the bottom but is also compressed against the upright wall in back of it. We can see a series of folds, echoing the form of catenary curves, descending between the two anchors. Each of these folds has a top plane and a bottom plane. The top plane of the uppermost fold of the setup is nearly horizontal.

The bottom plane is close to vertical, so that it almost faces frontward. With each successive fold, heading downward in the arrangement, the top plane becomes more vertical and the bottom plane becomes more horizontal. Eventually, they intersect with each other at an approximate right angle.

Where the center of the suspended formation hits the ground plane, two strong folds emerge at 45-degree angles to the plane at the back. Taken together, these two folds are the beginning of a compression pattern that forms as the cloth crashes against the ground plane. If we were to imagine, for a moment, that the cloth was

no longer being suspended between the two anchors, we would expect to see a pattern of "positive" and "negative" pyramids forming as a response to this vertical compression. These two folds then can be seen, collectively, as the top border of a large "negative" pyramid, with its apex pointed toward the wall. Above, the compression pattern integrates into the cascading folds between the two anchors.

◀ A cloth suspended between two anchors and compressed against a vertical plane and a ground plane.

Figure 1.66 also combines several of the phenomena we've previously examined. It depicts a compressed tube of cloth hung on a cylinder, with the resulting compression pattern indicated by simple spheres and cylinders.

If we were to look at this setup from the side, we would recognize the parallel fold formations that we saw in figure 1.16, on page 22. But here those formations are combined, above, with the break of planes around a curved surface that we saw in the right-hand diagram in figure 1.45 (page 45) and, below, with the adjoining planes descriptive of a catenary curve that we studied in figure 1.32 (page 34).

The cross section shown in figure 1.67 simplifies these influences schematically. As you can see, the component nodes and antinodes of the compression pattern align along the plane breaks suggested by the supported curve on top and the suspended curve below.

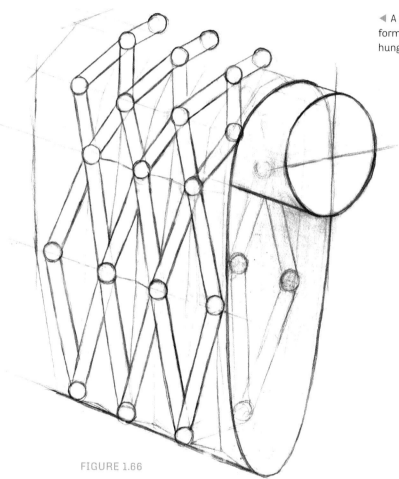

◀ A simplification of the fold pattern that forms in a tube of cloth surrounding and hung from a horizontal cylinder.

FIGURE 1.66

FIGURE 1.67

▲ A cross-section of figure 1.66.

Cloth Draped between Two Cylinders

In the setup in figure 1.69, we again see a combination of more basic patterns. (Obviously, this drawing greatly simplifies the appearance that a real setup of this kind might have, in order to clarify the forms.) There are several things to take note of in this configuration.

First, the cloth breaks into a familiar diamond-shaped compression pattern atop both the upper and lower cylinders.

Notice how, on top of each cylinder, there is a horizontal plane spanned by a line of elongated nodes.

Next, the section of the compression pattern that is closest to the top cylinder is greatly elongated. The triangular fold forms that make up that section travel down as far as the first break line in what begins to turn into an upward curve.

Finally, note the series of conical folds that forms at the bottom end of the cloth, each fold descending from a node in the compression pattern.

We could arrive at the arrangement depicted in figure 1.68 by splitting 1.67 horizontally, sliding the lower half of the drawing over to the right so that the left side of the lower half lines up with the right side of the upper half, and then repeating the pattern.

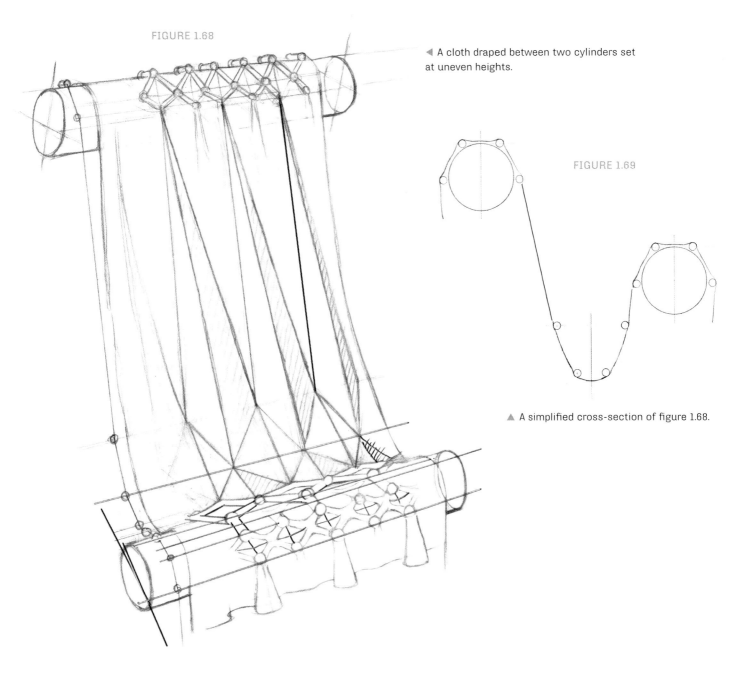

FIGURE 1.68

◀ A cloth draped between two cylinders set at uneven heights.

FIGURE 1.69

▲ A simplified cross-section of figure 1.68.

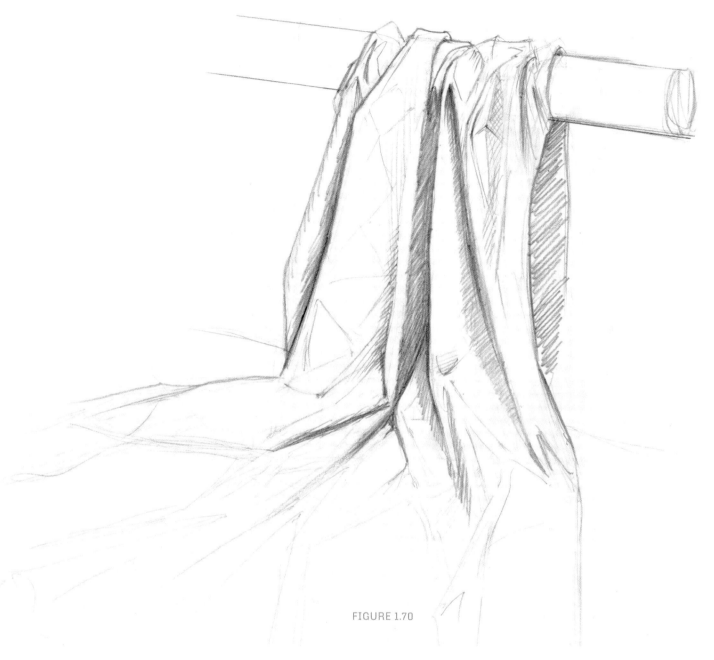

FIGURE 1.70

The setup depicted in figure 1.70 is similar to that in figure 1.69, except that here the cloth hits a horizontal ground plane instead of another cylinder. As in the previous composition, the cloth, although gathered into strong folds, breaks along a regular series of planes as it crosses over the cylinder, above. But the formation also shares some of the characteristics we saw in figures 1.62 and 1.63, on page 58: As the cloth hits the floor, a zigzag pattern works its way into each major conical section formed as the cloth falls off the cylinder's support. Finally, we notice that the compression pattern formed when the cloth strikes the ground plane fades out as the cloth conforms to the surface plane.

▲ A cloth draped between a cylinder and a lower horizontal plane.

Telescoping

A final common behavior of cloth is included for study in this chapter. This phenomenon, called *telescoping*, was not included in the previous section on variations to basic compression patterns, because it is not an irregular behavior but a regular behavior that appears in an *irregularly cut* piece of drapery. Many garments are constructed in such a way that there is a flaring of the diameter in the middle of a cloth tube, especially around the elbow or knee joint, where free mobility is the aim.

This is where telescoping typically occurs.

In each of the two conically shaped tubes of cloth shown in figure 1.71, the narrower portion tucks inside the wider portion. The configuration at the right is really the same as the one at left, just flipped upside down. Although it may seem obvious, remember that the smaller portion tucks inside the larger section, not vice versa. Remember, too, that each of these drawings depicts a continuous tube of cloth: If we viewed this arrangement in

section, from the side, we would see an S shape joining the two portions.

Because many garments have tubes that flare wide and then constrict back to a narrower diameter, it is also very common to see instances of "double" telescoping like that depicted in figure 1.72. Here, the smaller portions above and below the flare both tuck into that larger middle portion.

FIGURE 1.72

FIGURE 1.71

▲ Telescoping. Notice how the narrower portion of a conically shaped cloth folds inside a larger portion.

▲ "Double" telescoping. A flaring in the middle of a cloth tube will often cause telescoping at both ends of the form.

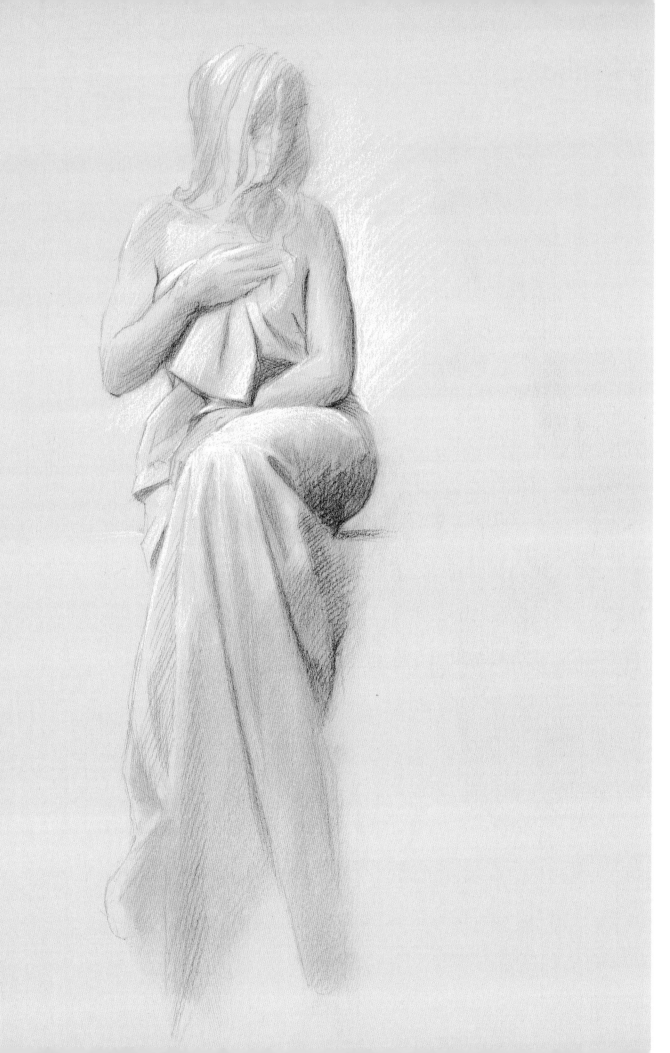

Chapter 2

DRAPING THE FIGURE

Chapter 1 explored the effects of gravity, compression, and suspension on drapery. In this chapter, we begin to look at how these principles influence drapery on the human form. First we'll explore tubular-shaped garments and then, in the later sections, form-fitted garments and loose draperies.

One's ability to draw the draped figure well depends preeminently on one's ability to draw the figure well. Indeed, it was the practice of many of history's greatest draftspersons to compose a nude figure before "clothing" it with the appropriate forms. Of course, you should approach your own drawing in ways that support your own artistic self-expression. Still, there are some guidelines that you may find useful to keep in mind when drawing the clothed figure:

- Think of the body as a group of solid forms—even as *hard* elements, as compared to the drapery that covers them.
- Look for the largest influences on the cloth you are depicting and express those first. Not only will the smaller details of folds subordinate themselves to these larger shapes, but focusing on them first will also give more solidity and accuracy to your drawing.
- Follow the drapery and its folds *around* the body, even to the far side, which you cannot see. Do not merely copy the aspect of a drapery arrangement that is facing you. Recognize—and represent—the paths of folds as they encircle the entire figure.
- Do not violate the integrity of the figure by "cutting into it" with the folds. Allow the cloth, even in its deepest recesses, to rest on the body's surface.
- Conceive of the drapery covering the body just as you conceive of the body itself—as masses in space delimited by planes though expressed in tone or line.

With these general guidelines in mind, let's turn our attention to tubular garments.

Tubular Garments

By far the most common forms of contemporary clothing are composed of tubes or cylinders of cloth. Larger tubes are constructed to encircle the torso, the hips, or the entire body. Smaller tubes encircle the limbs or even the fingers. Most garments are composed of a number of these tubes, joined to each other along a variety of seams.

From these basic forms, fashion designers create an untold number of variations. But in this chapter we will be examining *prototypical* garments, stripped of any regard to the material, folds, pleats, appliqués, or other ornamentation that defines a particular piece. Instead, the clothing presented here will be defined by just three factors:

1. The *number and kinds of cloth tubes* they are composed of.
2. The *main behavior* of the tube or tubes: Does the tube hang on the body at its top and free at the bottom, or is it compressed on the ground or another part of the body at its bottom?
3. The *gender* of the wearer. It should be noted that the characteristics of the body of the wearer, male or female, are more important than the cut of the garment in producing the gender variation. Even then, as should become clear as you compare the illustrations that follow, the difference is probably much less than you might at first think.

A few notes about the drawings in this section: First, the models depicted are well-built young adults of average proportion. They have not been distorted according to the extreme canons that are typically used in the creation of fashion drawings, comic books, and so on. The goal here is to present a method of draping the figure that may easily be adapted to any figure—human, monster, animal—in whatever worldly or unworldly proportion the artist wishes.

Second, the models are presented in both front and back poses, from a point of view looking slightly down at them and from an angle slightly to the side of the body's main axis. The aim in doing this is to more clearly illustrate the three-dimensionality of the forms, both of the models and the clothes. In creating your own drawings, you may want to do just the opposite, flattening out the forms by adopting a straight-on point of view. But even when doing this, always be aware that your goal is still the representation of a volumetric reality.

Finally, the series of three illustrations presented for each piece in this section is meant to represent three conceptualizations of the same phenomenon:

- The first drawing of each series shows the primary form of the tubes (marked in red lines) that make up the garment, their direction, their juncture with each other, and their large bends or compressions. Often, the first drawing will also show how the principal fold patterns arise from the compression of the tubes between body parts and from their suspension from the body's support.

- The second drawing shows the genesis of the fold patterns in the garment. Again, these arise from the compression of the cloth within the various projections of the body, from the opposition of the body's supporting surfaces to gravity's pull, and from the plane breaks of the body acting against the cloth.

- The last drawing of each series will be a tight rendering of the garment, as it visually appears.

The drawings are not meant as step-by-step instructions. Rather, they illustrate three aspects of the same garment that should be considered *simultaneously* when creating a representation of it: its size and position in space, its composite formations, and its surface appearance.

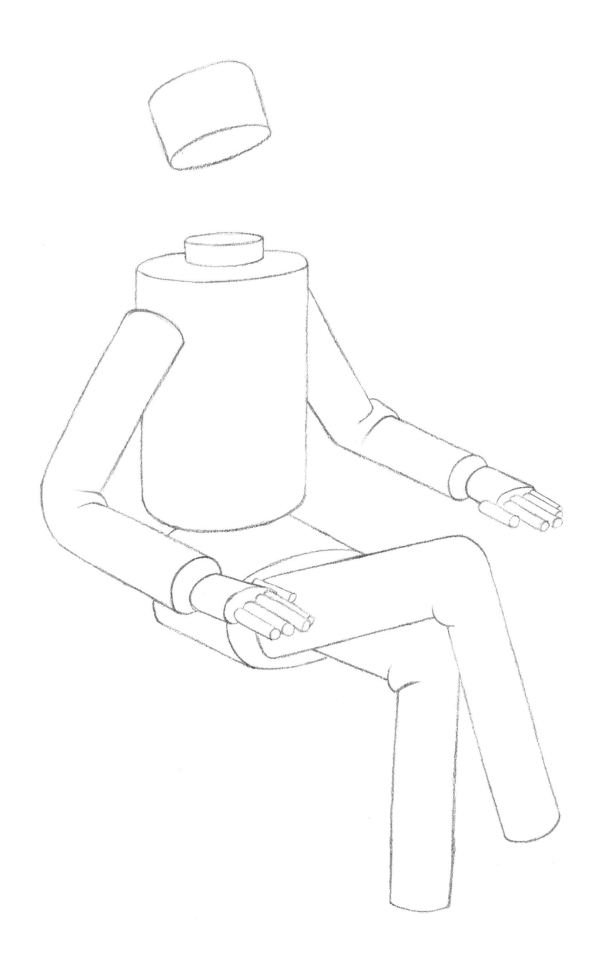

Woman's Dress (Cloak, Mantle, Tunic, Coat, Jacket)

At its most basic, the dress is a single tube that envelopes the trunk, suspended on the shoulders and hanging freely below.

The first major variable in the dress's design is the degree of tapering at the waist. The more the waist is contracted, the more the upper half tends to behave as a shirt, with its lower border sitting on the hips, buttocks, and, to a greater or lesser degree, the protuberance of the lower abdomen. The lower half, likewise, behaves more like a skirt, suspended from these same areas.

A dress that was not at all gathered at the waist—a cloak or a certain style of coat—would, admittedly, make for a purer example. But this example, which is tapered to only a moderate degree, is more typical of our standard idea of a dress. Both the sweater and skirt are analyzed separately (see pages 78–79 and 84–85) and may prove instructive by comparison.

The second major variation on the dress has to do with whether it has sleeves and, if so, of what length and style (these can vary greatly). For discussions of the treatment of long sleeves, see the entries Woman's Sweater and Man's Shirt, on pages 78–79 and 80–81, respectively. The dress shown here has cap sleeves, each of which behaves in a similar manner to the free-hanging skirt below. A conical shape usually forms at the point of the shoulder, which is the outermost limit of the plane of suspension. Expect to find some "negative" cones adjoining it.

A cuff of compressed material will be found between the sleeve and the body, with the greatest amount of compression facing downward, near the armpit, and then expanding above. As with the shirt, the amount of décolletage does not greatly affect the fold pattern, as it generally forms as it hangs from the supporting plane of the bust. The neckline can be simply conceived of as a hole or cutaway in the surface that covers the upper chest.

Last, as with the shirt, a collar may or may not be present. Most can easily be rendered as a simple cylinder encircling the neck.

FIGURE 2.1

FIGURE 2.2

FIGURE 2.3

FIGURE 2.4

FIGURE 2.5

FIGURE 2.6

◄ Woman's dress from the front and back showing tubular forms and fold pattern construction.

▲ Woman's dress from the front and back as a finished rendering.

Woman's Gown

The gown is identical to the dress, except that the central cloth tube that encircles the body is compressed against the ground (or at least the top plane of the feet). In this sense, it is entirely the same as a "floor-length dress."

The gown pictured here is sleeveless. Its upper border, constricted around the model's chest, hangs from this support. Like the dress on pages 70–71, this gown is tapered at the waist, so the weight of its lower portion is also borne on the upper surfaces of the model's hips.

As in any cloth tube resting on the ground plane, we can expect to see the formation of a compression band that is most accentuated nearest the ground. A group of suspended folds merges into this compression pattern in the front. These find anchor points in the forward-projecting points of the hips and thighs, while simultaneously being compressed between the thighs and the lower abdomen. Likewise in the back, the compression pattern blends with the suspended folds falling from the support of the model's buttocks.

The compression pattern reemerges as the upper portion of the gown sits on the model's hips, encircling her waist.

Since contemporary custom associates gowns with formal and relatively infrequent social occasions, deep trace folds from sitting or other activities are not pronounced. Nonetheless, they can be discerned at the sites where the body flexes: at the front of the waist, the front of the hips, and the back of the knees.

FIGURE 2.7

FIGURE 2.8

FIGURE 2.9

FIGURE 2.10

FIGURE 2.11

FIGURE 2.12

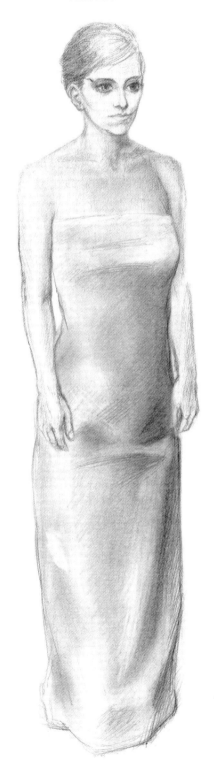

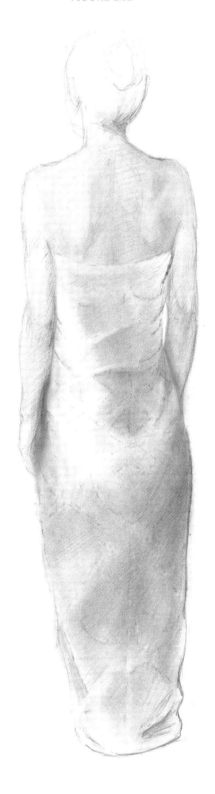

◀ Woman's gown from the front and back showing tubular forms and fold pattern construction.

▲ Woman's gown from the front and back as a finished rendering.

The Shoulders "Barrel Vault"

It may be helpful to consider all garments that cover the trunk as variations on a cloth draped over a barrel that has its long axis running sideways, through the shoulders. Its rounded surfaces would correspond to the chest in front and the shoulder blades in back. A hole in the cloth, of nonspecific shape, would allow the neck to pass through the top.

Close to either end of the barrel, let's add a depression that runs around the barrel, as if a ring of the barrel were tightened. In the front of the body, this constriction would correspond, on each side, to the vertical depression between the shoulder and the side plane of the chest, where it reaches toward the armpit. In back, it would correspond to the area between the inner border of the shoulder blade and the deltoid muscle, or shoulder cap, toward the outside.

Just as any cloth would form folds in these depressions, we usually find compression bands in these areas. They run front to back over the tops of the shoulders and join together again, below, under the armpits. There, they are further compressed between the arm and the side of the body. The general path that these forms take is indicated by the vertical red loops drawn around the shoulders in the illustration.

In front, these two bands are connected to each other by a curved fold or a series of descending curved folds that run across the chest. In back, their counterpart—a looping fold or a cascade of looping folds—hangs between the shoulder blades, connecting to the two compression bands running over the shoulders. The general path of these folds is also indicated in red.

The particularities of any specific garment—shoulder pads, deep necklines, loose cuts—may certainly modify the appearance of these fold forms. But the construction of the body and the pull of gravity make their presence, if only to a slight degree, a certainty.

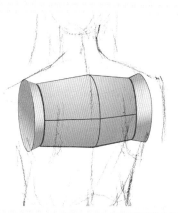
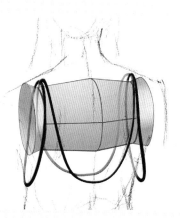

At its most basic, the jacket is composed of a large tube of material that envelops the trunk, with two additional tubes attached at the sides for the arms. It hangs from the shoulders and is suspended below. It is, in its basic construction, identical to a dress.

This jacket sports a large opening for the neck. Nonetheless, a looping fold can be distinguished draping across the upper plane of the model's chest. It is joined, at either side, by a vertical compression band that forms between the side plane of the upper chest and the shoulder. These compression bands are mitigated by the shoulder padding in the jacket, but they should still not be ignored.

In back, these same compression bands are bridged by a suspended series of folds that hang between the shoulder blades. These folds merge with the compression band that surrounds the waist.

If the cut of the waist is particularly narrow, a horizontal compression band will almost certainly form about it, which will usually integrate with the vertical compression bands encircling the shoulder joints.

Jackets usually have long sleeves, which may flare around the elbow to allow for greater mobility of that joint. The horizontal compression band that forms here proceeds from a dominant fold at the bend of the elbow, at the front side of the arm.

The collar or lapels, if present—and if not of a significantly different material

▼ Man's jacket from the front and back showing tubular forms and the construction of the fold patterns.

FIGURE 2.13 FIGURE 2.14 FIGURE 2.15 FIGURE 2.16

than the main body of the jacket—will follow the same fold pattern as the material beneath.

If the jacket is open—unbuttoned or unzipped in front—the compression around the waist will be far less pronounced, and the jacket's front panels, now loose, will usually take on a conical appearance, suspended from a point on the chest. Similarly, vents—vertical slits in the tailoring of the jacket at the rear or lower sides—will diminish the prominence of the horizontal compression folds around the lower portion of the jacket.

▼ Man's jacket from the front and back as a finished rendering.

FIGURE 2.17

FIGURE 2.18

Woman's Sweater

Whether long-sleeved, short-sleeved, or sleeveless, the sweater is defined by the central cylinder that, surrounding the trunk, is suspended above and compressed on the bottom. This compression may be due to the artificial constriction of a belt or of another garment worn over the hips, or it may simply arise from the sweater's lower border resting on the figure's hips.

Were the sweater to continue to hang freely below the waistline, the dynamics of its folds would be identical to those of a dress. But because it is compressed on the hips, a horizontal compression band is bound to form. Because of the habitual flexion of the trunk, this band usually presents a dominant fold at the level of the lower border of the rib cage. Also look for vertical nodal/antinodal break lines forming where the front plane of the abdomen joins the more sideways-facing planes of the flanks.

If the sweater is particularly tight or clingy, or if the figure has large breasts, a horizontal fold will form underneath the breast, where the garment is compressed between the breast and the rib cage. This will integrate into the vertical compression band that encircles the arm where it joins the trunk. A similar horizontal fold may also form above the breast, where the sweater is compressed between it and the upper chest. Either of these folds may be part of a compression band, which, meeting its counterpart on the opposite side of the body, forms a complete ring around the figure.

▼ Woman's sweater from the front and back showing tubular forms and the construction of the fold patterns.

FIGURE 2.18 FIGURE 2.20 FIGURE 2.21 FIGURE 2.22

If the garment is cut loosely or made of a relaxed material, a hanging fold may appear suspended from the foremost points of the breasts.

In this example, the model wears a long-sleeved sweater. The vertical compression rings about the armholes may extend to the outer sides of the arms, resting on their outermost projections: the muscular swellings of the upper arms. As in the man's jacket (page 76), the long sleeve develops a compression band about the elbow joint, proceeding from the dominant fold at the front of the joint.

▼ Woman's sweater from the front and back as a finished rendering.

FIGURE 2.23

FIGURE 2.24

The structure—and subsequently the fold patterns—of a man's shirt do not differ greatly from those of a woman's shirt. The chief differences—in the wearer, not the garment—result from the absence of breasts and relative narrowness of men's hips, which gives the man's shirt less of a platform on which to rest at its lower border. Thus, when the lower end of the central tube is cinched about the waist by a belt or waistband, the horizontal compression band that forms often overflows the remainder of the garment. In other words, the shirttails will telescope within the compression band of the waist. This compression band integrates with the folds

discussed in the analysis of the shoulders (pages 74–75), which are also present here.

If the model is large in the waist, then the compression band will form atop the belly area instead, and vertical folds will tend to be prominent around the waist, where the shirt is tucked into the pants.

In a long-sleeved shirt, compression bands form about the elbow joint, as in the woman's sweater. In this example, as we saw in the woman's sweater (pages 78–79), the vertical compression band around the armhole, which is especially compressed at the armpit, fans out to the upper, lateral aspect of the upper arm. The shirt's armhole in this example is, however, large,

and the shirt's tailoring is loose, so the lower limit of the compression band is at the same level as the horizontal compression band about the waist, with which it naturally integrates, much like the drapery in figure 1.65 on page 60.

The forearm part of the sleeve telescopes within the compression band at the elbow. Below, the sleeve attaches to the narrower cuff of the wrist, resulting in a compression pattern in this part of the sleeve. This compression is somewhat alleviated by a vent in the sleeve.

FIGURE 2.25

FIGURE 2.26

FIGURE 2.27

FIGURE 2.28

FIGURE 2.29
FIGURE 2.30

◀ Man's shirt from the front and back showing tubular forms and the construction of the fold patterns.

▲ Man's shirt from the front and back as a finished rendering.

The Hips "Table"

In most cases the hips present, at least to some degree, a platform of support for the lower body's garments. The nature of this platform is a bit more complex and variable than that of the barrel vault of the shoulders, but we can still formulate a generalized model that you may find useful in your drawing.

Let's picture a hexagonal plane that is longer side-to-side than front-to-back and that tilts somewhat downward toward the back. The points of this plane are defined by the most outward projections of the hips.

The backmost edge of the hexagon runs from the outermost points of one buttock to the other. No matter what the gender or build of the model, these points are relatively dependable landmarks from which we will see the suspension of drapery.

The front edge of this "table" is limited by the forwardmost projecting points of the thighs, near their tops.

The placement of the side points of the hexagon are the most variable, as they depend on the character of the model's body. On extremely lean subjects, this lateral-most point of the hip will be the greater trochanter of the femur, which is the hard, bony projection that can be felt at the side of the hip. On others, it will be the fatty or muscular tissue (once again, depending on the subject) found slightly below and either to the front or to the back of the greater trochanter.

This plane is indicated in the illustration by an orange hexagon. Note how a skirt—or any cloth overhanging this plane—would gather into the conical formations indicated drawn in red at each corner point.

Take note of the series of curved, suspended folds, also indicated in red, that fall from these anchor points, as well, like bunting hanging around the roof of a building. How pronounced these folds are depends on several factors, including the particular shape of the model's hips, the looseness and cut of the garment, and the garment's degree of wear.

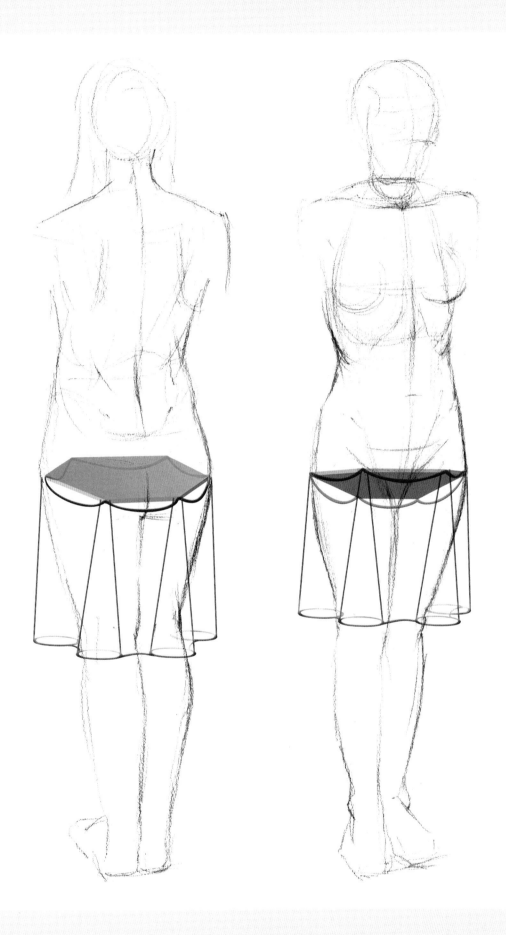

Woman's Skirt

The skirt is a single tube of material that is suspended from the waist and hangs freely below—unless, of course, it is floor-length, in which case its behavior will more closely resemble that of the lower portion of a gown (see pages 72–73).

Like any garment that covers the lower body, the skirt typically takes on four looping folds that, in their aggregate, circumscribe the hips. The front loop is suspended on either end from the fold of the thigh. Side folds, which may only be subtly visible, suspend from the hip point in the front, to the widest point of the thigh, to the buttock in back. In a tight skirt (as in tight trousers), a fold or series of parallel folds becomes very apparent when stretched over the oblique depression that separates the buttock from the side of hip. In back, the circuit is completed by a looping fold that, depending on the cut of the garment and the shape of the model, either hangs from the rearmost projection of the buttocks or is compressed on top of them, between the mass of the buttocks and the lower back.

Because the skirt is free-hanging at the bottom, four vertical conical formations almost invariably dominate its shape. Each hangs from one of the most outwardly projecting areas of the hips: at front, where the quadriceps muscle emerges; at the sides, from the widest points of the upper thighs; and in back, from the projection of the buttocks. Between each of these projecting conical forms, the skirt will recede, generally in broader, flatter planes.

Trace folds will usually be found at the front of the skirt, mimicking the fold of the thigh on each side and retaining the compression pattern that arises when the thigh flexes against the pelvis.

FIGURE 2.31

FIGURE 2.32

FIGURE 2.33

FIGURE 2.34

FIGURE 2.35

FIGURE 2.36

◀ Woman's skirt from the front and back showing tubular forms and the construction of the fold patterns.

▲ Woman's skirt from the front and back as a finished rendering.

Man's Shorts

Shorts are composed of a central tube encircling the hips to which are attached two tubes for the legs. These tubes are too short to be compressed against the feet or the ground.

In many ways, the fold structure of shorts is similar to that of the skirt, especially in the upper areas. Being free-hanging at the bottom, the fabric tends to form conical vertical projections where it hangs from the same suspension areas as the skirt: the fronts of the thighs, the wide points of the hips, and the buttocks in the rear. Looping folds tend to hang from these same points in the central, "hip" tube of the garment. As in the skirt, trace folds are usually found at the front of the shorts, vestiges of the compression folds formed when the thighs are flexed toward the pelvis, as when the figure is seated.

A pronounced compression band, running obliquely from the groin to the tops of the widest points of the hip, is accentuated at the site of the fold of the thigh.

Depending on the cut of the shorts, the narrower leg tubes may telescope within the hip tube at these folds.

▼ Man's shorts from the front and back showing tubular forms and the construction of the fold patterns.

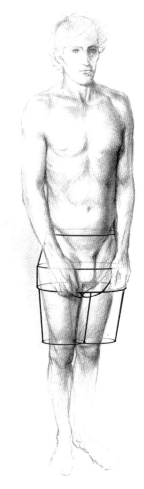

FIGURE 2.37

FIGURE 2.38

FIGURE 2.39

FIGURE 2.40

▼ Man's shorts from the front and back as a finished rendering.

FIGURE 2.41

FIGURE 2.42

The leg tubes of trousers, unlike those of shorts, extend all the way to the feet or ground (or both), and so they are compressed at the bottom. The arrangement of the tubes is otherwise the same—one for the pelvis and one for each leg.

How the leg tubes join to the central tube depends on the cut of the individual garment, and the relative diameters of these component parts play a role in determining how folds will form. If the leg tubes are wider than the hip tube, the hip tube will tend to telescope into the leg tubes at the level of the groin. If the hip

tube is wider, then the leg tubes will tend to telescope into it. In this example, the latter condition is more dominant, and so there is a bit of telescoping, both above and below, into the compression bands that form around the tops of the thighs, but mostly below.

Within a unified compression pattern that surrounds the hips, loop folds hang from the same points as described in the Hips "Table" on pages 82–83: the widest points of the thighs, hips, and buttocks.

A consideration must be made for the genital area, which, other than the toes, is

usually the most forward-projecting part of a man's lower body. Accordingly, a break line of nodal points will form down the center of this prominence. Good artistic judgment will have to arbitrate how much or little to stress the folds about this form.

To either side, the dominant fold of the compression band that forms between the

▼ Man's trousers from the front and back showing tubular forms and the construction of the fold patterns.

FIGURE 2.43

FIGURE 2.44

FIGURE 2.45

FIGURE 2.46

thigh and the hip echoes the anatomical fold of the thigh, rising obliquely toward an area just under the front point of the hip. This ring of trace folds continues around the sides of the thighs and back beneath the fold of the buttock. As we will see in chapter 3, the folds within this ring become more or less accentuated in accordance with the direction and amount of compression of the thigh against the hip.

Compression bands form about the knees, where the material rests on the swelling of the calf muscles, and at the bottom end of the pant legs.

The looping folds that form around the thighs and the calves vary according to the tailoring of the garment and the positions of the legs, but they almost always form complete rings that orbit the legs.

▼ Man's trousers from the front and back as a finished rendering.

FIGURE 2.47 FIGURE 2.48

Woman's Trousers

Women's trousers are very similar in structure and in their characteristic folds to men's. The woman's wider, somewhat shallower pelvis may lend the folds different proportions or emphases, but the pattern of compression and trace folds about the hips remains essentially the same, although with the obvious absence of the projection of the male sexual organs. Accordingly, the folds suspended from the hip points and the trace folds across the lower abdomen that derive from flexion of the thigh may stretch unbroken from hip to hip.

As in the man's trousers, the amount and type of telescoping where the leg tubes meet the hip tube, along the line of the thigh in the front and the fold of the buttock in the back, vary according to the cut of the garment. A tight-fitting trouser may produce a horizontal fold above the buttock in the back, stemming from the extension (backward flexion) of the leg, and the compression ring of the hips may stand out in greater relief over the depression that separates the buttock from the side of the hip.

The dominant horizontal fold of the compression band about the knee faces rearward. It echoes the flexion fold of the skin of this area.

The character of the compression ring that encircles the ankle depends on the

▼ Woman's trousers from the front and back showing tubular forms and the construction of the fold patterns.

FIGURE 2.49

FIGURE 2.50

FIGURE 2.51

FIGURE 2.52

length of the trouser leg. If the trouser leg ends below the top of the foot, the dominant fold will echo—and arise from—the horizontal juncture of the foot and the lower leg, facing forward and somewhat to the outside. If the pants are long enough, a similar, lesser fold will form at the back of the ring, above the heel at the site of the Achilles tendon.

An elongated compression pattern usually bonds the compression band around the knee with that around the ankle. Once again, this can vary according to the tailoring of the trouser leg.

▼ Woman's trousers from the front and back as a finished rendering.

FIGURE 2.53

FIGURE 2.54

Man's Overalls (Coveralls)

Overalls present a final variation on clothing that consists of tubes. In overalls, a large tube covering the entire trunk is joined to two tubes below—one for each leg. The entire garment hangs from the shoulders and is compressed at the bottom, where the pant legs hit the ground or the tops of the feet. (Coveralls are basically the same, although they have sleeves in addition to these forms.)

The long length and simple nature of this garment give rise to long, diagonally looping folds from the hip to the bottom of the pant leg. These may vary, depending on the cut of the individual piece.

Although overalls are usually designed without a tapering at the waist, you should be aware of the gentle horizontal compression band that nonetheless forms as the garment sits atop the hips.

A certain amount of trace folds will be visible at the level of the groin, complying to the fold of the thighs.

Compression bands will also form around the ankles, where a sizable portion of the weight of the cloth may push against the tops of the feet.

FIGURE 2.55

FIGURE 2.56

FIGURE 2.57

FIGURE 2.58

FIGURE 2.59 FIGURE 2.60

◀ Man's overalls from the front and back showing tubular forms and the construction of the fold patterns.

▲ Man's overalls from the front and back as a finished rendering.

Lessons from the Masters

GIBSON

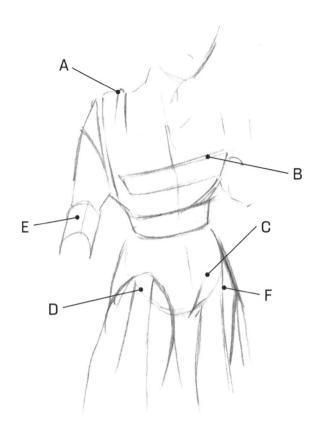

In the early twentieth century, Charles Dana Gibson's popular illustrations of beautiful young women often appeared in American magazines such as *Life* and *Collier's Weekly*. The self-assured young ladies he portrayed—and the style in which he depicted them—were so instantly recognizable that they became known as "Gibson Girls."

Gibson's pen-and-ink work elegantly and assuredly described his subjects in a medium that could be reproduced on the printing press. In this sample, the traces of Gibson's pencil sketch are still visible beneath the ink drawing, allowing us to compare his first conception with his finished line. As with other illustrators, the details Gibson chooses to omit are as significant as those he chooses to include. True, his economical line work

was probably partly intended to counter ink's tendency to spread on newsprint, but it also enabled him to achieve a dazzling and sophisticated look.

In the pencil, a compression band of material can clearly be seen encircling the model's shoulder, constricted between her neck and chest on the one side and between her arm and deltoid (shoulder-cap muscle) on the other. Indications of this formation have been reduced to a few vertical strokes capped by an inverted U atop the model's shoulder at *A*.

Her blouse, severely constricted at the waist, burgeons out into a pattern of deep compression folds above it. Note how the vertical lines that define the flat, boxy cut of the dress still break with the change in plane of the bosom, along line *B*.

Gibson also chooses to accentuate the flat plane changes of what would otherwise

be a cylindrical form of the sleeve at *E*, where it folds over the group of muscles in the forearm known as the supinator group.

In a similar way, the lines that describe the skirt follow from the shape of the thighs and hips underneath. At *C* and *D*, two conical forms hang from the forward-most projecting points of the upper thighs, telling us their position and, along with the sharply inclined lines at *F*, informing us that the model's left hip is higher, supporting her weight.

▶ Charles Dana Gibson (1867–1944), *Sweetest Story Ever Told*. Pen and ink over graphite underdrawing on paper, 11 x 14⅛ inches (27.9 x 35.9 cm), c. 1910. US Library of Congress, Prints & Photographs Division, LC-DIG-ppmsca-01590

Form-Fitted Garments

Many of the clothes we wear are specially constructed to conform to the body parts they dress. Because these are too variable in design to catalog, and because their specific tailoring to the forms of the body diminishes the occurrence of folds within them, in this section we will look at only a few examples of garments that cover the head, feet, and breasts.

Hats

Let's start at the top of the body, with the hat. In whichever of its multitudinous variations, the hat features an inverted bowl shape that surrounds the cranium. In addition to decorative embellishments, a variety of visors or brims—originally devised for protection from the elements—may be added to it.

A head covering made from a hard material is better known as a helmet, of which, again, there are numerous variations. Helmets tend to be constructed to cover as much of the head as possible and, since they are made of a rigid material, have no folds whatsoever.

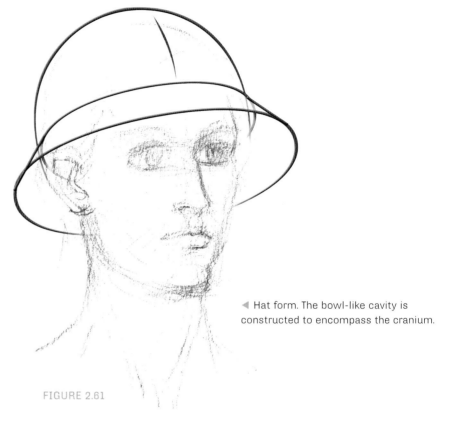

◀ Hat form. The bowl-like cavity is constructed to encompass the cranium.

FIGURE 2.61

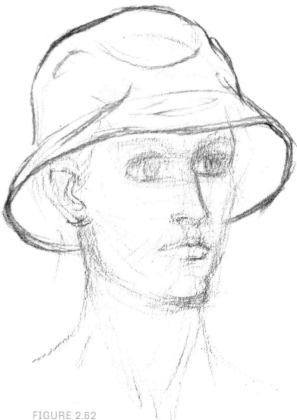

▶ Although the hat is specially constructed, some slight folds may appear in the crown or brim, especially in more pliant materials.

FIGURE 2.62

Gloves

The hand is one of the most structurally complex areas of the body, permitting us a staggering variety of movements, from the subtle to the powerful. The basic anatomical parts of the hand consist of the five fingers, each divided into three segments; the thumb, divided into two; and the flat body of the hand, which takes up approximately one half of the hand's full size.

Gloves are tailored to cover and protect all these parts. Essentially, they are composed of a group of tubes conforming to the fingers and thumb that join a larger, more flattened tube for the body.

While the fingers are able to move independently of one another, their component segments are linked to each other, at the knuckles, by a simple hinge joint. In flexion, the fingers will bend, folding upon themselves toward the palm. Just as we find flexion folds in the skin of the fingers, on their palmar surfaces, at the undersides of the knuckle joints, we will notice comparable folds forming in the finger tube of the glove running transversely to the direction of the compression.

Similar folds form, both in the glove and the hand, at the large knuckle joints where the fingers articulate with the body of the hand.

In extension, the fingers unfold to a position in which their segments form a straight line with one another when

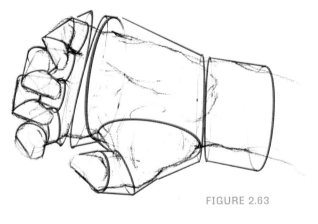

◀ Note the fold lines that will appear in the gloves at the site of any flexion of the hand's joints: at the finger knuckles, along the line where the fingers meet the palm, at the thumb's knuckles, along the line where the thumb meets the palm, and at the wrist.

FIGURE 2.63

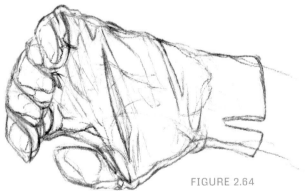

◀ The fold patterns that form when the fingers and thumb are flexed.

FIGURE 2.64

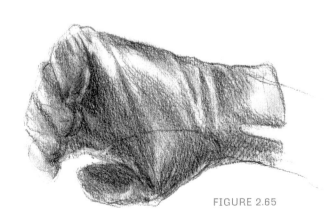

◀ A glove, fully rendered, covering a hand with flexed fingers and thumb.

FIGURE 2.65

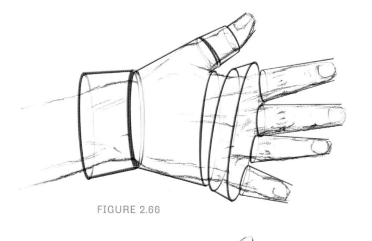

FIGURE 2.66

◀ The fingers themselves do not bend backward. In extension they only reach a relatively straight position. Therefore, no fold lines form on the dorsal surface of the fingers. Where the fingers meet the body of the hand, however, extension is greater, so folds will form along the line of the large knuckles. The wrist, being very mobile, gives rise to a strong compression pattern if the glove is long enough to cover it.

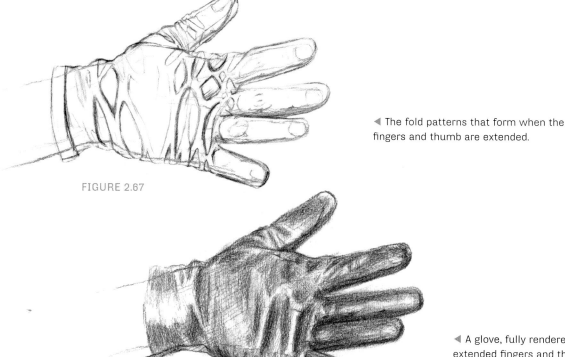

FIGURE 2.67

◀ The fold patterns that form when the fingers and thumb are extended.

FIGURE 2.68

◀ A glove, fully rendered, covering a hand with extended fingers and thumb.

seen from the side, or even form a slight backward arch. Because this backward angle is greatest where the fingers meet the body of the hand, a single large transverse fold can appear, running across the hand, along the line of the large knuckles. Since this backward arch is only slightly pronounced, if at all, at the other joints of the fingers, folds generally do not form in gloves along the dorsal (or fingernail side) of the fingers.

When the thumb flexes or extends, analogous folds form at the underside of its two knuckle joints. However, the whole of the thumb is very mobile, since the metacarpal bone that leads to it enjoys a very liberal articulation with the bones of the wrist. Therefore, folds will form both in the skin and in a glove between the palmar surface and the fleshy prominence of muscles that lead from the palm's midline to the large knuckle of the thumb.

Finally, if a glove is long enough to cover the wrist, a compression pattern of folds will appear close to the glove's opening. Because the hand can rotate in a fully circular motion at its juncture with the wrist, this compression pattern tends to be evenly pronounced at the front, back, and sides. Of course, in whichever direction the wrist flexes, those folds compressed between the hand and forearm will become accentuated.

Shoes and Boots

At the bottom of the body, we have the feet and ankles, which are covered by shoes or boots. Like hats, shoes—while shaped to adhere to the living form—are designed in a nearly limitless number of decorative variations.

Also like hats, they can be made of a hard material for extra protection of the foot or to minimize the foot's movement, as in some sports and medical uses. Usually, though, shoes are made of a thick but somewhat flexible material, which affords support and protection.

Of such materials, leather is the most common. Because of its thickness and rigidity, the leather of shoes and boots is not given to a capricious array of folds. Rather, shoes tend to develop a typical and consistent compression pattern at the few sites where the foot and ankle are mobile.

In the foot proper, the only significant joint motion is where the metatarsals—the bones of the instep—meet the toes. In figures 2.69 and 2.70 we can see how the

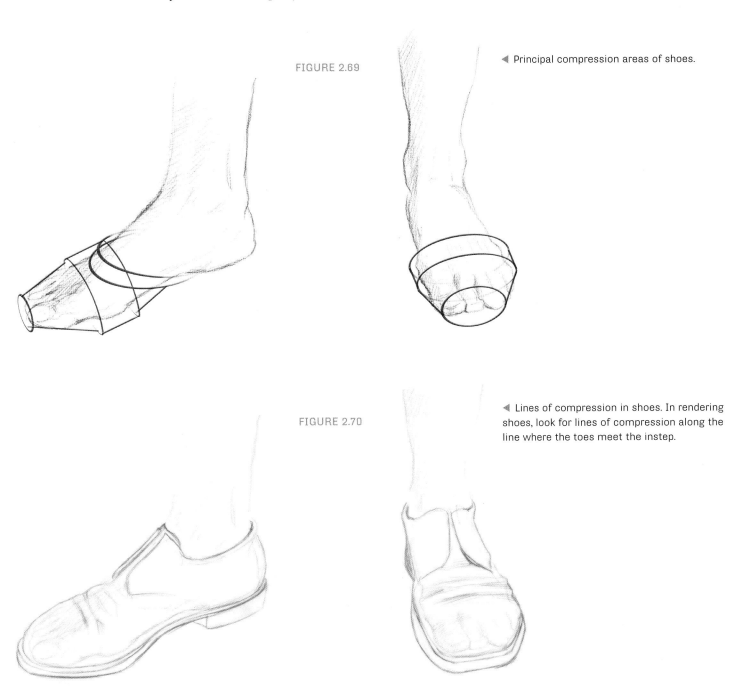

FIGURE 2.69

◀ Principal compression areas of shoes.

FIGURE 2.70

◀ Lines of compression in shoes. In rendering shoes, look for lines of compression along the line where the toes meet the instep.

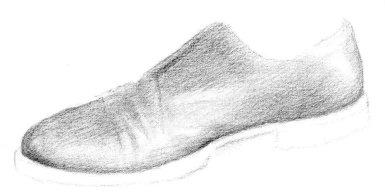

FIGURE 2.71

flexion of the foot in this area produces a telltale series of compression folds running horizontally across the toe knuckles, right along the line where they meet the body of the foot.

The pattern of a series of compression folds traversing the foot where the toes flex against the instep reappears in figures 2.72–2.76, which depict a pair of boots. But boots, unlike ordinary shoes,

rise above the ankle joint. Therefore, in addition to the fold we just examined, we also expect to see a band of compression folds arising about this juncture. The dominant fold of the compression pattern at the ankle aligns with the horizontal juncture of the foot with the shin. This fold, echoing the direction of the foot's flexion, is to the front of the ankle and slightly to the outside.

A secondary fold in the pattern, complementing the dominant fold, can be found at the back of the ankle, where the Achilles tendon meets the heel. Both folds integrate comfortably within a compression pattern that encircles the entire joint.

FIGURE 2.72

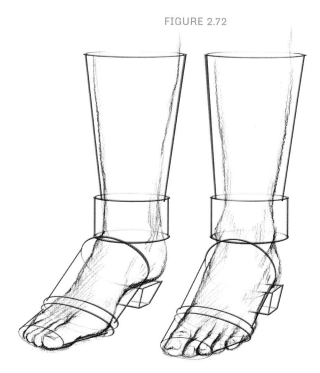

▲ Principal compression areas of boots: between the toes and the instep and around the ankle.

FIGURE 2.73

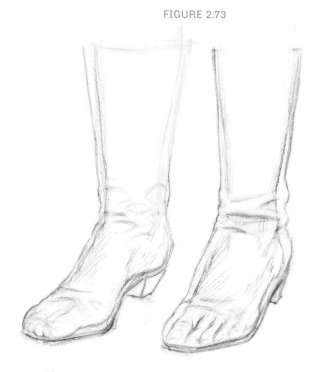

▲ The compression band about the ankle. The dominant fold at the front is paired with a lesser one just above the heel, to allow for the flexion of the foot in the opposite direction.

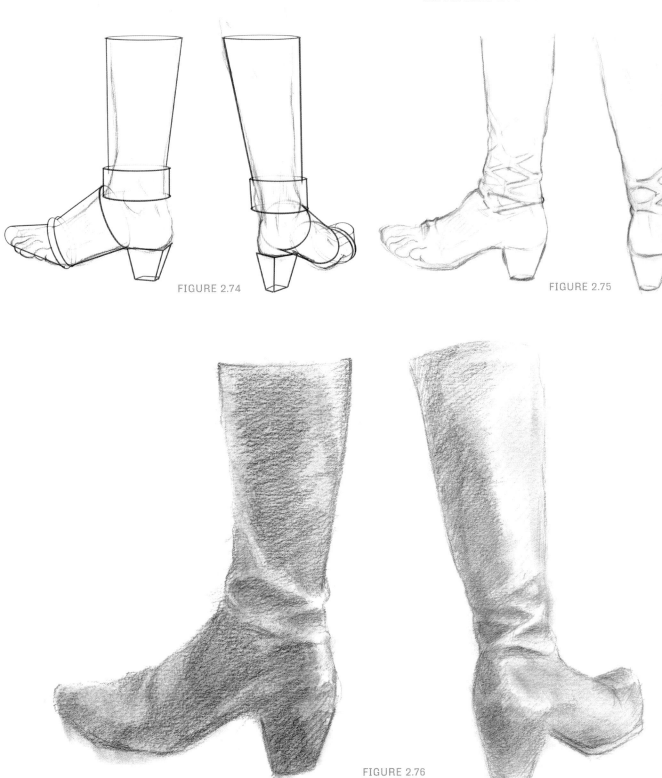

▼ Principal compression areas of boots, seen from the back.

FIGURE 2.74

▼ A dominant fold at the front of the ankle is complemented by a lesser one just above the heel, within a compression band that surrounds the ankle.

FIGURE 2.75

FIGURE 2.76

▲ The boots seen from the back and side, fully rendered.

Brassiere

Some mention should be made of under-garments. Although most undergarments can be likened to garments previously described, such as sweaters (pages 78–79), skirts (pages 84–85), and shorts (pages 86–87), the brassiere is specifically designed to conform to the shape of the breasts and to prevent the emergence of folds.

To some degree, the brassiere also shapes the breasts to its design. Like many undergarments, brassieres are often designed to be as invisible as possible under the clothes that cover it. Care is therefore taken to avoid areas of the body where folds would inevitably develop. By conforming to the natural prominences and recesses of the body, the brassiere avoids producing bulges in the overlying layer.

▼ The brassiere.

FIGURE 2.77

Loose Drapes

Loose drapery, which is neither sewn into a tube nor specially constructed to fit the body snugly, forms our third category of clothing. Loosely draped clothing behaves no differently from the cloths we studied in chapter 1, except that it rests on human forms.

Head Scarf

Let us again begin at the top of the body, with the head. A head scarf, or kerchief, is depicted in figure 2.78. Note how, as the material takes leave of the supporting dome of the head, it develops a compression pattern of folds with a strong vertical emphasis. This is caused by the weight of the hanging cloth pushing in on itself from the sides. This behavior of the cloth is similar to that we saw in the drawing of the loose cloth resting on a sphere in figure 1.44 (page 44). That is because the cranium is essentially shaped like an elongated sphere, or egg. This drawing could just as easily be depicting a hood, which would be joined to a collar around the neck. Its folds would form identically. For that matter, notice how similar the masses of cloth defined by these folds are to those of a long head of hair!

FIGURE 2.78

▲ Head scarf. Compression folds form around the perimeter of the cranium.

Neck Scarf

By this point, it should be apparent the folds in garments made from loose drapes are defined by the part or parts of the body they rest on or encounter as they hang. In the neck scarf shown in figure 2.79, note how the compression folds behave as expected, according to the position of the drape. Where the scarf encircles the model's neck, gravity compresses the scarf into horizontal folds or, at least, further compresses the array of folds that the model put into the cloth while tying it.

Where the scarf descends from the knotted area at the model's throat, note how the compression folds are primarily vertical in nature. This is a result both of the forced compression from the knotting of the material and of the horizontal pressure that the cloth is exerting upon itself under gravity's pull.

▶ Neck scarf. Notice the horizontal compression folds in the portion that surrounds the neck and the conical folds that hang suspended from the knotted area.

FIGURE 2.79

FIGURE 2.80

In figure 2.80, we see a model who has wrapped a shawl around herself, pushing the shawl up her forearms—hence forming the compression folds that appear there. But also notice the compression folds that form between the model's upper arms and her chest, and note how those folds originate from the plane break between the top and sides of the model's chest. As with the neck scarf, a strong horizontal fold forms around the back of the model's neck, where gravity compresses the shawl on her shoulders.

▲ A shawl wrapped about the shoulders.

Cape

A cape is like a shawl, but longer. As we see in figure 2.81, the material hangs suspended off the outer edges of the figure's shoulders and mostly forms simple vertical folds that run the cape's length. The fabric hangs on the shoulders, either by being tied to the front of the neck or by some sort of mechanical contrivance. The material is compressed between the inner borders of the shoulder blades and the upper arm muscles. Between these gatherings, a cascade of suspended folds drops down the figure's back. Note the similarity of the structure of these folds with the side of the tablecloth we looked at in figure 1.57 on page 53.

Poncho

Because it has an aperture for the head to pass through, a poncho is not a perfectly loose drape. Nonetheless, it is a single piece of material and thus hangs on the human form as a loose drapery would—breaking into conical formations that hang from the body's most laterally projecting areas and long, vertical folds where it is compressed between the body's intersecting planes.

▶ A cape, draped on a figure's shoulders.

FIGURE 2.81

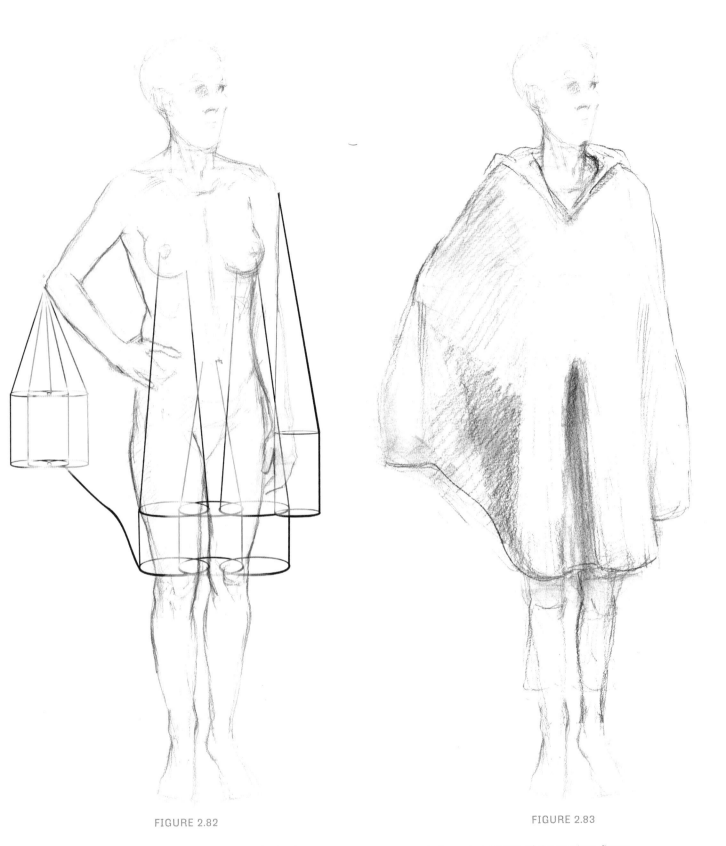

FIGURE 2.82

▲ A poncho. Supported by the girdle of the upper body, the poncho folds into conical formations at the points where it projects farthest from the body. (The cylindrical formations below them are caused by a fringed border.)

FIGURE 2.83

▲ A rough rendering of the previous figure.

Classical Draped Clothing

Not since Roman times have Western people commonly dressed themselves in togas, chitons, or any other garments constructed from loose drapes. But, since artists throughout the ages have used these garments to evoke the Classical era, it's worth considering one such garment here. Also, loose drapes such as the toga depicted in figure 2.84 can work to an artist's advantage because their folds, unbound by the constraints found in either tubular or form-fitted garments, can be significantly manipulated toward a specific artistic end, such as augmenting a figure's action or adding compositional lines. A countervailing disadvantage is that it is much more difficult to predict the behavior and therefore to represent the character of such wildly unrestrained clothing.

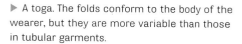

▶ A toga. The folds conform to the body of the wearer, but they are more variable than those in tubular garments.

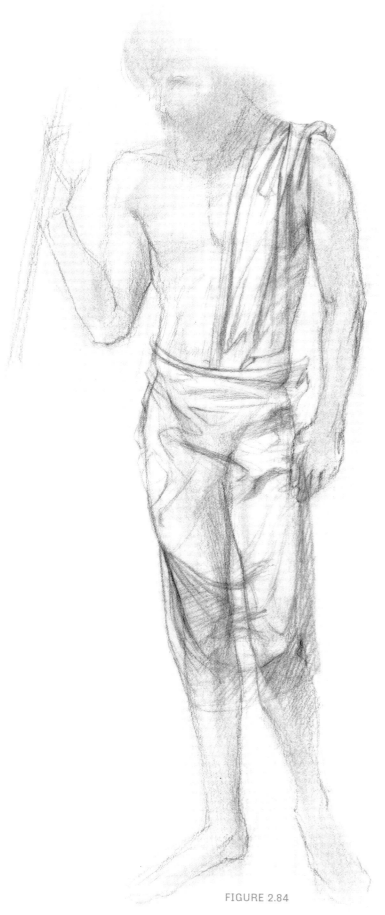

FIGURE 2.84

A Tubular Garment as a Loose Drape

In closing this chapter, let us examine the interesting example, depicted in figure 2.85, of a raincoat draped over an arm. That the raincoat happens to be a tubular garment is irrelevant here. Draped over a model's forearm, it behaves as any other loose drape would, forming a series of vertical folds over the horizontal cylinder of her forearm, just as we observed in the more abstract setup we first encountered in figure 1.16 (page 22).

in figure 1.16 (page 22).

FIGURE 2.85

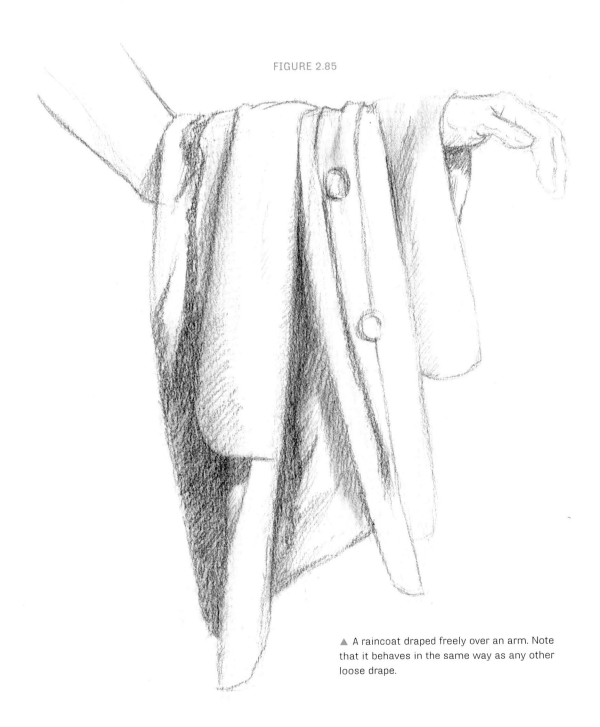

▲ A raincoat draped freely over an arm. Note that it behaves in the same way as any other loose drape.

LEYENDECKER

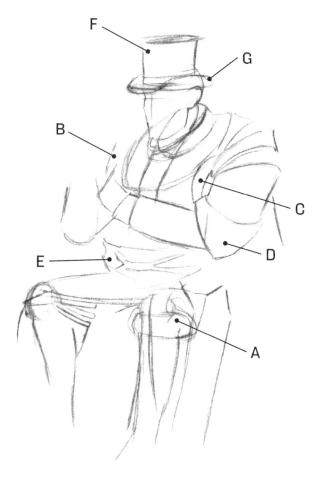

Born in Germany and raised in Chicago, Joseph Christian Leyendecker trained in the French Academy system before returning to the United States, where he would eventually become one of the most successful illustrators of his day. His work appeared in a variety of media, from commercial advertisements to covers for the *Saturday Evening Post*.

While his work inspired generations of American illustrators, including Norman Rockwell, his style remains unique, and he is especially notable for his treatment of drapery. Leyendecker typically described the recessed areas of folds with a series of broad, parallel strokes, such as are clearly seen at the left knee (*A*) of the gentlemen on the right. He also delineates the ridges of the folds, which, however small the radius, are always cylindrical in form, with sharp edges.

Aside from these stylistic tropes, the fold patterns that run through the figure's clothing appear as expected. Compression bands encircle the shoulder joints at *B* and *C*. Another tapered compression band, at *D*, arises from inside the fold of the arm at the elbow.

Note the band of compressed folds in the figure's vest (*E*), which arises, despite the substantial width of his waist, from compression of the garment by his thighs and hips.

The gentleman's top hat (*F*) is obviously conceptualized as a cylinder surrounding the orb of his cranium. The brim (*G*) is a disk whose sides have been bent upward at right angles.

▶ J. C. Leyendecker (1874–1951), *Railway Compartment*, oil paint on canvas (29½ x 21½ inches). Museum of American Illustration at the Society of Illustrators

THE EFFECTS OF JOINT MOVEMENT

In previous chapters, we have looked at how compressive force acting on cloth results in various fold patterns. In this chapter, we will explore how a range of body movements gives rise to habitual fold formations in clothing.

Up until now, we have looked at clothing as it appears when resting on the body in a neutral, standing position with the limbs fully extended. In the pages that follow we will chiefly look at how the *flexion* of the limbs—loosely defined as how the drawing of body parts closer to one another affects clothing. Such actions, of course, will compress any covering between the flexing parts and thus give rise to folds. Conversely, the extension of the joints—the component parts moving away from one another—generally results in the diminution of any folds formed by flexion.

Generally, clothing is designed to cover the body with all its parts fully extended. And, for the most part, we dress ourselves each morning with our limbs straight. It is only subsequent movements of the day that bring our appendages into flexion and folds into our clothes. So fold patterns, being results of this movement, tell a story of our past actions. Wherever we see folds, we know the body is likely to have moved in a direction perpendicular to their path. Likewise, whenever the body moves, we should expect to see the generation of perpendicular folds.

Of course, gravity is also always playing a role. Some of the drawings in this chapter reveal a change in the appearance of clothing that is more the result of a particular body part's changed position in relation to gravity than of the direct mechanical influence of the bones and muscles.

There is a further phenomenon of which the artist should be aware: Folds in clothing tend to persist. After being folded in a particular manner, clothing tends to maintain "trace folds"—creases that remain for a time after the condition that created them has disappeared. Sometimes, such folds even remain in the cloth permanently.

Flexed Trunk

Standing (Front View)

If the main body of a shirt is conceived of as a large tube, then it is easy to predict that flexion of the trunk—when the chest and the front of the pelvis are drawn toward each other—will produce pronounced horizontal compression of the clothing across that juncture. These accentuated folds result from the further constriction of the compression band that had previously formed around the waist of the wearer, just above where the shirt rests on his or her hips.

Look for this horizontally stressed compression pattern to blend with the vertical looping folds that border the chest, which are compressed between the sides of the chest and the shoulders. In this pose, with the model standing and bent forward, gravity will pull this gathering of material, suspended from the tops of the shoulders, further downward.

▶ Flexion of the rib cage against the pelvis. This movement results in a horizontal stress upon whatever cloth tube surrounds the trunk.

FIGURE 3.1

▶ Resulting fold pattern. The compression band around the waist is further constricted across the waistline, accentuating the folds in front.

FIGURE 3.2

Standing (Rear View)

When the trunk is flexed, the most prominent fold patterns in the front are horizontal. In the back, they are either vertical, running parallel to the spine, or they are an even mix of horizontal and vertical folds.

The lower back, pushing against the compression ring around the waist, tends to de-emphasize the compression pattern in that area. What tends to be emphasized, instead, is the series of nodal points that stack vertically along the inner border of the shoulder blades and continue, below, along the line where the rearward-facing plane of the lower back meets the more sideward-facing plane of the loins. Look also for a line of nodal/antinodal points along the full length of the projection of the spine.

▶ Flexion of the trunk, seen from the back. The frontward flexion of the torso equates to a stretching in the back.

FIGURE 3.3

▶ Resulting fold pattern. The "trace" compression pattern in this figure's shirt, formed while she was standing upright, is now diminished as it lies flat on the back.

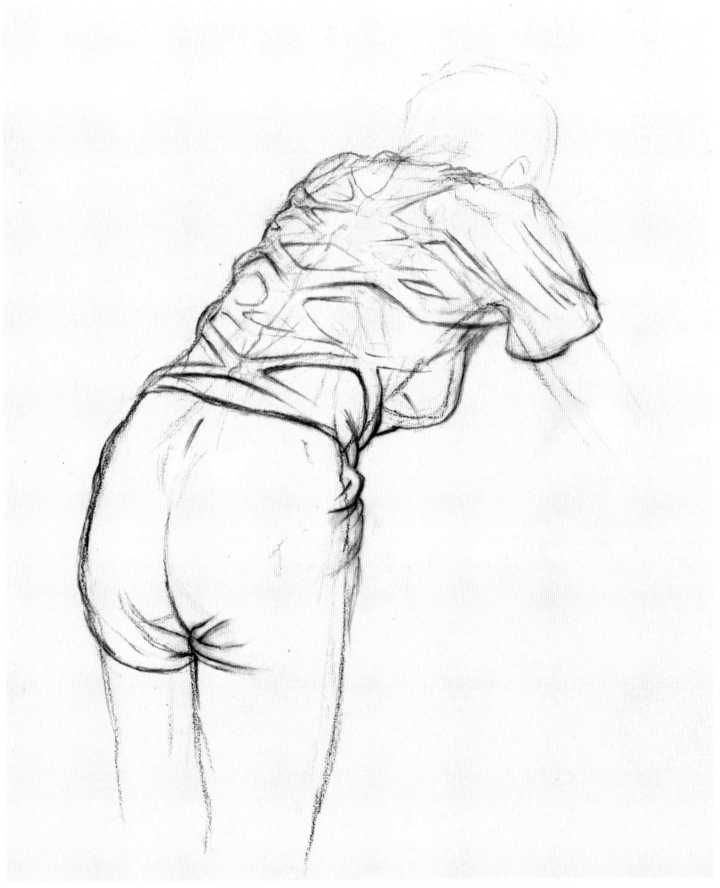

FIGURE 3.4

Seated (Front View)

When the trunk is flexed in a seated position, the mass of the rib cage is drawn even closer to that of the pelvis. If the seated figure is wearing a dress, jacket, or gown, the compression band that is already sitting on the hips will become further compressed in front, resulting in an interference pattern of heavy horizontal folds that grow lighter as they make their way to the back.

If the figure is wearing a shirt with a skirt or trousers, there will be even greater frontal compression of the horizontal compression band sitting on the hips, since the shirt, usually tucked into the lower garment's waistband, has nowhere to expand. Many times, however, the fold pattern of the shirt will blend into the upper compression band of the pants or skirt.

▶ Resulting fold pattern. The model's blouse is now acutely compressed along the horizontal line of her waist. The ensuing folds merge with those that hang suspended from alongside the neck.

▶ Flexion of the trunk in a seated position. The rib cage is flexed upon the pelvis, and the thighs, flexing against the pelvis, add further stress to the front of the clothes.

FIGURE 3.5

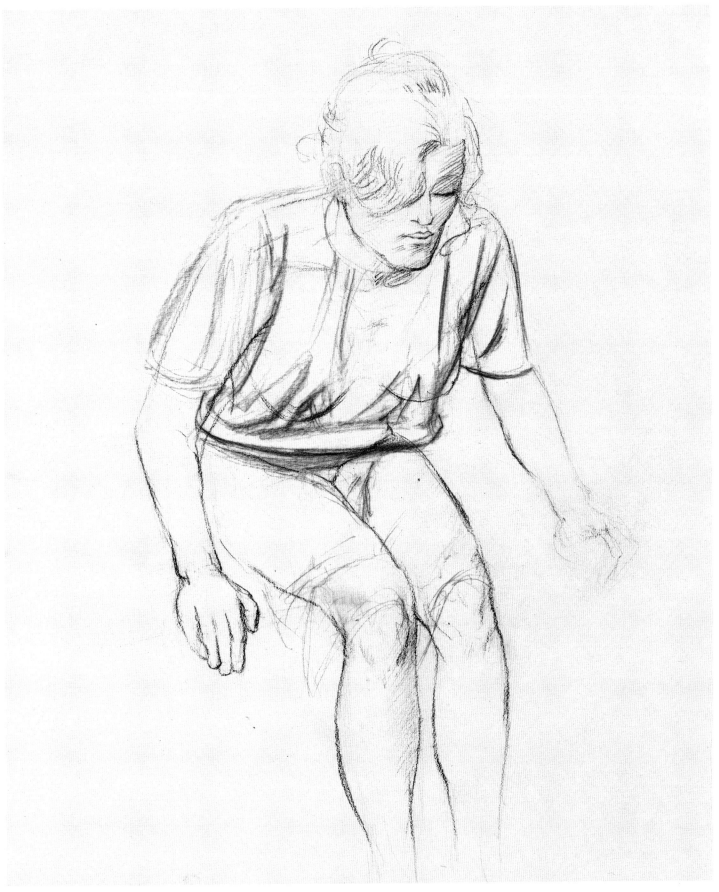

FIGURE 3.6

Seated (Three-Quarter Rear View)

As we have seen, when the flexing figure is seated, the compression band formed around the figure's waist is even further compressed at the front of the figure, between the masses of the rib cage and pelvis. At the back of the figure, however, the rings of nodal/antinodal points maintain their distance. Therefore, any concurrent folds give the effect of converging upon the front of the figure. Note how the nodes of the fold pattern align on the lines marking plane changes between the rearward-facing plane of the back and the side rearward-facing planes.

▶ Resulting fold pattern. Although it is more greatly constricted in front, the compression band that encircles the waist is still visible in the back, sitting atop the hips.

▶ Flexion of the trunk in a seated position, seen from the back. As the rib cage, pelvis, and thighs all flex toward one another, compressing the clothes in front, the vertical plane breaks at the back and sides of the back continue to affect the folds of the shirt.

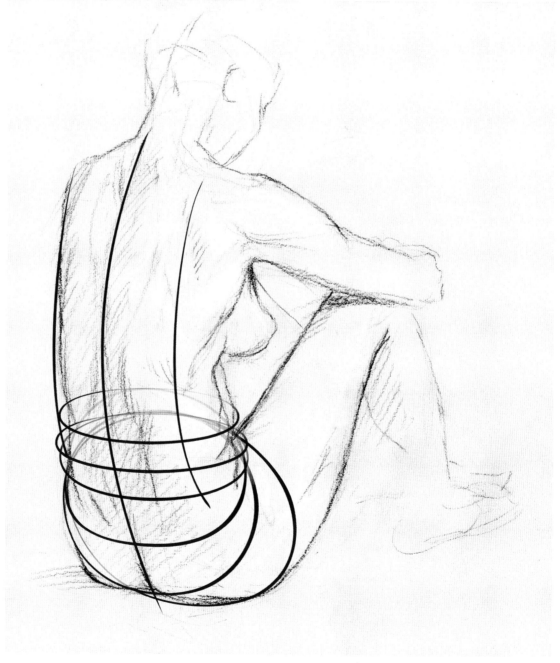

FIGURE 3.7

FIGURE 3.8

BLOCK

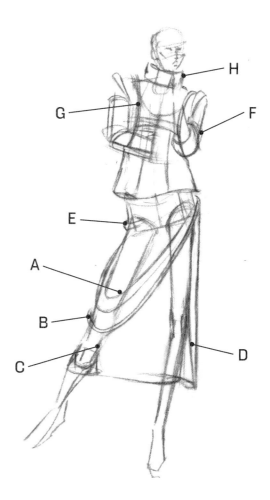

Kenneth Paul Block's work held a prominent presence in the fashion world for decades, regularly appearing in *Women's Wear Daily* and *W*, where he was a staff illustrator, as well as in promotions and advertising for leading designers and retailers.

Block's prodigious and exquisite work, extending from the 1950s into the 1990s, varied greatly in style, from comparatively prosaic renderings to flat, colorful washes accented with vivid, almost wild lines. But the drawings always performed their core function of transmitting the composition and style of the clothing.

In this piece, Block delivers a convincing idea of the model's suit despite the incredible anatomical proportions of her body. Whereas the classic canon for figure drawing calls for a figure to be seven and a half times her head height, in fashion drawings the figure is usually drawn nine head lengths high, or even more, with a disproportionate amount of that height allotted to her legs. Block's success in making the drawing believable is partly due to his adherence to the natural appearance of cloth as it behaves under stress.

Notice not only the large looping fold (*A*) that hangs suspended between the model's left (high) hip and her right thigh but also the subsequent folds that descend down the leg at *B* and *C*. From her high hip, where the remainder of the skirt suspends freely, we find a customary conical form (*D*), even though the skirt is slit through the length of that area. And although he uses a quick, vigorous line, Block still makes certain to add the contour of a horizontal area of cloth being squeezed between her right hip and thigh at *E*. Similar straight-on contours can be seen describing the cloth compressed by her left elbow at *F*.

Also notice how the shadow area on the model's jacket follows the looping fold (*G*) that, however subtly, hangs across the chest from the inner margin of both shoulders. The jacket collar is, obviously enough, conceptualized as a simple cylinder (*H*) encircling the neck.

▶ Kenneth Paul Block (1925–2009), *Female model in pin-striped jacket and long skirt.* Black marker on gray paper, 25 x 19 inches (64 x 48 cm), 1992. Museum of Fine Arts, Boston, Gift of Kenneth Paul Block, made possible with the generous assistance of Jean S. and Frederic A. Sharf (2009.1381)

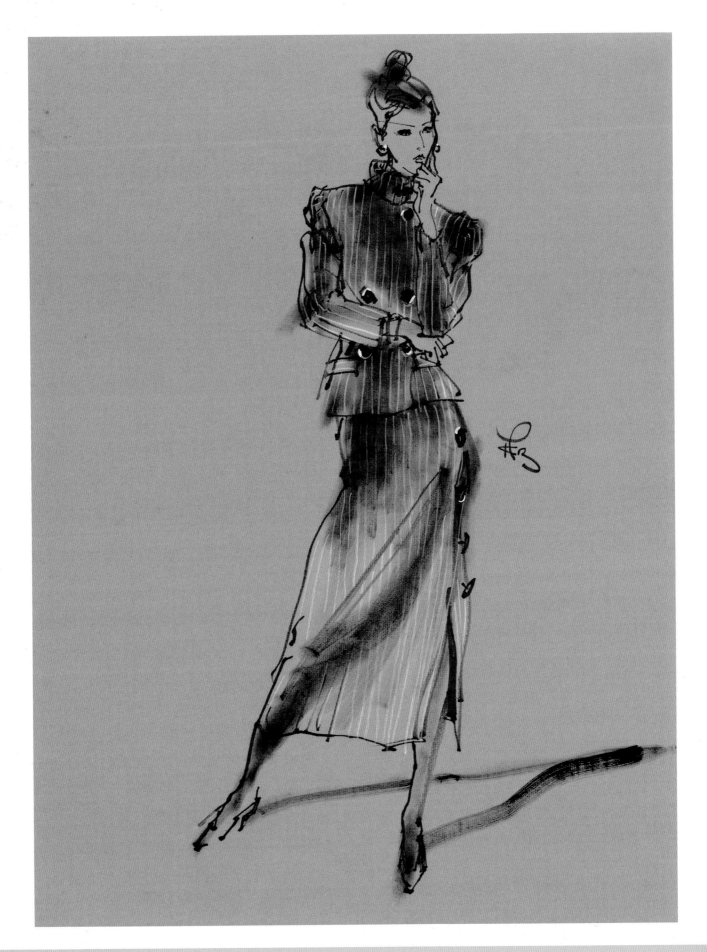

Extended Trunk

Front View

The extension of the trunk, more commonly known as a backbend, is the opposite of the flexion of the trunk. Now the front of the rib cage is drawn farther away from the front of the pelvis.

The effect this action has on clothes is the opposite of that produced by flexion. In flexion, horizontal stresses dominated the folds in the front view, while vertical stresses became more apparent in back. Here, however, the vertical folds at the figure's front, caused by the compression of the arms, are accentuated. These would be present even if the arms hung at the figure's sides against the rib cage. The curved suspended fold that normally hangs from the plane of the chest is further compressed into a longer, more vertical U shape. The compression band that sits atop the waist is more expanded in front and may tend to form folds atop the abdomen or at the flanks.

▶ Extension of the trunk. An extension of the torso in front is accompanied by a compression, or flexion, of the rib cage upon the pelvis in back.

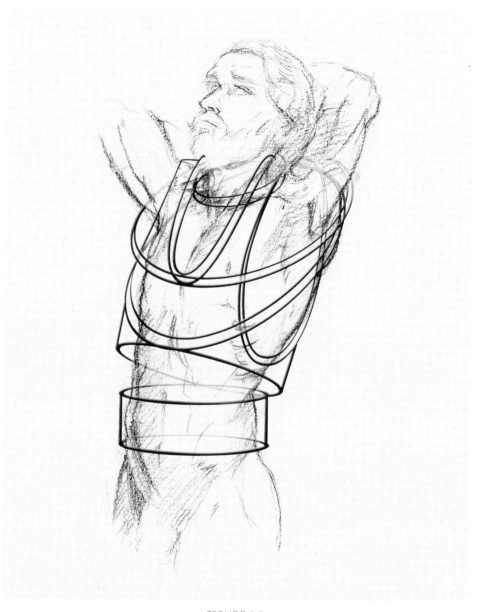

FIGURE 3.9

▶ Resulting fold pattern. With the front of the torso extended, the compression pattern in the front of the shirt takes on a vertical stress. Note how rings of nodes align on the breaks of plane between the chest and abdomen.

FIGURE 3.10

Rear View

When viewing the back of a figure whose trunk is extended, look for a strong, dominating, horizontal fold at the lower back, where the mass of the rib cage tilts back on that of the pelvis. As when the trunk is flexed, the garment forms nodal/antinodal lines along the major vertical plane breaks of the upper trunk: at the inner borders of the shoulder blades and where the small of the back joins the more sideways planes of the lower back.

Here, the model is depicted wearing a shirt, in which a compression band—as is typical—sits on the hips. If she were wearing a dress or gown, this pattern would be likely to continue downward over the hips.

Note the rings of compressed cloth, emphasized by this position, that sit atop the projection of the breasts and below them, atop the projection of cartilage at the frontal opening of the rib cage.

▶ Extension of the trunk, seen from the back. Extension of the torso in front equates to flexion in the back. The central tube of the model's shirt is compressed along the horizontal line where the rib cage approaches the pelvis.

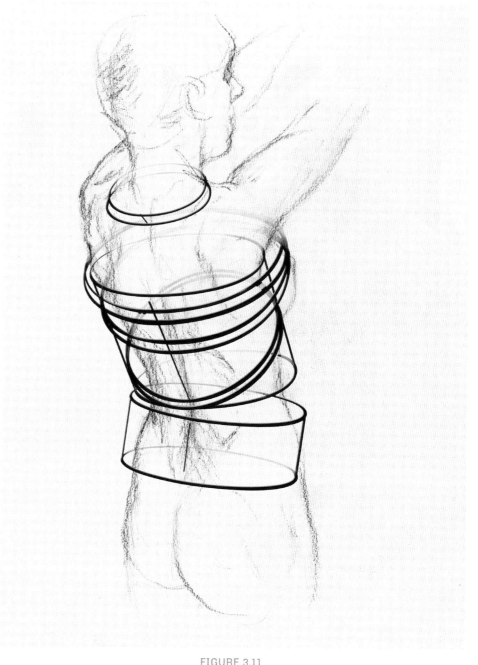

FIGURE 3.11

▶ Resulting fold pattern. The shoulders, breast, and rib cage at the model's front provide surfaces from which looping folds will hang, encircling to her back.

FIGURE 3.12

The Effects of Joint Movement

Rotated Trunk

Front View

As the model's upper trunk rotates toward her right, the left side of her rib cage comes forward, obliquely compressing the cloth of her shirt. Therefore, the folds that result, perpendicular to this movement, appear to reach toward her right—or rearward—shoulder. The compression band that naturally appears at her waist, compressed against the support of her hips, is subject to the greatest degree of twisting; the garment remains anchored to the upper plane of her bosom above and to her hips below.

If the model's trunk were aligned straight forward, we would see the nodal/antinodal points stack vertically along the major plane breaks of the abdomen, where, on either side, the frontal plane of the belly meets the planes of the flanks and where the drapery suspends off the top planes of the breasts. But the twisting of the trunk displaces these points from their regular vertical axes. Between the breasts and along the front plane of the upper abdomen, however, these points lie comparatively static, since the mass of the rib cage and the breasts atop it tend to turn as a unit.

▶ Rotation of the trunk. When the model rotates her rib cage over her pelvis, one shoulder comes forward as the other moves back.

FIGURE 3.13

▶ Resulting fold pattern. The folds in the model's shirt, already there when she was at rest, appear to skew toward the rear shoulder, following the direction of her twist.

FIGURE 3.14

Flexed Leg

Standing (Front View)

When the leg is flexed, the thigh draws forward, closer to the pelvis. In a two-legged garment, this causes a compression band to form at the juncture between the leg and the hip, its upper border mimicking the fold of the thigh beneath. The band continues over the top of the thigh, and sometimes, depending on the tailoring of the garment, it reaches as far back as the buttock, where the stretch in that area causes the pattern to fade.

This band often integrates with another set of folds reaching around the inner aspect of the rearward leg to its posterior aspect, creating a figure S of folds running front to back, underneath the floor of the pelvis. A looping fold or set of folds usually hangs suspended from the upper surface of the thigh, and a similar loop will appear on the upper (posterior) surface of the rearward leg.

A second compression pattern across the upper part of the hips blends with the one at the crotch and usually circles completely around the body.

▶ Resulting fold pattern. Looping folds will hang, suspended, from the top surface of the rearward leg (called the "back of the leg" at rest) and the top surface of the forward leg (called the "front of the leg" at rest).

▶ Flexion of the left leg. The model's forward leg compresses his pants at the juncture of the thigh and pelvis.

FIGURE 3.15

FIGURE 3.16

When the thigh is flexed—drawn closer to the hips—the clothing will fold markedly along the fold of the thigh. (The skin beneath reacts in the same way.) As you would expect, a compression pattern takes form around this dominant fold.

If both thighs are flexed, this fold will be reflected at the fold of the groin of the other leg and, depending on the garment, will usually blend in to a single fold. This is especially true if the model is wearing a skirt or any garment where the tube of material surrounding the hips extends well below the level of the groin.

When only one thigh is flexed, the compression folds appear chiefly on that side, and there is commonly an accentuation of the folds across the front of the hips at the higher levels of the compression band.

▶ Legs of a seated figure. In a seated pose, the thighs are flexed toward the pelvis, producing a horizontal stress in the clothing.

This compression band is squeezed more tightly in front, while the folds at the figure's rear maintain a static distance. The material also tends to conform to the figure's buttocks, meaning that only the most projecting parts of the fold pattern will continue to show at the rear.

▶ Resulting fold pattern. The model's skirt forms a compression pattern from the constriction, mimicking the socketing of the thighs into the hips.

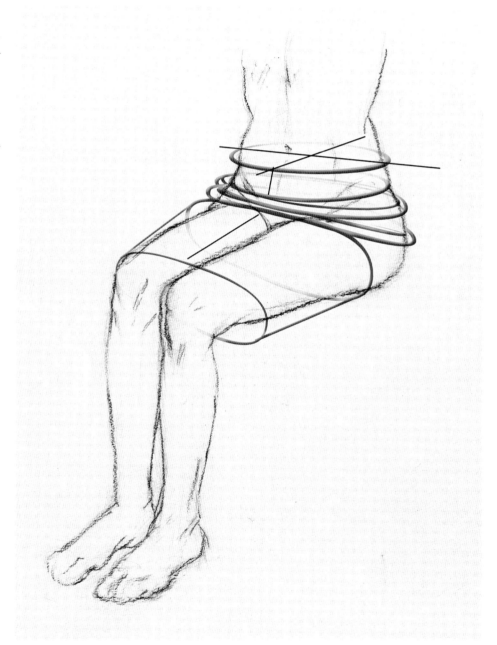

FIGURE 3.17

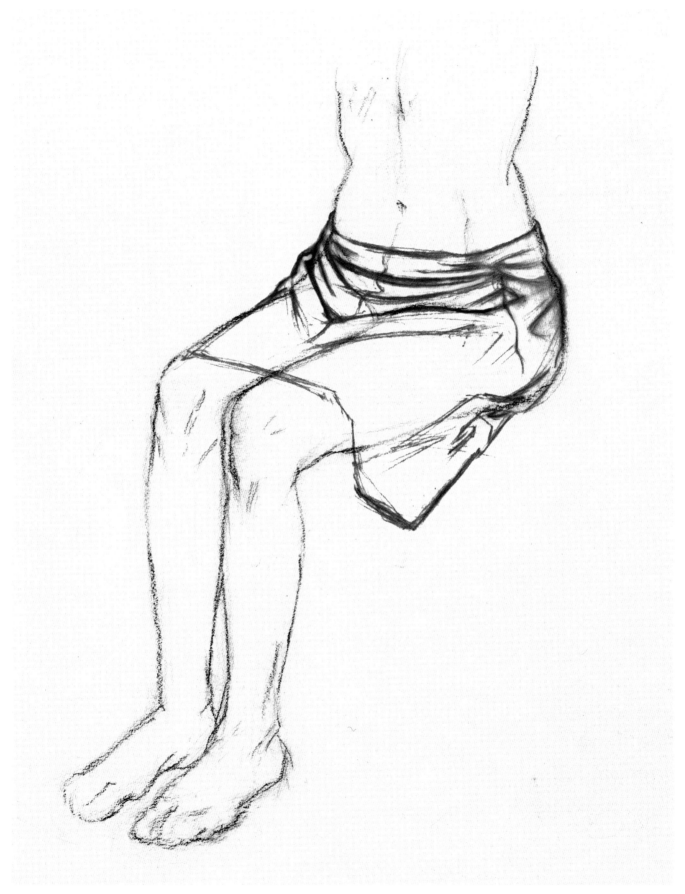

FIGURE 3.18

The Effects of Joint Movement 133

Flexed Thigh
Standing (Rear View)

Here, with one thigh flexed against the pelvis, we see the formation of a compression band where the tube for the thigh meets the tube of the hips. This band tends to limit itself to the side of the hip being flexed. This pattern would fully and markedly encircle the hips of the figure if she were wearing a skirt, but here, as you can see, it only happens to a limited extent. This is because the three tubes of cloth that compose the model's pants tend to compartmentalize the folds.

Wherever we see flexion (and therefore compression of the clothes) along one aspect of a joint, we expect the garment to be stretched on the opposite side. Here, the compression pattern formed at the front of the thigh fades out at the buttock, conforming to the shape of the figure in its receding phases.

Take note, also, of the great looping folds now hanging from the support of the horizontally disposed thigh.

▶ Flexed thigh. When the thigh is flexed forward, the folds of the pant leg hang from its top surface.

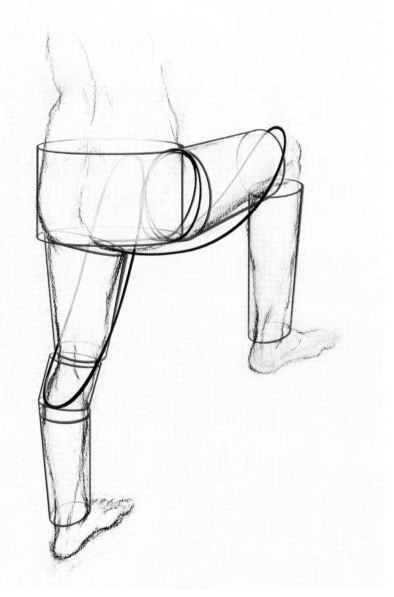

FIGURE 3.19

▶ Resulting fold pattern. A compression pattern arises from between the thigh and pelvis. The stretch of the pants against the surface of the buttocks, in back, diminishes the folds in that area.

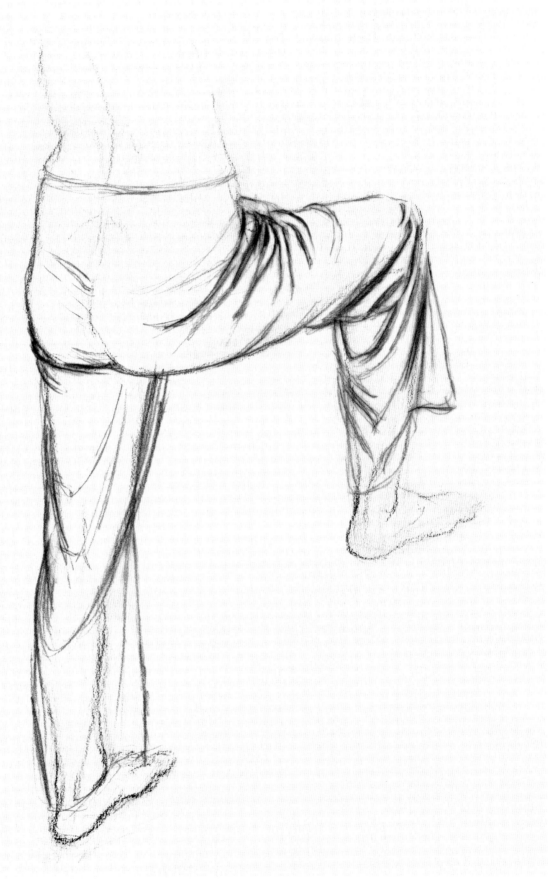

FIGURE 3.20

The Effects of Joint Movement 135

Extended Thigh
Standing (Rear View)

In this pose, the thigh is extended against the pelvis—drawn back farther to the rear than it would be in a neutral standing position. Another way of saying this would be that the thigh is "flexed backward." And the result is a patterning of the folds opposite to that seen in the previous set of drawings.

Note the development of an apparent compression pattern under the buttock, with its dominant fold following the same line as the gluteal fold of the figure.

When the thigh was flexed, the garment conformed more closely to the rear of the figure. Here, however, the cloth will tend to stretch across the front of the hips.

Note the subtle but distinct presence of a suspended loop hanging toward the front of the thigh, which is now the underside of the cylinder.

▶ Extended thigh. In extension, the thigh is compressed against the pelvis in the rear.

▶ Resulting fold pattern. Compression folds form between the buttock and thigh, and additional folds form above the buttock because of the contraction of the gluteus maximus muscle.

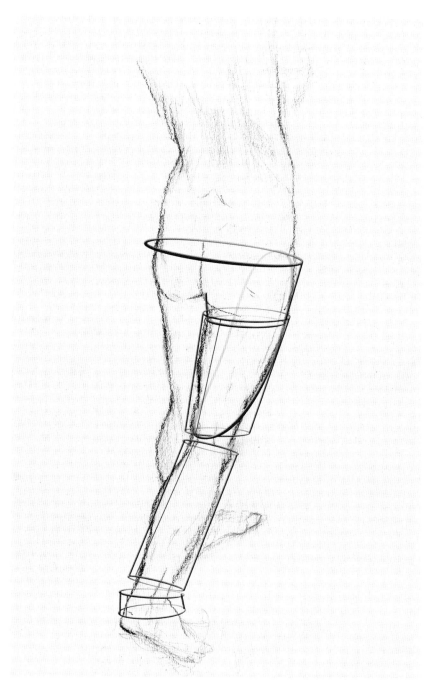

FIGURE 3.21

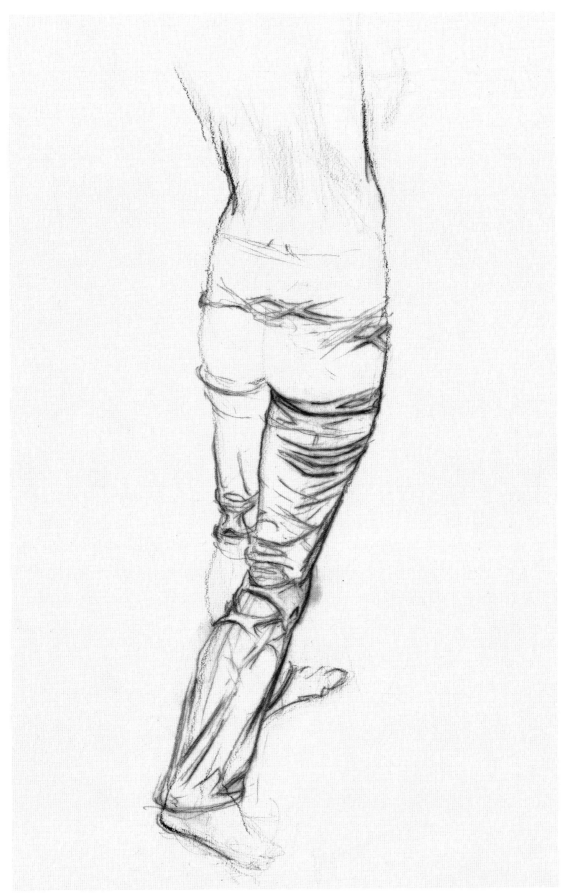

FIGURE 3.22

Abducted Thigh
Standing (Rear View)

When the leg is abducted, it is drawn sideways, or laterally, away from the center line of the body, and the thigh draws closer to the side of the hips. As expected, a compression band forms in this compressed area, though it will not be as pronounced if the degree of abduction is not as great as that pictured in these drawings.

The fold pattern that forms there does not usually end there. At the level of the crotch, where the material is one large tube encompassing both thighs and the hips, the cloth is widely stretched, and the fold pattern that wraps around the outside of the lifted leg can be seen to curve completely around the pelvis to the juncture of the hip on the far side.

Note how the lifted thigh, in this position, makes what is in effect a single large tube out of the tubes for the hip and leg. Therefore, a looping fold that suspends from the top of the abducted thigh can extend all the way to the far hip.

▶ Abducted thigh. When the thigh is abducted, or drawn sideways, front-to-back folds will arise between it and the side of the pelvis.

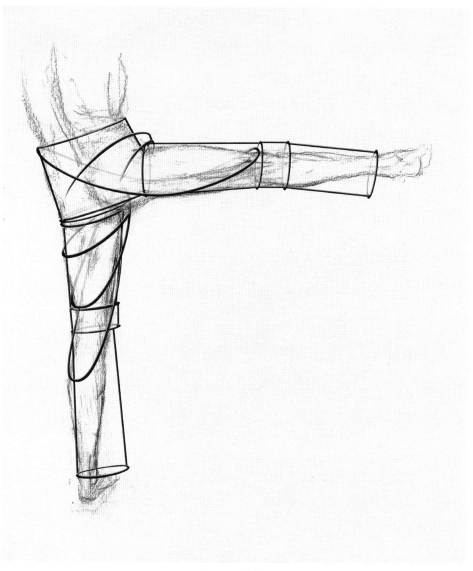

FIGURE 3.23

▶ Resulting fold pattern. The lateral surface of the thigh, usually at the side, is now the upper surface. Folds will, accordingly, hang from this support. The compression pattern in the central, hip section of the pants will continue around to the opposite side of the pelvis.

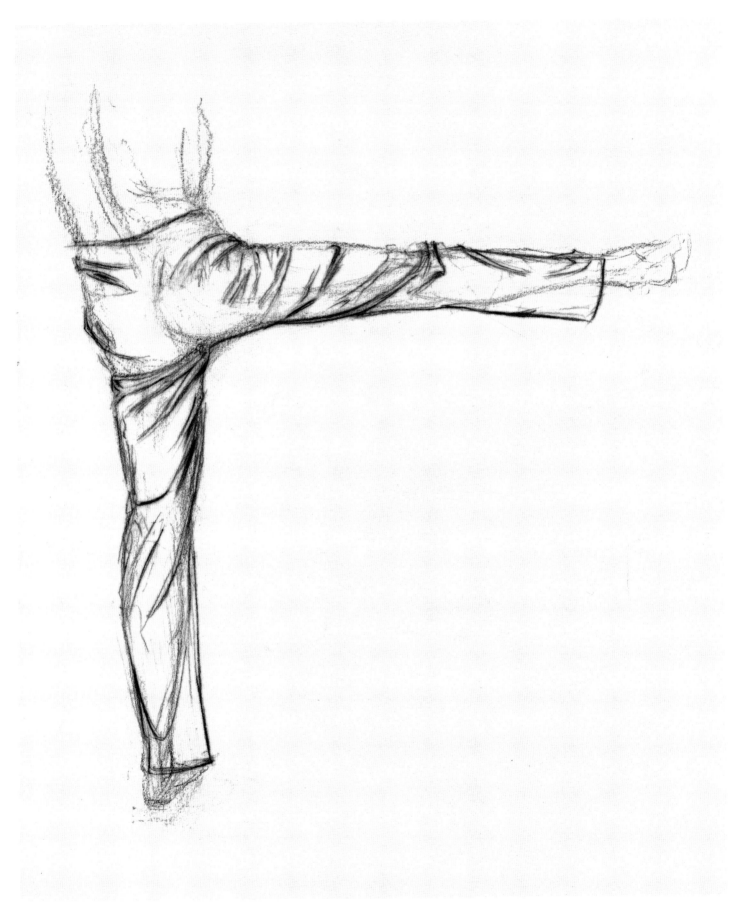

FIGURE 3.24

The Effects of Joint Movement 139

The compression band around the knee, which is usually present in the standing figure, is especially compressed at the back of the knee during flexion. As usual, the dominant fold of the pattern follows its anatomical counterpart; here, it is analogous to the flexion line of the knee, the horizontal line at the back of the knee joint.

Remember that *this* area, not the kneecap, is where the fold lines will converge. It's easy to be misled because of the common presence of a looping fold that tends to form between the buttock and the top of the knee when the leg is in a standing position. When we sit, a trace of this fold, with its terminus at the upper margin of the kneecap, tends to persist.

Because of the extreme stretch between the front (kneecap side) and the back of the knee, several small tension folds may arise, also appearing to "point" toward the kneecap. But it is not the kneecap that causes the greatest folds to appear about the joint, but the compression behind the knee. If anything, the kneecap area, oppositely situated to the area of flexion, stretches the clothing and compels it to conform to the shape of the knee. Here, as usual, only the projecting portions of the compression patterns remain intact. The receding areas conform to the shape of the joint.

In the side view of the legs shown in figures 3.25 and 3.26, we can see that the thigh is parallel to the ground, the knee is moderately flexed, and the foot is positioned forward of the knee joint. The lower part of the pant leg, therefore, rests upon the anterior (front) surface of the skin. A looping fold hangs between the knee and the dominant fold at the front of the ankle, which arises from the habitual compression of the cloth along the juncture of the lower leg and the foot.

On the model's right (rear) leg in figures 3.25 and 3.26, the suspended portion of the lower pant leg hangs from the forward edge of the knee in a conical form.

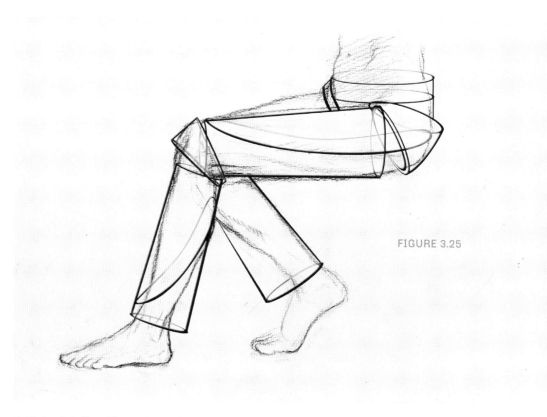

FIGURE 3.25

▲ Moderately flexed knee, viewed from the side. Because the model is seated and her left knee is only moderately flexed, the anterior (forward) planes of both the thigh and shin become the top surfaces of the leg, supporting a number of suspended looping folds.

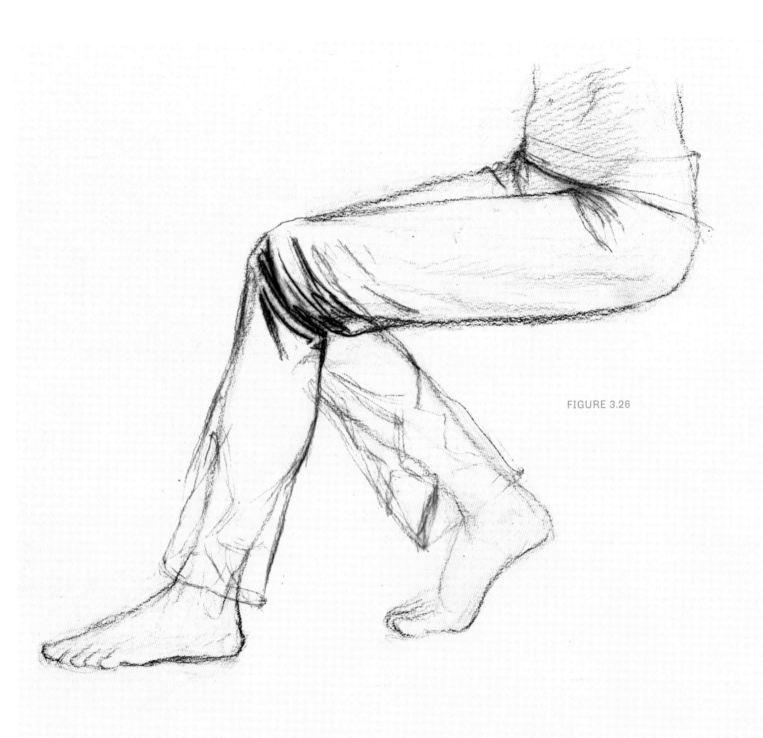

FIGURE 3.26

▲ Resulting fold pattern. In this seated pose, compression folds form not only behind the knee but also between the front of the thigh and the pelvis.

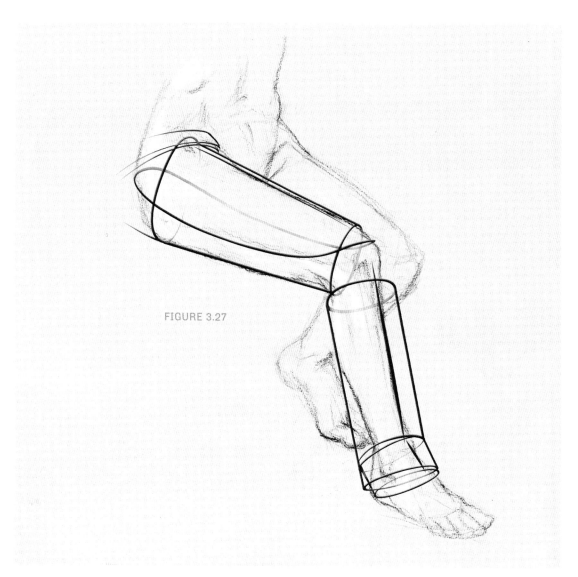

FIGURE 3.27

▲ Moderately flexed knee, viewed from the side and slightly above. Flexion of the knee causes a compression of the pant leg behind the knee joint. The lower part of the pant leg, suspended from the front (now top) part of the leg, can also buckle where it crosses the ankle joint.

▶ Resulting fold pattern. In tight garments, the compression patterns that form are subdued.

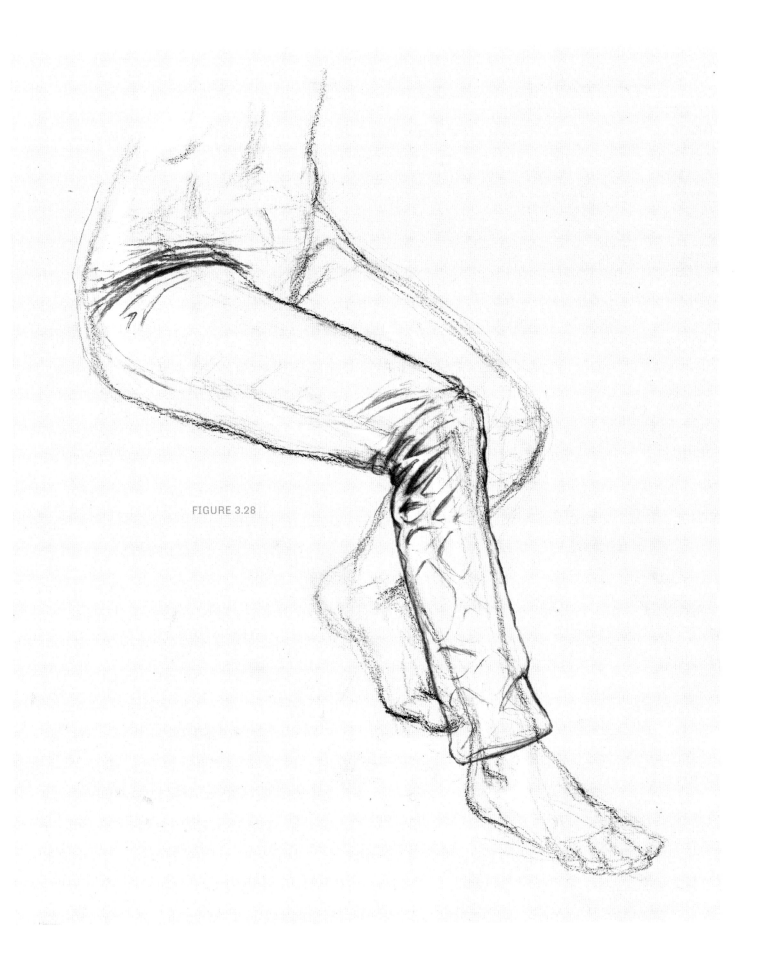

FIGURE 3.28

In figures 3.29 and 3.30, the model's near (left) leg is sharply bent, with the lower leg at an angle of less than 90 degrees to the thigh. The far leg, by contrast, is only moderately flexed. In figures 3.31 and 3.32, the positions of the right and left legs are reversed.

As when the leg is moderately flexed, the compression band that usually forms around the knee of the figure is squeezed between the thigh and calf, but to an even greater degree, resulting in deeper ridges and troughs at the site of the pattern. These, of course, proceed from the dominant fold, here hidden, at the back of the knee.

In the poses showing a moderate flexion at the knee, the tube of the lower pant leg was suspended off the anterior surface (shin) of the lower leg. Now, it is suspended off its posterior (calf) surface. Therefore, the looping folds that reach from the back of the ankle, near the Achilles tendon, to the knee are bound to form here, as they would on any such inclined cylinder.

A secondary loop or set of loops, criss-crossing the first, very often arises, as well. It extends from the trace fold at the front of the ankle to the rear of the knee. You can see its analog in the far leg in any of the figures here.

▶ Strongly flexed knee, viewed from the side. In this pose, the model's left thigh is flexed against her pelvis, and her left lower leg is strongly flexed against the thigh.

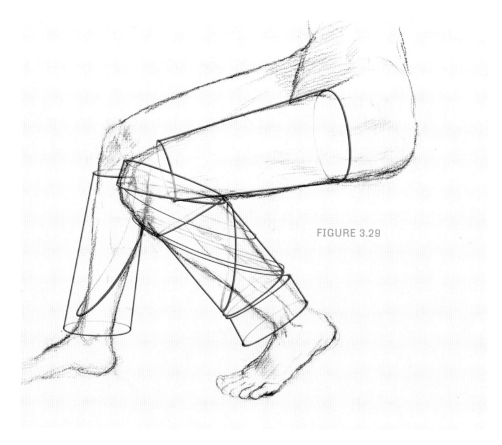

FIGURE 3.29

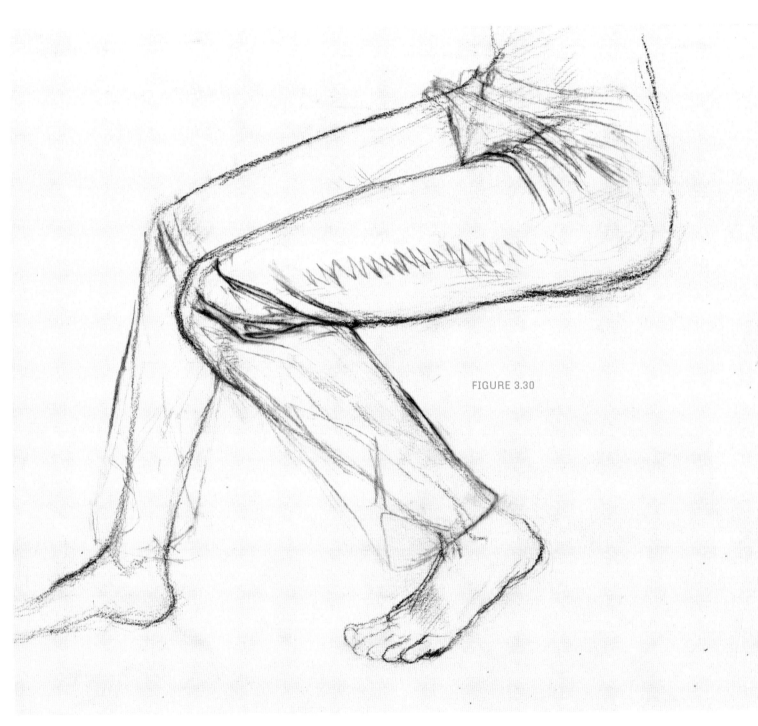

FIGURE 3.30

▲ Resulting fold pattern. Compression patterns appear at the points of stress—between the thigh and the pelvis and at the back of the knee.

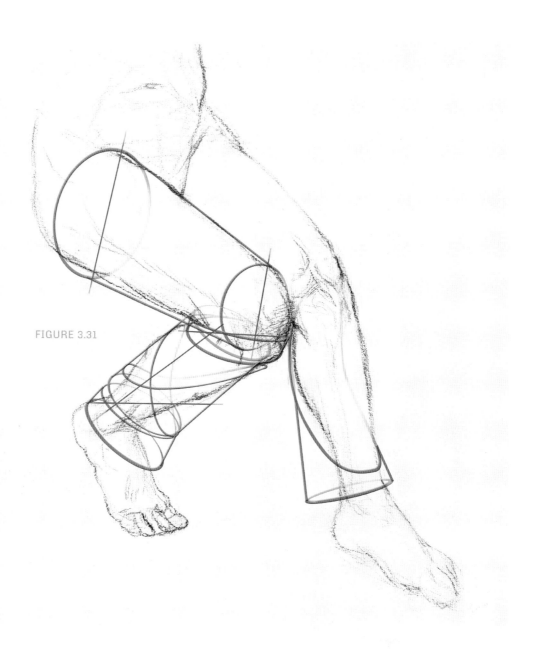

FIGURE 3.31

▲ Strongly flexed knee, viewed from the side and slightly above. With the lower leg strongly flexed, its posterior (calf) surface now becomes the upper surface. The lower pant leg and its looping folds will suspend from this support.

▶ Resulting fold pattern. The compression pattern at the back of the knee merges with the folds that suspend from the front of the knee to the back of the calf.

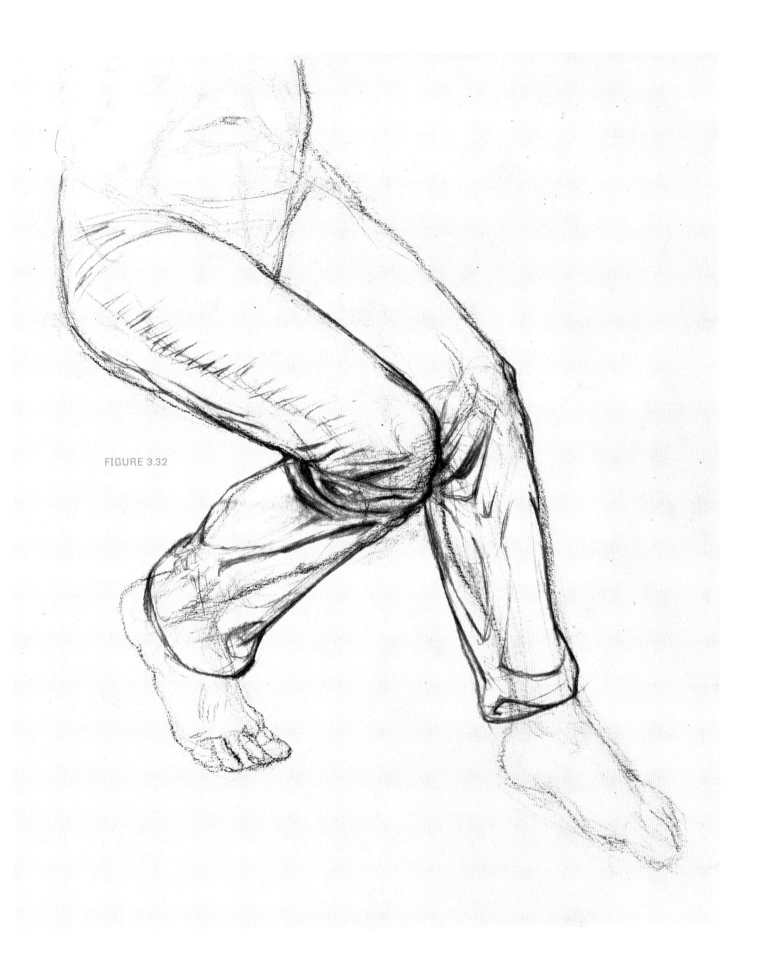

FIGURE 3.32

Flexed Shoulders

Adducted Forward (Front View)

When the shoulders are drawn toward the midline of the body (adducted), they compress the garment horizontally, resulting in a series of vertical folds. These commonly run down from either side of the mass of the neck to the compression band about the waist. This compressing force also accentuates the compression bands that run along the sides of the chest and under the armpits. Watch for a horizontal line of nodes and antinodes as these folds encounter the plane break that occurs at the juncture of the top plane of the chest with the forward plane of the abdomen.

▶ Shoulders adducted forward, front view. When the shoulders are adducted—drawn horizontally toward each other—the result is a vertically stressed compression pattern.

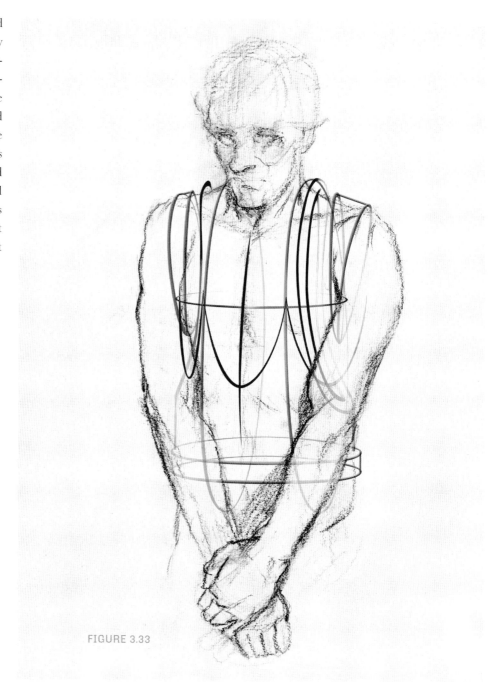

FIGURE 3.33

▶ Resulting fold pattern. In adduction of the shoulders, the frontal portions of the vertical compression bands that encircle the shoulder joints become emphasized.

FIGURE 3.34

ANTONIO

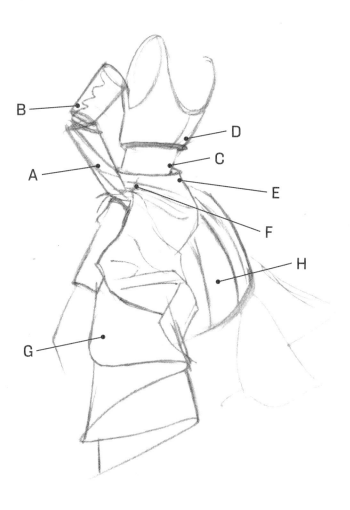

The work of Antonio Lopez, known simply as Antonio, spanned several decades. The glamour and excitement of the fashion world radiates through his loose and vigorous drawing style. While not losing any of the personality of the dress, Antonio communicates its structure and folds through splashy, vibrant colors interrupted by strong highlights and energetic line work.

At *A*, folds in the model's glove, suspended from her elbow, run from the elbow to what in this pose is the upper surface of her forearm. Above, on her upper arm, the long glove is compressed vertically, resulting in the vertical squiggly separation between lit and shaded areas at *B*.

The band of a large bow (*C*) tied around the model's waist constricts it so that it telescopes the main tube of her dress both above (*D*) and below (*E*).

Notice the series of parallel folds in the yellow skirt at *F*, perpendicular to the angle at which the model's wrist is compressing the fabric against her hip. From this point of support, a series of flattened cylindrical folds (*G*) descends. The remainder of the skirt (*H*), unaffected by any such disturbance, falls from around the model's derrière and right hip in an even series of vertical folds.

▶ Antonio Lopez (1943–84), *Yves Saint Laurent dress #12* (from the YSL autumn-winter catalog, 1984–85). Pencil and watercolor on paper, 7¹⁄₂ x 11 inches (19 x 28 cm), 1984. Estate of Antonio Lopez and Juan Ramos and Galerie Bartsch & Chariav

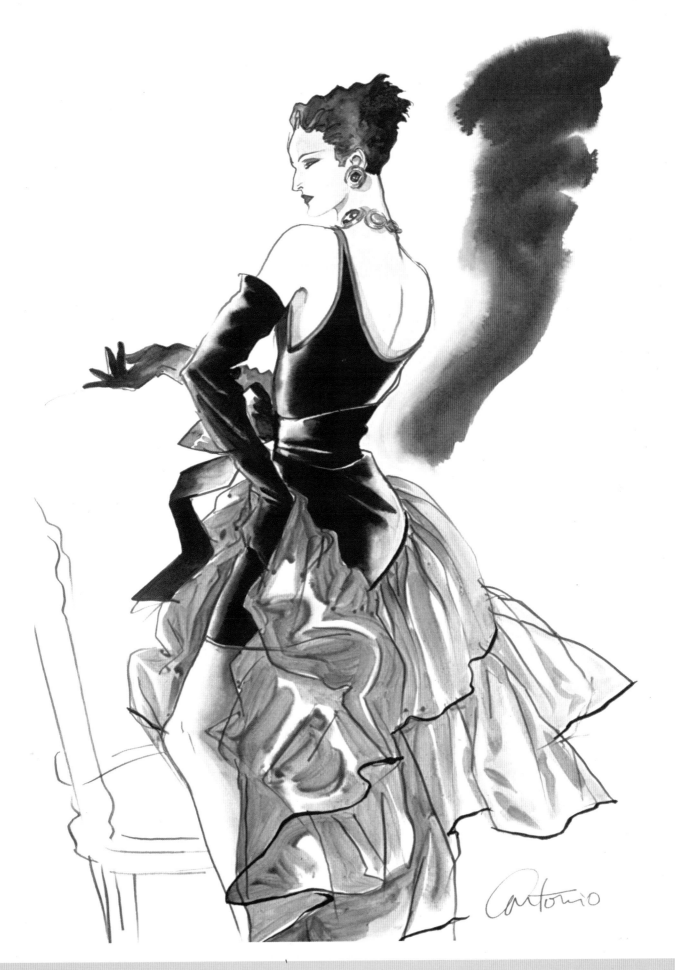

Adducted Forward (Rear View)

When the shoulders are adducted for-
ward toward the body's center line, the
emphasis of the folds in the front, where
the fabric is compressed, are vertical.
In the back, however, the emphases are
either horizontal or neutral. The pulling
action of the shoulders tends less to cre-
ate folds across the back, where the fab-
ric is stretched, than to emphasize those
fold patterns that already exist from other
causes. Specifically, it brings into sharper
visibility those horizontal rings of com-
pression that appear transversely through
the main tube surrounding the trunk.

Look for sharp pattern breaks along
the inside borders of the shoulder blades.
Stretched between these two projecting
edges at the middle of the upper back,
the compression pattern will stand out in
sharper relief, since its lower portion will
not be deformed from contact with the
mass of the body.

▶ Shoulders adducted forward, rear view.
When the shoulders are drawn forward to-
ward the front, the back of the shirt will fold
as it crosses over the vertical borders of the
shoulder blades.

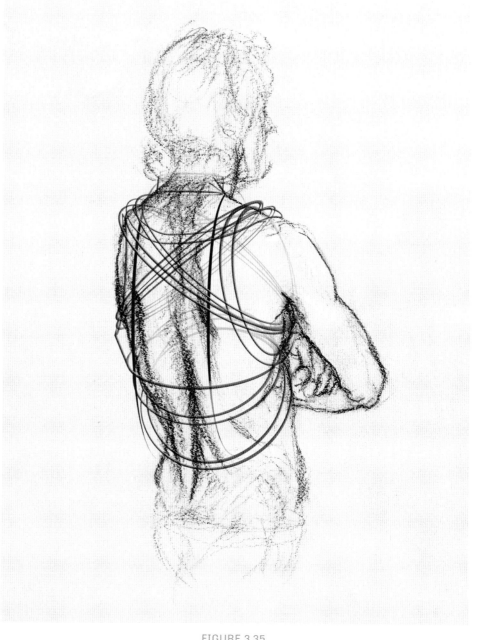

FIGURE 3.35

▶ Resulting fold pattern. When the shoulders
are drawn forward, the compression pat-
tern that encircles the trunk is horizontally
stressed across the model's back.

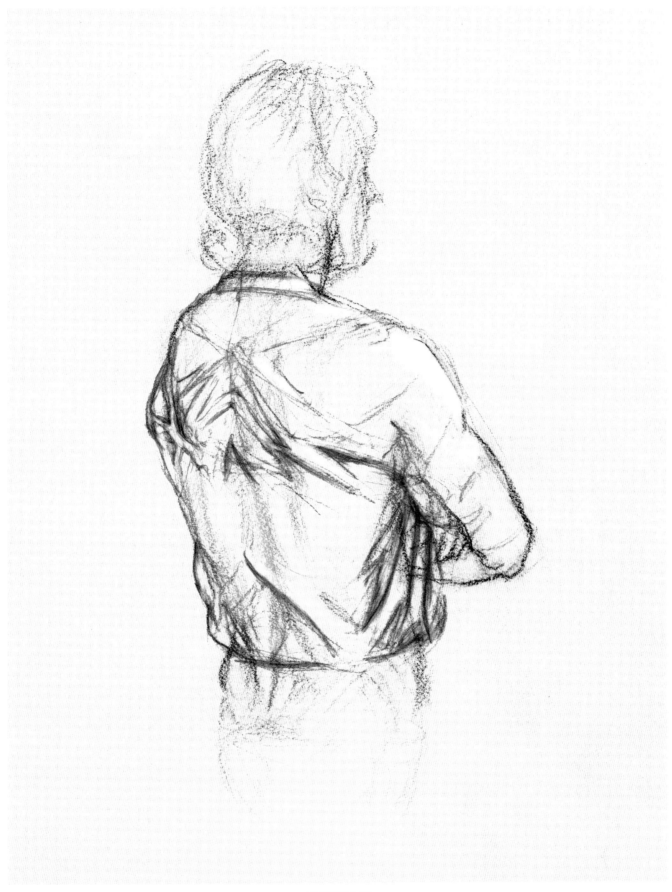

FIGURE 3.36

Adducted Backward (Rear View)

In these drawings, the shoulders are again adducted—drawn toward the midline of the body—but this time toward the back, not the front. Correspondingly, we now see vertical folds appearing in the back of the garment, where the fabric is being horizontally compressed between the masses of the shoulders. Note the similarities between figure 3.37 and figure 3.33 on page 148. It's as though the body has turned around, with the red lines indicating the compression patterns staying mostly the same.

The compression rings that form under the armpits and around the shoulders are, once again, further compressed. Vertical bands of compression now run down either side of the spine, compressed by the mass of the shoulders. Note the break line at the lower angle of the shoulder blades, similar to the one in figure 3.33 that fell along the meeting of the chest and the abdomen.

As usual, expect these folds to reconcile themselves with those of the compression band at the waist that rests on the hips.

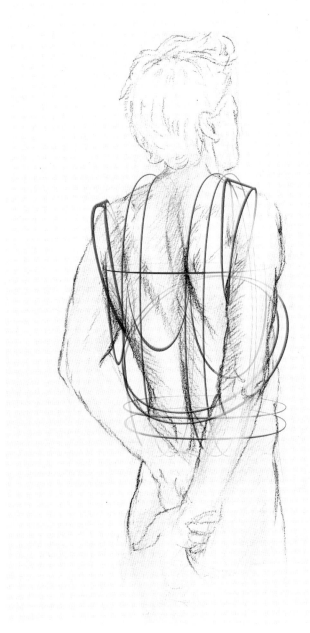

▶ Shoulders adducted rearward, rear view. When the shoulders are adducted rearward, the result is a vertically stressed compression pattern at the back of the figure.

FIGURE 3.37

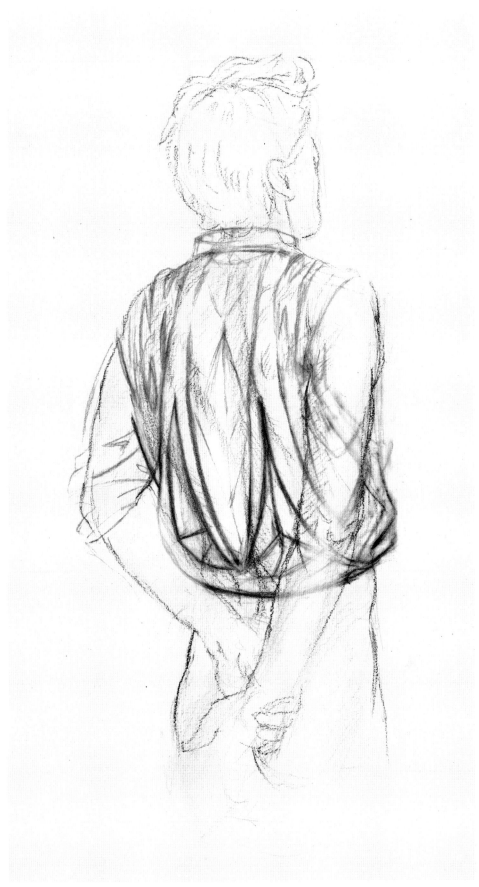

FIGURE 3.38

◀ Resulting fold pattern. The vertical compression bands that form over the shoulder blades integrate with the horizontal compression band that encircles the waist.

Arms Extended

Extended Forward and Raised Overhead (Side View)

The long tube of the shirtsleeve, which usually hangs vertically downward, is inverted in this pose. Not surprisingly, the result is a series of horizontal compression bands, notably where the sleeve sits on the top of the shoulder and where the wrist cuff sits atop the sleeve.

In the middle of the sleeve, at the elbow, the diameter of the cloth tube widens. Here, there is some telescoping of the upper part (closer to the wrist) into this middle section; simultaneously, the middle section telescopes around the narrower part that surrounds the upper arm, positioned below.

Suspended looping folds form at the undersides of the arms as the arms are lifted. These folds are still apparent with the arms now fully lifted, but to a less accentuated degree. Their folds become integrated with the aforementioned compression bands.

▶ Resulting fold pattern. Series of horizontal compression bands form atop the places where the limbs thicken—the forearms, upper arms, and shoulders.

▶ Raised arms. As the extended arms make their way overhead, the cloth tubes that make up the shirtsleeves are compressed downward.

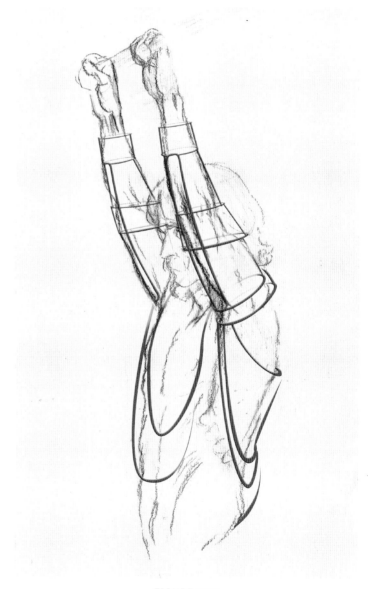

FIGURE 3.39

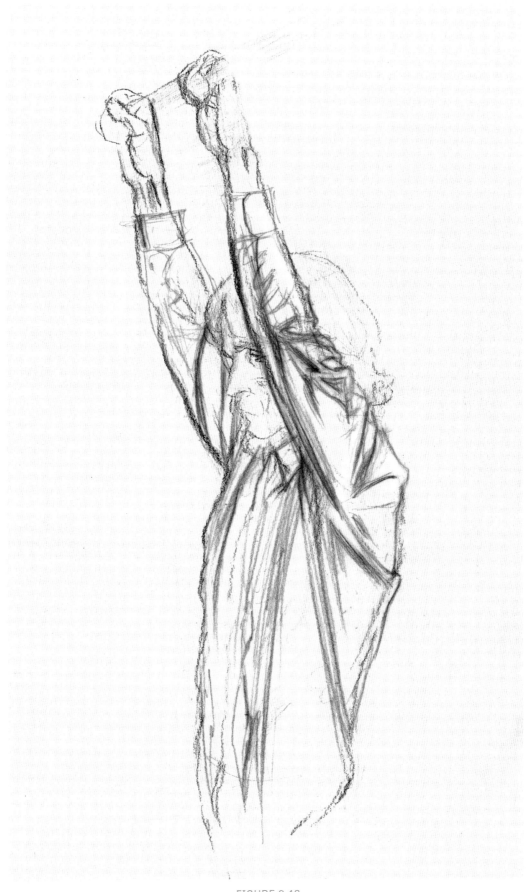

FIGURE 3.40

When the arms are raised to shoulder height and reach forward, the compression bands that always encircle the shoulder joints are now compressed more strongly between the pectoral muscles and the upper arms.

In one sense, the entire arm is acting as a single cylinder on which the cloth tube of the shirtsleeve hangs. Accordingly, a long, looping horizontal fold hangs suspended along the bottom of the form, from the wrist cuff to the armpit. But because the elbow is slightly bent, the sleeve may be divided into upper and lower (forearm) forms. The cloth maintains the compression band that is found around the elbow when the arm is at rest.

With the arm in this horizontal position, also look for the formation of looping folds that rest on the lateral (in this pose, the upper) surfaces of the extended arms.

▶ Arms extended forward. When the arm is raised and reaches forward, the bottom part of the sleeve suspends from the top plane in long looping folds. Smaller looping folds rest on the top surface of the arm.

FIGURE 3.41

▶ Resulting fold pattern. Trace compression folds at the elbow, resulting from previous flexions of the arm, still influence the general pattern of folds in the sleeve.

FIGURE 3.42

The Effects of Joint Movement 159

Extended Backward (Three-Quarter Rear View)

When the arms are extended to the back, looping forms will hang suspended from one end of the sleeve (the armpit) to the other (the cuff). There will also be a looping fold that rests on the posterior (back) side of the arm, which is now the top surface of the form. In fact, you may see two of these looping forms, separated from each other by the flaring of the sleeve about the elbow, and the looping form on the upper arm may telescope into this widening. In a garment that fits more tightly than the shirt depicted, a significant amount of twisting may occur in the folds of the sleeve, as well.

The backward extension of the arms is almost always accompanied by the rearward adduction of the shoulders (see pages 154–155). In any case, there will be a significant intensification of the compression pattern between the arm and the shoulder blade.

▶ Resulting fold pattern. Because the fabric of the model's shirt is somewhat stiff, the enlargement of the sleeve in its tailoring around the elbow becomes a factor in the patterning of the folds. Note how the compression bands in this area persist even though the arms are at a 45-degree angle from vertical.

▶ Arms extended rearward. In this position, the posterior aspect of each arm becomes the top, and the bottoms of the sleeves hang suspended from this surface in long, looping folds. Smaller loops of folds rest atop the arms, at the triceps region.

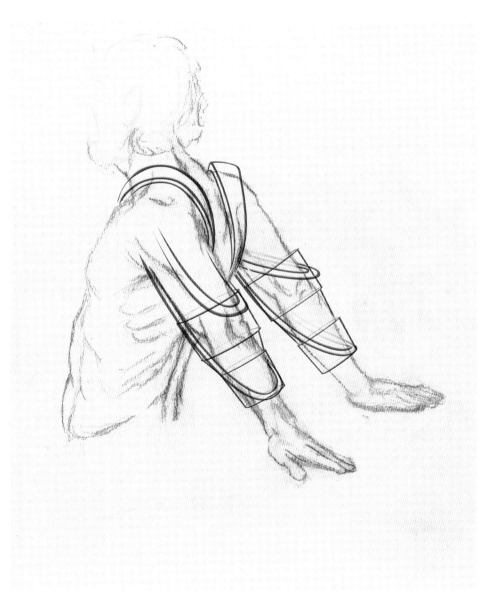

FIGURE 3.43

FIGURE 3.44

STAVRINOS

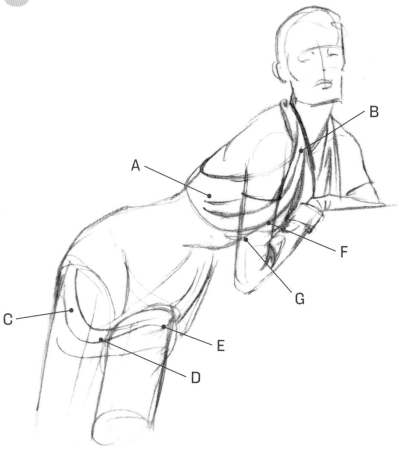

▶ George Stavrinos (1948–90), *Beauty on Chaise*. Pencil and tempera on board, 16 x 14 inches (40.64 x 35.66 cm). Museum of American Illustration at the Society of Illustrators

George Stavrinos, who taught at the Fashion Institute of Technology in New York City, was an artist and fashion illustrator known for his graceful, silvery, and assured style. To achieve the fluid, elegant effect of the drapery in this drawing, Stavrinos takes some liberties with the form of the folds, softening the plane transitions into fluent, serpentine lines. But he never abandons the essential structure of the drapery, transmitting a sense of its architecture to the viewer.

The sparkly, seamless gatherings of the dress's front are conspicuously shown off at the side of the chest (*A*). But notice how these folds continue, behind the model's right arm, to find their other area of suspension, alongside the neck at *B*.

Again, the folds at *C*, suspended from the model's right hip, are probably much more sinuous than they actually appeared. But Stavrinos takes care to let their contours describe, first, the space between the two legs at *D* and then the shape of the model's left thigh as they rest over its upper surface at *E*.

Notice how the looping ring fold in the glove (*F*) perfectly integrates with the rest of the compression pattern, which is indicated by the vertical squiggly line between light and shadow at *G*.

Extended Laterally (Front View)

The lateral extension of the arm is usually accompanied, in some measure, by the elevation of the shoulder blade. Accordingly, look for emphasized areas of compression where the arm meets the shoulder and where the shoulder meets the side of the neck. If only one arm is raised, large looping folds will form around the trunk, suspended between these points and a supporting area on the far side of the torso, usually at the waist.

If, as pictured here, both arms are raised, these looping folds can clearly be seen across the width of the body, forming concentric semicircles about the neck and chest.

The sleeve usually carries trace folds from the arms in their resting position, but twisted, following the direction of the wrist. Gravity exerts its influence on the downward portion of the sleeve, causing subtle looping to appear along that aspect, hanging between the armpit and cuff. The dominant fold of the elbow still expresses itself as a vestigial compression pattern.

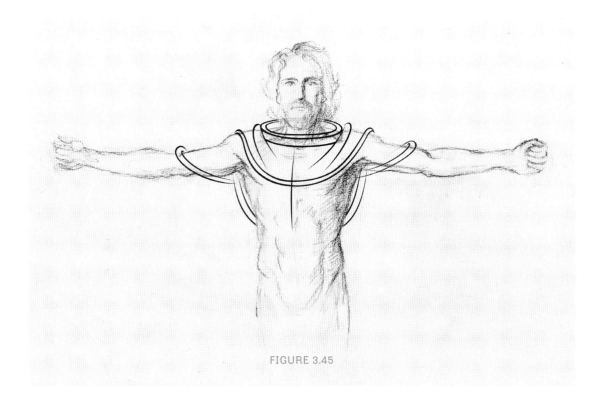

FIGURE 3.45

▲ Arms extended laterally. In this position, the lateral (side) aspects of the arms become their upper surfaces. The bottoms of the sleeves hang suspended from these surfaces in long, looping folds. Smaller loops of folds rest atop the arms at the triceps region.

FIGURE 3.46

▲ Resulting fold pattern. The model's palms are turned forward. Accordingly, the compression patterns in the shirtsleeves have twisted backward and away from the viewer, toward the radial (thumb) sides of the wrists.

The flexion fold at the bend, or "crease," of the arm reverberates in the dominant fold of the compression pattern around the middle of the sleeve. Often, the cut of the sleeve is wider around this joint, and the increased pressure between the upper and lower arm can combine with this greater amount of material to result in very narrow but large folds. The cloth cylinder of the upper arm is likely to telescope within this compression band.

In back, by the elbow, with the rear of the arm pressing against the sleeve, the compression pattern fades out to near invisibility. So there is a marked shift between deep folds at the front and shallow folds at the back, all within the same compression pattern.

▶ Arms flexed, but with the upper arms resting in a neutral position. The model's flexed arms cause compression bands that are particularly constricted between the forearm and upper arm. Looping folds hang from atop the shoulder to the elbow, where the tube of the sleeve widens.

It is very common, especially in looser and suppler garments, to find a looping fold suspended between (and perhaps tucked within) the compression band at the elbow and the top of the shoulder. In very loose garments or those with large armholes, this loop may instead extend around the chest and back to the far side of the neck.

▶ Resulting fold pattern. Trace folds in the cloth tend to make the folds strongest toward the interior flexion line of the elbow, the common site of this type of compression between the upper and lower arms. Because the model has not rotated his forearms, the lines of nodes that mark the break of plane over the forearms remain relatively straight.

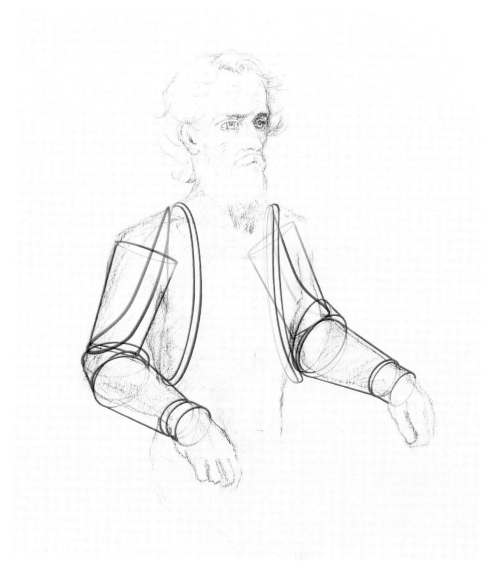

FIGURE 3.47

FIGURE 3.48

The pose in these drawings is essentially a compilation of the mechanics we have seen at work previously: elevation and forward adduction of the upper arm, and flexion of the arm at the elbow. The degree of flexion is essentially the same as it is in figure 3.47, on page 166. Here, however, the model's posture puts her forearm in a position where its long axis is nearly parallel to the ground. Accordingly, look for a looping fold, as always, at the bottom side of this form. It hangs suspended between the sleeve cuff and the compression pattern at the elbow.

As before, an increased amount of pressure between the forearm and upper arm results in deep folds at the compression band around the elbow. The compression bands between the shoulders and the chest are likewise pronounced.

Like the kneecap when the leg is flexed, the elbow stretches the material between it and the fold of the arm. Especially in cases of supple or tight-fitting garments, the shirt material conforms to the shape of the hard, bony point of the elbow.

In this pose, there is not much twisting in the forearm, and therefore there is not a great degree of rotation of the compression pattern in the forearm portion of the sleeve.

▶ Arms flexed, with the upper arms raised. With the upper arms elevated and the forearms flexed at a 90-degree angle, the posterior aspect (back) of the forearm now becomes the topmost plane, supporting the sleeve and its folds. The compression band between the forearm and upper arm is squeezed more tightly.

FIGURE 3.49

▶ Resulting fold pattern. Although the model has not greatly rotated her forearms when bringing them into this position, the upper arms are rotated outward as well as uplifted. We therefore see the fold that encircles the shoulder being twisted outward.

FIGURE 3.50

TYPICAL POSES

The human body is capable of assuming a limitless number of poses. Obviously, it would be impossible to create a complete catalog of them. The purpose of this chapter is therefore to study the behavior of clothing in some of the most common poses that one encounters in life and in art—one example being the *contrapposto* pose, in which a person puts most of his or her weight on one leg. We will examine the broad effects on clothing produced by large-scale body movements such as shifting one's weight, sitting down, etc.

Principal draping patterns vary little between the genders or among the various types of garments worn. An examination of the major disposition of the fold formations—indicated on the following drawings by red lines—will bear out this consistency in cloth's behavior.

As always, gravity is the primary influence. Where cloth rests on a support, it molds itself to that form. Where it hangs freely, it heads straight downward. Where it is suspended from two anchored places, it hangs in a curve. Where it is forced upon itself, either piled atop a supporting surface or squeezed between some other elements, it forms some variation of the compression pattern that we looked at in chapter 1.

Even in the less common poses depicted in this chapter, such as reclining or inverted poses, the cloth behaves predictably. When you draw a clothed figure, be ready to convey this sense of the mechanics of the folds to your viewer. Always remember the form and position of the body underneath. Then look first to the largest dynamics that are at play—gravity, resistance, compression, expansiveness—and convey those broadly in your drawing. The details of the folds will quickly find their natural place within the larger scheme.

Contrapposto

The pose depicted in these drawings is commonly known as the *contrapposto* pose. It has numerous variants and is often encountered in Western art. In contrapposto, the model favors one leg, known as the "supporting" or "standing" leg because it bears most of the body's weight. The other leg, called the "free" leg, bears far less weight. (Only rarely is the "free" leg entirely free, however. It usually plays some, more minor role in supporting the figure.) The free leg is most often bent at the knee, although sometimes it is held straight. The supporting leg is almost always straight. Most important, the pelvis inclines toward the side of the free leg, so that the hip on the side of the supporting leg is higher than that of the free leg, which relaxes toward the ground.

As a natural counterbalance, the trunk above the pelvis inclines in the opposite direction, so that the shoulder over the free leg becomes the "high" shoulder and that over the standing leg becomes the "low" shoulder.

FIGURE 4.1

▲ Placement of major folds in a dress on a model in the contrapposto pose. The looping folds of the skirt come to rest on the points of the figure that project farthest to the sides. In this case, they include the model's left thigh.

FIGURE 4.2

▲ Construction of the fold patterns. The dress is compressed into vertical fold patterns between the breasts, between the legs, and between either side of the abdomen. A large, looping fold runs from the model's right hip to the top of her left thigh, which is projecting outward from her body. A series of subtle folds cascade farther down from these two areas of support.

FIGURE 4.3

▲ The finished rendering.

Model Wearing a Dress

This pose has an immediate effect on the figure's clothing. No matter what the model is wearing—a coat, trousers, a skirt, or, as here, a dress—at least one large looping fold will take the high hip as an anchor. Its other primary anchors will be the *most lateral* points of support that the garment can find on the figure—that is, the farthest points on the opposite side of the body. These almost always occur on the thigh of the free leg, if it is extended outward from the body, as well as the buttocks and, sometimes, the projection of the thigh muscles toward the front or side.

Especially if the garment is cut tightly above the hip but more generous below, look for a series of gradually descending loops, all sharing an anchor at the high hip. And, as the high hip of the contrapposto figure finds a natural counterpoint in the high shoulder, also look for a large looping fold, or series of folds, that takes the opposite shoulder as an anchor.

FIGURE 4.4

▲ Major folds, rear view. The large, looping folds that run between the model's right hip and her left thigh continue around the back of the figure. A large conical formation descends from the most lateral area of the model's right thigh. Although subtle, a compression band will develop around the model's waist, where the dress rests upon her hips.

FIGURE 4.5

▲ Construction of fold patterns. A "stair step" pattern is prevalent in the series of folds descending from between the hip and thigh. Because the cut of the skirt flares slightly, the additional material will collapse upon itself in the conical folds that descend vertically from the model's right hip. More vertical folds appear along her spine, compressed between the shoulder blades, above, and the loins, below.

FIGURE 4.6

▲ The finished rendering.

EISNER

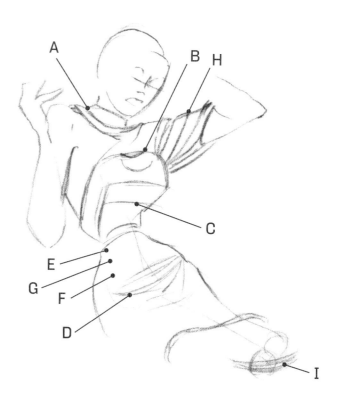

Will Eisner was a pioneer in comic book illustration. This character, a femme fatale called P'Gel, is from his most celebrated comic, *The Spirit*, which ran from 1940 to 1952.

Needless to say, no human being actually looks like this. The tiny waist, large bosom, and hollowed-out lower abdomen constitute an exaggerated agglomeration of those characteristics that were conventionally ascribed to a sexually desirable woman of the time. Nonetheless, the portrayal would lose all plausibility if Eisner did not clothe the figure according to naturalistic principles.

At *A*, Eisner indicates a compression band embedded in the collar encircling P'Gel's neck. Folds of this pattern actually continue down the entire front of the figure, suspended between the breasts at *B* and gathering above the tightly cinched waist at *C*. The pattern is echoed in the folds that hang between the points of the hips (*D*).

At *E*, note how the horizontal constriction of the figure's belt results in a series of vertical folds. These folds, part of a compression pattern that was obviously well considered, continue down to *F*, although their delineation is annulled by the highlight that runs through the shiny

dress atop the flattened dome shape of the figure's abdomen at *G*.

At *H*, a series of parallel and slightly twisted folds runs from the figure's left armpit to the top surface of her upper arm. Note the similar graphic treatment of the compressed folds between the thigh and the cushion at *I*.

▶ Will Eisner (1917–2005), *The Spirit*, dated May 25, 1947. Brush and ink with white correction paint on Bristol board, 16 x 22 inches (40.64 x 55.88 cm). © Will Eisner Studios, Inc.

Model Wearing a Shirt and Trousers

The broad fold patterns seen on this model's clothing are similar to those of the previous series. This is because in both cases the model has adopted a contrapposto pose.

Here, a large looping formation crosses diagonally, like a sash over the model's upper body, from her (high) right shoulder to her left (supporting) hip.

At the same time, however, the model's rib cage is rotating forward on her right side, toward the supporting leg, and back on her left. This is a natural tendency in a contrapposto pose. But when this happens, the compression of her shirt between the advancing side of her rib cage and her hips gives rise to folds that run in a perpendicular direction—obliquely toward her left (low) shoulder.

And so we end up with a pattern of intersecting folds—those running toward the right shoulder and those running toward the left. Which is emphasized is up to you and the particulars of the model's pose. If there is a large degree of tilt between her shoulders, then those folds running toward the high shoulder will be emphasized. If her body is sharply twisted, then the folds running toward the low shoulder will be emphasized.

Consequently, a twisting of the compression pattern that encircles the waist is likely to occur. Look for a slanting of the pattern between the nodal points that appear along the lines of division between the front of the chest and its sides, the

FIGURE 4.7

▲ Placement of major folds in shirt and trousers on a model in the contrapposto pose. As a rule of thumb, fold lines can be drawn toward the model's rear, "high" shoulder. A similar looping fold also rests upon the model's left, "high" hip. The model's hand, pressing against her waist, is the source of additional folds.

FIGURE 4.8

▲ Construction of fold patterns. In heavier cloth, trace folds resulting from previous stresses are embedded into the garment. Here, they are visible where the thighs socket into the hips and at the knees.

FIGURE 4.9

▲ The finished rendering.

abdomen and the flanks, and the flanks and the lower and middle back.

The folds in the lower body's clothing are more straightforward. The looping folds that surround the model's hips rest high upon the her left (high) hip and descend toward the right. These folds are more visible in the rear, where they cross the buttocks. In front, the lowermost of these loops terminate at the crotch, where the thigh of the free right leg creates a compression pattern of its own as it draws

toward the pelvis.

If the trousers were looser or had a lower inseam, this might not be the case. In such cases, the looping folds around the hips might continue far below the level of the crotch, behaving exactly as they did on the dress of the model in the contrapposto pose.

Because the model is wearing her shirt outside her pants, the compression pattern that surrounds the waist, sitting on the upper limits of the hips, is diminished in appearance. The folds of the

upper portion of the pants' waist transfers through its lower portion, blending the two garments together in one compression pattern. (Ironically, the two garments here are actually behaving more like a dress than the dress that we previously looked at, which, because it was tightly drawn in at the waist, created a more pronounced series of folds in this area.)

FIGURE 4.10

▲ Major folds, rear view. The stress of the large diagonal fold in the shirt is toward the rearmost shoulder. In this rear view, that means the model's left shoulder.

FIGURE 4.11

▲ Construction of fold patterns. Looped folds run through the central tube (the hip portion) of the pants, suspended on the high hip and the outstretched right leg.

FIGURE 4.12

▲ The finished rendering.

With the jacket buttoned, this contrapposto pose results in fold patterns nearly identical to those of the dress on pages 172–173. The chief difference stems not from the model's gender but from the fact that his weight is chiefly supported by his left leg instead of his right. His pants, naturally enough, form patterns consistent with those seen on the trousers of the female model on pages 176–177.

Once again, a large sashlike loop suspends from the model's right (high) shoulder and from his left (high) hip. And it crisscrosses obliquely with a series of compressed folds that travel in the direction of his left (low) shoulder.

From the high hip, a series of loops descends through the trousers. The lowest of these, passing just above the inseam of the trousers—and therefore analogous in form to such a fold on a dress or skirt—reaches as far as the right knee.

FIGURE 4.15

FIGURE 4.13

FIGURE 4.14

▲ Placement of major folds in a suit on a model in the contrapposto pose. A looping fold hangs suspended between the model's high (left) hip and his outstretched thigh. Folds are accentuated toward his high (right) shoulder, as well as his rearward (left) shoulder.

▲ Construction of fold patterns. Compression bands form at the bottoms of the trouser legs, where they hit the feet. A conical form suspends from the knee. A series of looping folds hangs between the armholes of the jacket and the most lateral points of the arms.

▲ The finished rendering.

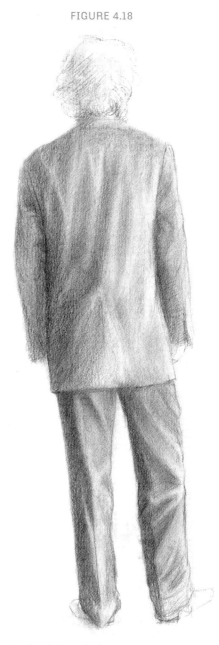

FIGURE 4.18

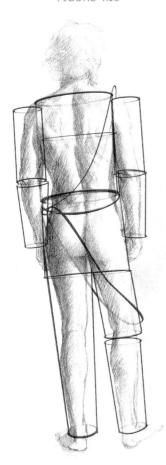

FIGURE 4.16

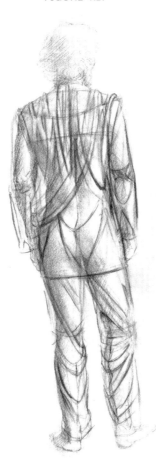

FIGURE 4.17

▲ Major folds, rear view. A fold runs from the hip toward the far (model's right) shoulder. A looping fold suspends between the model's left (high) hip and the knee of his free leg.

▲ Construction of fold patterns. The changing vertical planes of the upper back compress the jacket into folds that mimic the trunk underneath. The arms of the jacket and the upper right trouser leg hang suspended from the top surfaces of those limbs.

▲ The finished rendering.

Seated Pose

Model Wearing a Dress and Crossing Her Legs

In any seated pose, the thighs are flexed toward the hips. When viewing the figure from the front, you should therefore expect to find further compression of the compression band that usually forms around the upper hips. Note the basic contrast between the folds of the clothing on the model's upper body, which have vertical stresses, and those around her waist and thighs, which are horizontally disposed.

Rings of folds will extend to the back of the hips, where they may appear more pronounced in the depression of the small of the back and between the buttocks.

It is possible to retrace the manner in which the model sat down through the pattern of the folds in her clothes. If the model, when sitting down, used her hands

to smooth the fabric of her skirt behind her thighs, or if the material was anchored behind the knees as the model took her seat, the skirt will appear smooth, as it does here. A sudden, abrupt seating would have produced a series of compressed folds under her thighs.

FIGURE 4.19

FIGURE 4.20

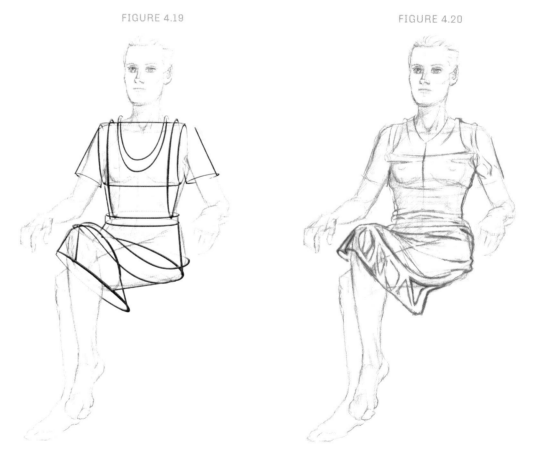

▲ Placement of major folds in a dress on a seated model. The sharp flexion of the model's thighs against her hips creates deep horizontal folds along that line. Her thighs, now horizontal, support large, ringlike folds. Note that if the skirt overhangs the knee, a small conical fold will hang suspended from that point.

▲ Construction of fold patterns. Because the model is sitting straight up, the fold pattern in her upper torso is the same as that found in a standing pose. Small looping folds run through the sleeves, resting on the outsides of the arms, which, in this pose, have become their top surfaces.

▶ The finished rendering.

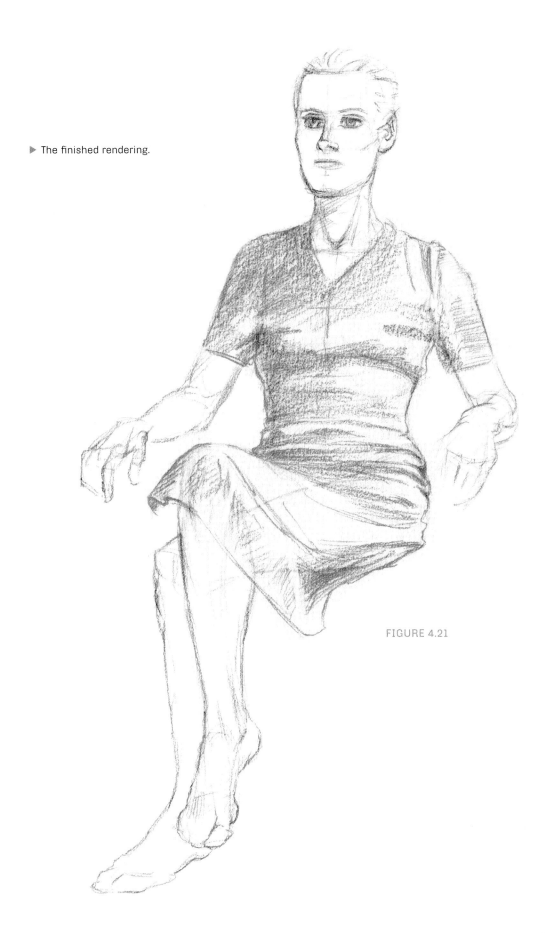

FIGURE 4.21

Reclining Pose

Model Wearing a Dress

As in any pose, gravity pulls down on both the figure and the clothing when a model is lying on her side. The dress the model is wearing is essentially a tube that wraps around the long axis of her body. Viewing this pose, we see trace folds from the compressions that formed while the model was standing, most notably, the compression band gathered around her waist. We also see the compressions and suspensions formed when the body adopted this horizontal orientation.

The model's right hip is now the high point on her body, so loops of suspended folds fall to either side of it. The same happens at the highest point of her rib cage.

The compression folds that, if she were standing, would form between and along the vertical midline of her shoulder blades are now horizontal and twisted away from her waist. Additional rings of compressed folds concentrate where her thighs are flexed moderately toward the front of her pelvis.

FIGURE 4.22

◀ Placement of major folds in a dress on a reclining model. The model's right side is now the upper surface of her body. Accordingly, gravity will pull her dress into looping folds that rest on this surface. The highest points along the model's upward side, including the projection at the hip, "press" the dress into forming folds on either side of them.

FIGURE 4.23

◀ Construction of fold patterns. The right side of the model's rib cage is rotated somewhat backward. Accordingly, the folds in that direction are accentuated. Notice the small, concentric loops that rest atop the model's body.

FIGURE 4.24

◀ The finished rendering.

Inverted Pose

Even when a model is standing on her hands, clothing reacts predictably under gravity's pull. The main tubes that encompass the trunk, hips, and legs are as vertically oriented as in a standing pose. But now they are compressed in the opposite direction. Accordingly, look for compression bands where the garments come to rest on places where the body thickens, including the shoulders, the juncture of the legs and hips, and the knees.

FIGURE 4.25

FIGURE 4.26

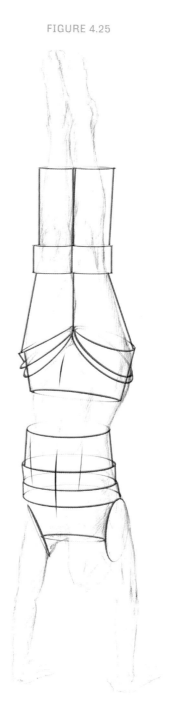

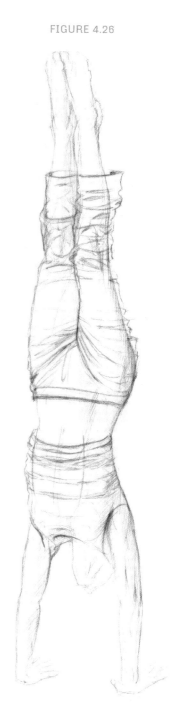

▲ Placement of major folds in a shirt and trousers on a model doing a handstand. Compression bands form on what are now the top surfaces of the model's body: the thighs, the hip joints, the lower rib cage, the undersides of the breasts, and the shoulders.

▲ Construction of fold patterns. The compression patterns run symmetrically over this symmetrical pose. Note the line of nodes/antinodes where the rib cage's planes change from the front to the sides.

Model Wearing Shirt and Trousers

The bottom openings of the clothes as shown on this handstanding model (which were designed to hang suspended but now open upward) do not have much to support them, and they therefore deform into irregularly shaped ovals as they collide with the body. The waistband of the pants, by contrast, assumes a generally even curve around the upper hip area.

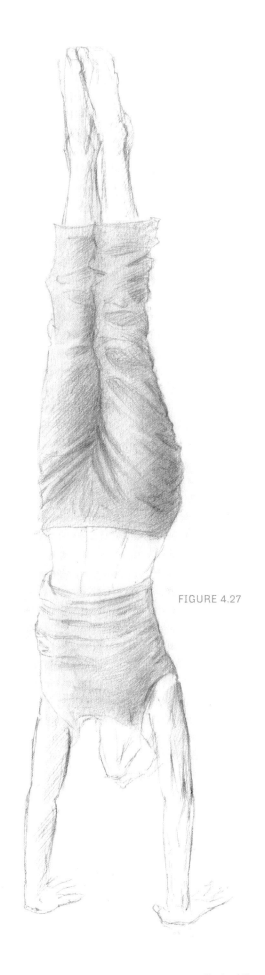

FIGURE 4.27

▶ The finished rendering.

THE MOVING FIGURE

Chapter 3 addressed the movement of the body's parts—the effects that flexion, extension, rotation have on drapery. This chapter is concerned with the body's locomotion through space, specifically with its most common means of doing so: walking and running.

There is very little difference between walking and running, as far as their effects on clothing are concerned. The various acts of locomotion are composed of smaller movements, and any one section of the clothing that a person is wearing is indifferent as to whether or not it is part of a greater phenomenon.

A few factors need to be considered: One is the *inertia* of the clothing—its tendency to remain in its current state of rest (or motion) as opposed to the autonomous actions of the body, which the clothing may not immediately follow. Therefore, assuming that the subject is wearing some sort of garment constructed of tubular forms, his or her body parts may collide forcefully with whatever aspect of the garment is in the limb's path. When this happens, the garment may temporarily conform itself closely to the surface of the limb. Meanwhile, the opposite side of the clothing tube may tend to "bow out" to the limit of the tube's circumference.

Another factor that may need to be considered is *wind drag*, especially if the figure is moving quickly and is wearing a light or loose-fitting garment.

Remember, too, that gravity is always still at play, drawing clothing downward at every point, until it is overpowered into another direction.

Above all, continue to look for the largest movements at play in the clothing first, and then subordinate the details of your drawing to these larger lines and forms.

Man Walking

In walking, the lead leg flexes forward. After it is planted on the ground, it becomes the supporting leg for the rest of the body as the pelvis is abducted and rotated upon it, allowing the rear, extended leg to travel forward and become the new lead leg.

The upper body acts in coordinated opposition to the action of the lower body. As the right leg steps forward, so does the left shoulder, bringing the left arm with it. Thus, there is an ongoing rotation of the rib cage against the pelvis.

This twisting within the trunk is made evident in the fold pattern of the clothing. In rotation, the folds of the trunk, compressed between the advancing side of the rib cage and the pelvis, appear to be skewed from the front waistline toward the rear shoulder. From the back, the opposite happens: The folds appear skewed from the rear flank toward the forward shoulder.

The folds that appear on the legs are consistent with those depicted in the movements illustrated in figure 3.15 on page 130. When flexed against the pelvis, the leading thigh compresses the trouser material into a compression band that rounds over the top of the thigh. Behind, the opposite happens: The trouser leg forms a band of compression folds between the rear of the thigh and the buttock.

A smaller compression pattern may form over the top of the buttock of the rear leg, as well, as the large gluteal muscle contracts in drawing the leg back and the pelvis forward upon it.

Compression bands form behind the knee when the knee is flexed, as similarly happens within the fold of the arm, opposite the elbow, when the arm is flexed.

When the arm is drawn backward, look for a greater accentuation of folds in that direction within the compression band that encircles the shoulder joint. When it is drawn forward, look for a greater accentuation of folds in front of the shoulder.

Large suspended looping folds will descend from the limbs, hanging from whatever their upper surface is at any particular moment. Their appearance may be faint, especially in tightly fitting garments, but they will nonetheless be there. Look, for example, for looping folds hanging from the top surface of the forward (flexed) thigh and from the rear surface of the rear (extended) thigh.

FIGURE 5.1

 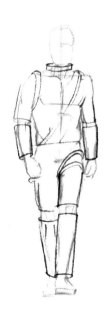

▲ Man walking, seen from the front.

FIGURE 5.2

▲ Man walking, seen from the rear.

FIGURE 5.3

▲ Man walking, seen from the side.

Woman Walking

The difference between the genders makes little difference when it comes to the effect of walking on the mechanics of clothing. The female figure is presented here more out of interest in the effect of walking on the skirt that she is wearing.

The fold patterns in tubular garments that are tailored close to the body are relatively easy to predict because they have little spare room in which to move. Skirts, by contrast, being far freer at the bottom, are more susceptible to inertia, wind drag, and other haphazard forces, especially when they are cut generously or made of flimsy material.

In walking, after the lead foot is planted, the opposite hip rises, allowing the rear leg to start to swing forward. This movement also brings the bell-like shape

of the skirt with it. But the timing of this movement is unpredictable, depending on factors such as the skirt's weight and length. The only thing that is certain is that the skirt will react in rhythm with the wearer's gait. If we were to view the cone of the skirt from above, we would see it as an oblong shape that swivels about the wearer's center.

It is common to see the bottom opening of the skirt, launched by the supporting hip toward the other side of the body, arrive back at the original side of the body just as weight is once again being placed on it, due to the "time delay" of the inertia of the material.

Generally, when seen from the side, the front (flexed) thigh brings a series of folds compressed above the knee upward with

it. These extend rearward and downward to the trailing leg.

The rest of the garment behaves in the same way discussed in our observations on the walking male figure. The looping folds on the trunk reach from the front waistline to the rear shoulder and from the back flank to the forward shoulder.

The sleeves, too, fold in a manner similar to that seen on the walking man's figure. The compression band between the arm and the shoulder becomes more pronounced with the arm's movement in that direction. Even in a short-sleeved shirt, the cloth will hang suspended from the upper surface, depending on the arm's inclination.

FIGURE 5.4

▲ Woman walking, seen from the front.

FIGURE 5.5

▲ Woman walking, seen from the rear.

FIGURE 5.6

▲ Woman walking, seen from the side.

Man Running

As opposed to walking, where at any given time one foot or the other is planted on the ground, in running the figure becomes airborne for an interval, having been launched off the supporting leg. Aside from this difference and from the generally more extreme and rapid nature of the body's movements, however, the general dynamics of running are the same as those of walking. The torso still twists, rib cage against pelvis, although to a more pronounced degree. The arms work in coordinated opposition to the legs; when the right leg is forward, so, too, is the left arm (more or less). Therefore, the form of the folds of the runner's garments relate closely to those of the walker.

As in walking, the twisting movement of the trunk creates pronounced folds between the front waist and the back shoulder and between the back waist and the front shoulder.

The pant leg, compressed between the front (flexed) thigh and the pelvis, also generates a pronounced fold pattern. The same happens in the rear, between the buttock and the rear of the thigh, when the leg is extended.

The top surfaces of the limbs give rise to suspended looping folds hanging from them. The increased degree of movement of the limbs in running brings these folds to a nearly horizontal orientation.

FIGURE 5.7

▲ Man running, seen from a front three-quarter view.

FIGURE 5.8

▲ Man running, seen from a rear
three-quarter view.

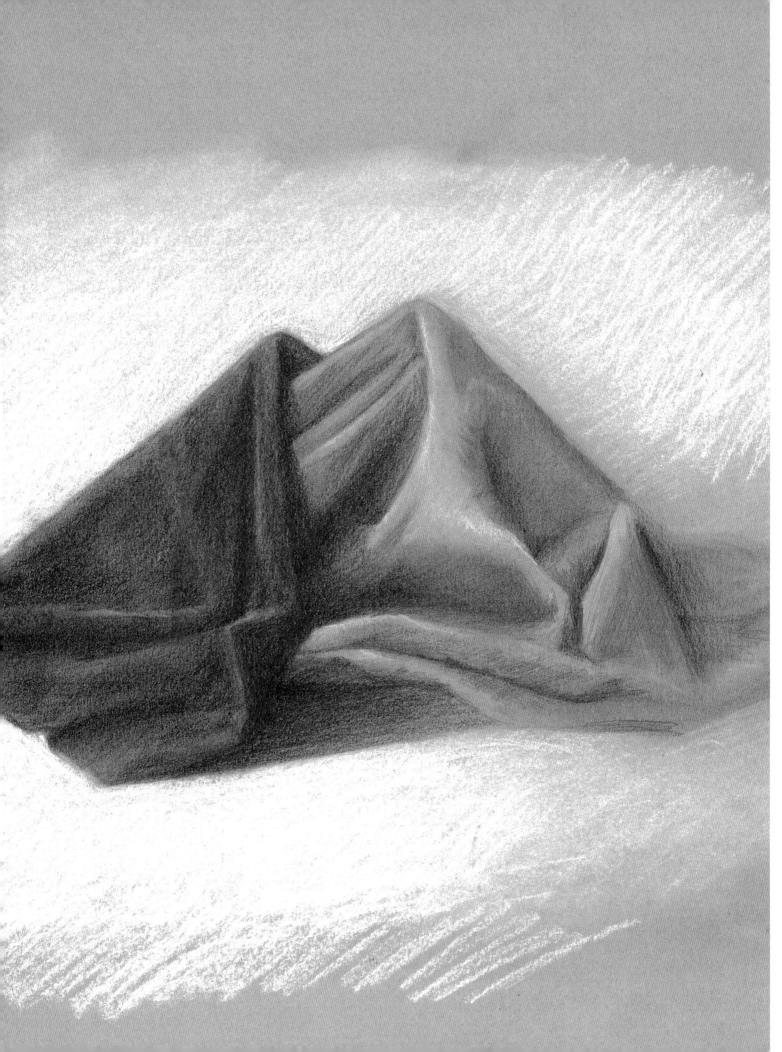

Chapter 6

OTHER FACTORS AFFECTING DRAPERY

So far, we have looked at the impact of mechanical forces on cloth and the resulting fold formations. We've also studied how those factors specifically apply to the form and movements of the body. There are, however, other factors that should be considered when depicting drapery.

Although the interaction of the human form and clothing is likely to be your chief interest as an artist, there is a world of other forces with which drapery can interact. The wind, for example, though not corporeal, may have a very powerful influence upon your drapery studies, as can the pushing or pulling of any another, foreign force. When this is the case, you can exploit drapery's appearance to your advantage, letting the viewer know what forces, even those unseen, may be at play in the work.

You should also give consideration to the particular characteristics of the material you are representing. The cloth's color and value are obvious factors. But you should also consider its texture, weight, shininess, stiffness, etc.

In some instances, these additional factors will have a great influence on the way that cloth behaves. You will need to be able to recognize the degree to which they influence its appearance—and, in turn, decide how much you want them to influence your drawing.

Layering

When one piece of cloth passes over another, or even over a different section of itself, it will reflect, however subtly, the presence of the cloth beneath, just as it would any other object. Most cloths, being thin, do not show much of an influence in a covering layer. But if the cloth underneath is folded, or if the cloth covering it is under tension, that influence will be more pronounced.

A bulge formed in the covering layer is generally larger but duller than any corresponding bulge in the fabric beneath. Look, for example, at figure 6.1, which depicts a hypothetical sphere that has been banded across the middle by one fabric and overlaid with a second. Note how the covering fabric, pulled by gravity, "takes a bounce" off of the lower layer before continuing downward. Thus, the relief of the lower layer is augmented in the covering layer, but it is not as sharply defined.

Figure 6.2 illustrates how the relief of one cloth can make itself apparent, however faintly, through a covering layer.

Figures 6.3 and 6.4 illustrate a slightly different phenomenon. In figure 6.4, the model's coat, which covers the shirt and pants she wears in figure 6.3, echoes the same fold patterns found in the clothes she wears underneath. This is not so much because those folds are forming a relief that shows through the outer layer, as in the previous examples, as it is because *both* sets of clothes are subject to the same stresses that her body and gravity place on them. This is especially apparent in the sashlike looping fold that forms between the model's left (high) shoulder and her right (low) hip and in the folds that descend from that same hip across her pelvis.

FIGURE 6.1

▲ This sphere is wrapped in one fabric and covered by a second. Note how the covering layer takes the direction exaggerated by the red arrows.

▼ One piece of fabric overlies another, which overlies a tube. The relief of the bottom layer, demarcated by the red line, is visible though faint.

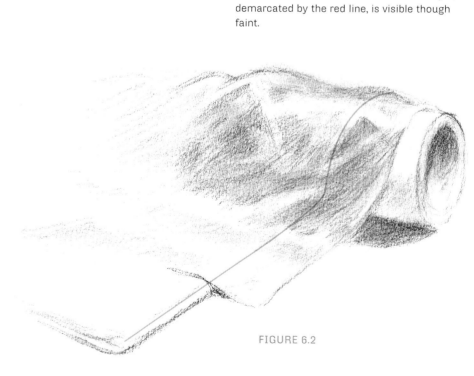

FIGURE 6.2

FIGURE 6.3

FIGURE 6.4

▲ A model in contrapposto pose wearing a shirt and jeans. Note how the folds run from her right hip to her left (rear) shoulder.

▲ The same model wearing a coat. The outer garment is subject to the same fold patterns manifested in the clothes she wears in figure 6.3.

External Forces

The ways cloth folds in response to force were discussed in detail in chapter 1, and those results will be consistent no matter what the source of the force. Here, let us take a brief look at the effects on cloth of forces unrelated to the body's own motion.

Figure 6.5 depicts a skirt being arbitrarily pulled at. Yes, the pulling force here is the model's own hand, but it could just as well be a hook, a tree branch, or someone else's hand. The resulting forms are not very different from those we saw in the opening illustration for chapter 1 (page 10), where a tube of cloth surrounding a cylindrical form is drawn, at one point, toward an external anchor. The result, in both cases, is a compression pattern that runs horizontally through the tube of cloth, but whose "rings" are pressed close to one another near the source of the external compression and flare out more evenly farther away.

An opposite force—an external compressive force—might be at play in the same garment, as the close-up of a shirt being cinched by the waistband of a skirt in figure 6.6 demonstrates. In this type of strong mechanical compression, the vertical folds that would naturally form as the tube of the shirt is compressed horizontally upon itself are further compressed into a series of sharp undulations. These, in turn, may be altogether flattened as they travel beneath the compressive material.

The same dynamic is visible in the drawing of pant legs tucked into the tops of boots in figure 6.7.

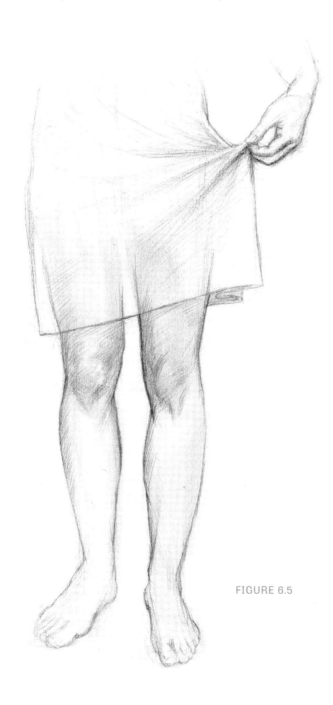

◀ An external force pulling on a skirt.

FIGURE 6.5

FIGURE 6.6

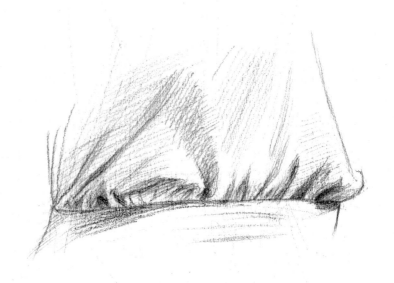

▶ The cinching of a waistband—an external compressing force upon a shirt.

FIGURE 6.7

◀ Pant legs being compressed by a pair of boots.

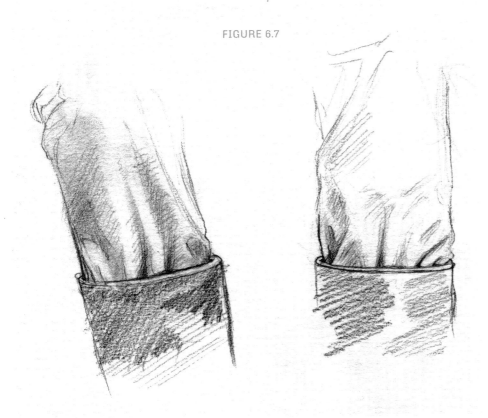

Wind drag is another of these external forces, one that has been commonly depicted in Western art from the Nike of Samothrace to superhero comics. The wind is, of course, invisible, so your drawing will need to describe both the mass of air that gives character to the drapery and the drapery being contorted by the mass of air.

Remember to render your flying drapery as resting on a soft and round billow of air. There should be no flat planes or sharp angles in the cloth, unless you want to obtain a "wind-whipped effect," in which case the drapery is likely to collapse upon itself.

If, as in figure 6.8, the wind is dragging the figure's clothing to one side, then the figure's clothing will be compressed against his or her body on the opposite side. In our drawing, the model's dress is somewhat tight, so the fabric of the skirt and scarf only become free of the body's contours where there is some slack in them.

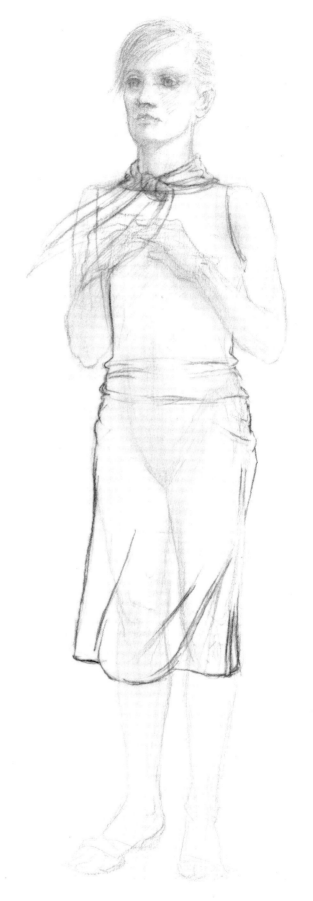

▶ Windblown drapery. Note the use of curved lines, especially in the scarf, to imply that the cloth is resting on a billow of air. The figure's clothes are compressed against her left side.

FIGURE 6.8

Materials

When depicting drapery, there are two sets of characteristics you should pay attention to. The first is the nature of the fold mechanics that we examined at great length in chapter 1: the size of the folds, the expansiveness of the material, its suppleness, and so on. The second set of characteristics has to do with the cloth's surface properties: its color, texture, and reflectiveness. The drawings that follow represent but a small sample of the vast variety of materials, textures, colors, and surface properties that you are likely to encounter. Remember that, especially when drawing imaginary garments, your depictions of fabric should show both its mechanical behavior and its surface characteristics.

In figure 6.9, a cube is draped with a piece of plain cotton muslin, which can serve as a base of comparison with other types of materials. The reaction of the cloth is as expected: The top surface of the cube supports the cloth in a flat plane. As the cloth overhangs this surface and presses against itself, conical formations form at the corners. These, in turn, along with the extension of the cloth, further fold when they hit the ground plane, causing a slight compression pattern at the site of the base of the cube and showing some zigzagging in the corner folds.

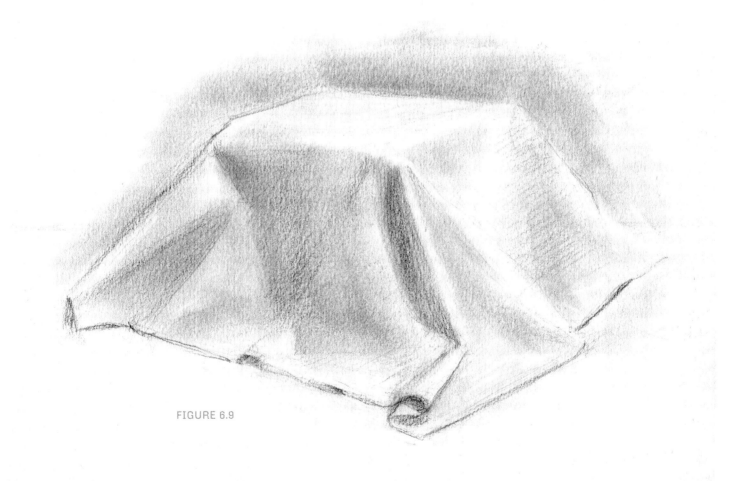

FIGURE 6.9

▲ Cotton muslin.

The cotton denim depicted in figure 6.10 is a stiffer and heavier fabric than the muslin. Therefore, the conical projections at the corners of the block tend to retain their shape more, almost defying the force of gravity pulling on them. The folds have broader, more even planes, which tend to terminate in sharper bends that are more uniform along their length. If this arrangement were rendered as a line drawing, it would be done with a series of nearly straight lines rather than the gently curved lines that would be used to describe the folds in figure 6.9.

▶ Denim.

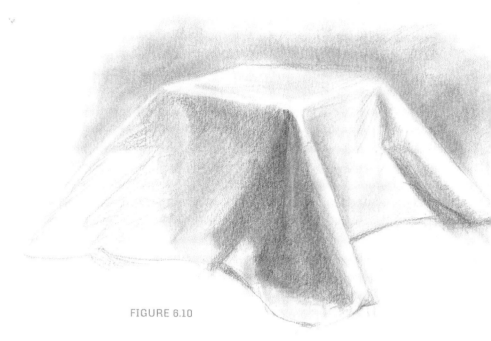

FIGURE 6.10

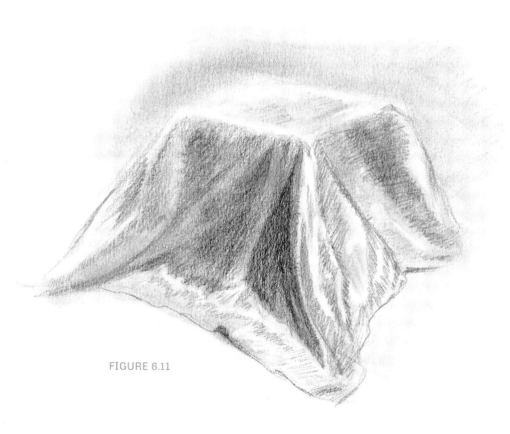

FIGURE 6.11

▲ Velvet.

Figure 6.11 shows the same setup, but this time the cube is covered with velvet, a material known for its suppleness and luster. As in the previous illustrations, the velvet lies in a flat, unmodulated expanse on top of the cube. But where it passes beyond the edges of this support, the folds that form are soft and wavy. Note how the conical formations at the corners cave in on themselves. When the supple material hits the ground plane, it immediately flattens out again, conforming to the form of that surface.

Velvet has a peculiar, shimmering surface. Because it is very shiny, the rendering here is done in a number of quickly changing and broad-ranging values, from the strong lights at the reflections of the corner cones to the strong darks in the shadows. To get a shimmering effect, these tones were applied using a series of hatches running perpendicularly to the direction of the length of the planes.

The silk taffeta depicted in figure 6.12 presents a variation in suppleness and luster. In softness, the taffeta is similar to the cotton muslin in figure 6.9. It has medium-size folds that will break into smaller ones under moderate stress. The planes of the folds are gently curved and moderately expansive. But the taffeta is much shinier than the cotton, and so we see a greater range of light-to-dark values, which change much more quickly. Overall, this material has a darker local color, or general tone, than the cotton. So while the shadow areas are drawn much darker than those of the cotton, the highlights reach just as high a value.

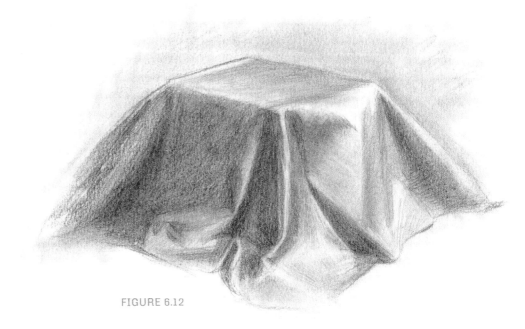

FIGURE 6.12

▶ Silk taffeta.

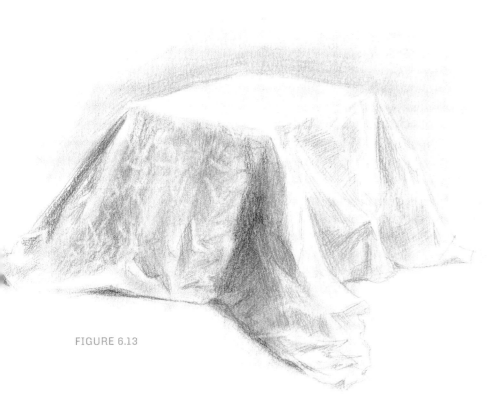

FIGURE 6.13

▲ Wet drapery.

Finally, look at figure 6.13, which is a rendering of the same cotton cloth we saw in figure 6.9 but now saturated with water. When drapery gets wet, it naturally gets heavier. The forms of the folds are no longer able to hold their shape over a distance; they collapse under gravity's pull. What had been full, smooth planes are now fragmented into series of small, irregular wrinkles.

The expansive property of the material diminishes dramatically. The cloth now conforms very closely to the surface on which it rests. Only the upper, projecting, "positive" parts of the fold pattern detach themselves from the object beneath. In many examples of Classical and Mannerist art, wet drapery (or "wet" drapery, where an appearance of wetness is conveyed even by dry cloth) is represented through the addition of these partial, "positive" phases of the folds to the nude, giving the impression of a closely adhering garment.

Chapter 7

TIPS, TRICKS, AND SHORTCUTS

This chapter should not be taken as a substitute for the information contained in the previous pages. Its purpose is less to instruct than to demystify some commonly used "abbreviations" for communicating the appearance of drapery.

If you use any of these techniques—or, far better, develop some of your own—you will find that they are but shorthand for expressing the phenomena already examined. All these techniques should have their origin, however distant, in the structure of folded material. And so, before examining these summary graphic techniques, let's quickly review the best practices for rendering drapery:

- When you draw drapery, think of it in three dimensions even though you are expressing it in two.
- Establish the shape of the object on which the drapery is resting, whether human or otherwise; then conform the drapery to it.
- Consider the mass of the drapery first, then its planes, and last its lines.
- Remember that drapery will generally form folds perpendicular to the direction in which it is compressed, although it may, under particular circumstances, form folds in the same direction in which it is stretched.
- Recall that when drapery is suspended from two points, the folds will hang in an even curve (although this curve may be divided into flatter planes).
- And remain aware that the folds in drapery will correspond to the plane changes of the form upon which it rests.

Three Basic Arrangements

Before moving to our survey of tricks and shortcuts, let's have a look at the three sample arrangements we will be using, each rendered using a traditional approach.

In figure 7.1 we see a tube of cloth encircling a cylinder, similar to those we have encountered in previous chapters. Toward the bottom of the drawing, the material gathers into a compression band, into which the material telescopes, both above and below. Toward the top of the drawing, another compression band is unevenly compressed, the stress being more forceful at the left side. Hence, the rings of folds are drawn more tightly together in this area and farther apart toward the right.

Figure 7.2 shows a cloth suspended against a wall between two anchors, between which the cloth falls in a cascade of front-to-back folds.

The setup in figure 7.3 is similar to that of figure 7.2, except that here the height of the anchors is uneven and the cloth has been twisted.

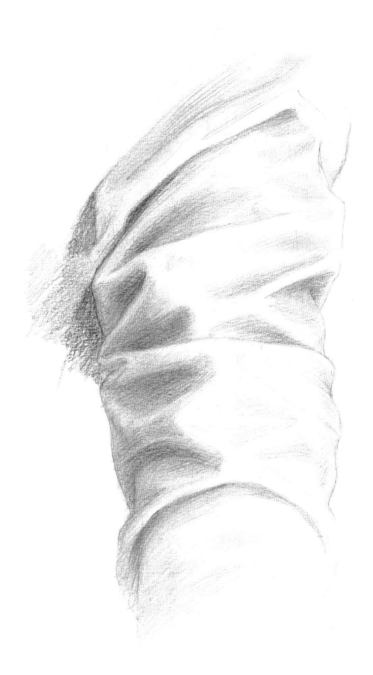

▶ A tube of cloth surrounding a cylinder. Note how the cloth telescopes into the compression band near the bottom of the drawing, both above and below it. Near the top of the drawing, another compression band is further compressed on the left side.

FIGURE 7.1

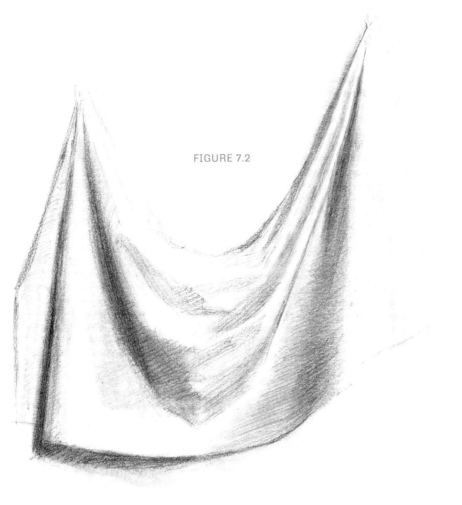

FIGURE 7.2

◀ A drapery suspended against a wall between two anchors. The folds of the cloth descend in a stairstep pattern of gradually narrower U-shaped curves.

▶ A drapery suspended against a wall between two uneven anchors. Here, the cloth has been twisted so that the side of the cloth that faces the wall at the left side of the drawing is facing the viewer at the right.

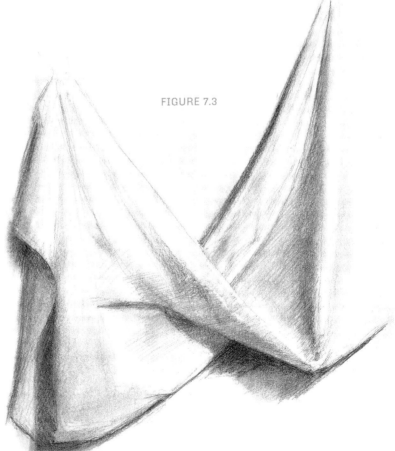

FIGURE 7.3

TOWSLEY

(Walt Disney Productions)

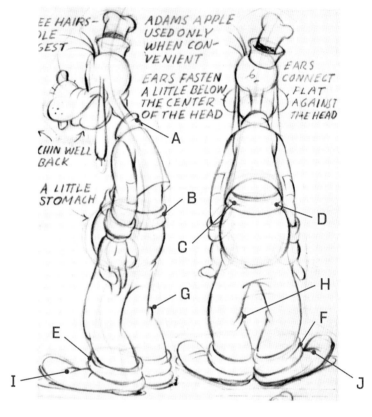

Labels on the model sheet:

EE HAIRS—
)LE
GEST

ADAMS APPLE
USED ONLY
WHEN CON-
VE NIENT

EARS FASTEN
A LITTLE BELOW
THE CENTER
OF THE HEAD — A

EARS
CONNECT
FLAT
AGAINST
THE HEAD

CHIN WELL
BACK

A LITTLE
STOMACH

B

C

D

G

H

F

E

I

J

© Disney

Clothing behaves the same way on dogs as it does on humans. In this case, the dog in question is Goofy, one of the popular classic characters created by Walt Disney Productions. Here, we see a model sheet created by animator Don Towsley, which was reproduced and distributed within the animation studio so as to keep the style, proportions, and features of the character consistent.

Because thousands of hand drawings were necessary to produce a single animated film, it was necessary for animators to develop a graphic means by which to communicate form with a minimum of line work. We can see in this model sheet how the dark, final line work is a shorthand form of the more complete conceptions of form that are indicated in the lighter pencil line.

For example, a single stroke, placed along the deepest recess of a fold in any of the compression bands in the figure's clothes, serves to define the whole pattern. This is true at the collar (*A*), and the waist (*B* and *C*). But note that the waist does pick up a second stroke for definition, at *D*, as does the pants cuff (*E* and *F*).

Simple inverted U shapes are used to define the projections, or ridges, of the folds formed by the compression of the knee joint (*G* and *H*), and, in the shoes, by the compression between the instep and the toes (*I* and *J*).

▶ Don Towsley (1912–86) for Walt Disney Productions, "Goofy" model sheet. Photostatic reproduction of pencil on paper, 12½ x 10 inches (31.7 x 25.4 cm), 1937. Reproduction courtesy of the Cowan Collection © Disney

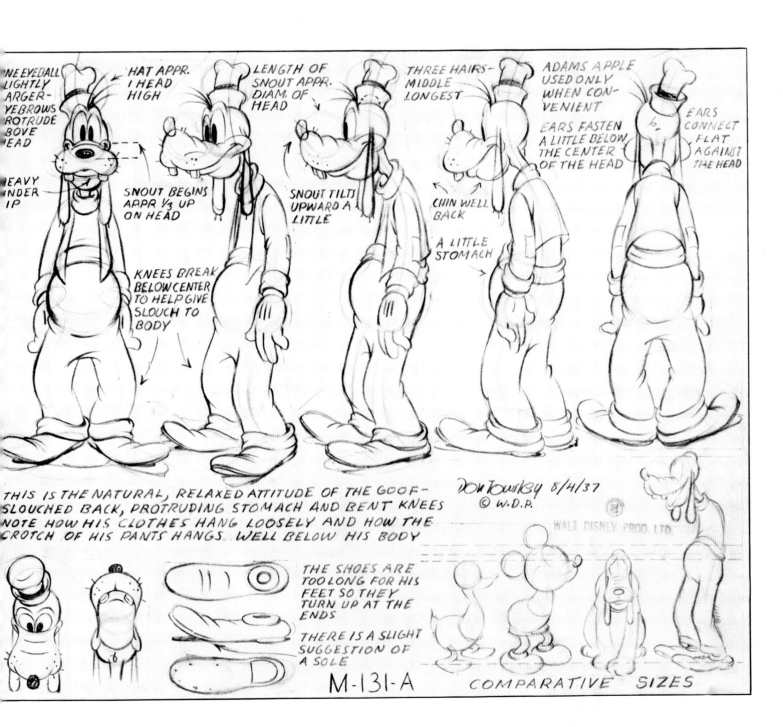

NE EYEBALL
LIGHTLY
ARGER-
YEBROWS
ROTRUDE
BOVE
EAD

HEAVY
NDER
IP

HAT APPR.
I HEAD
HIGH

SNOUT BEGINS
APPR ⅓ UP
ON HEAD

KNEES BREAK
BELOW CENTER
TO HELP GIVE
SLOUCH TO
BODY

LENGTH OF
SNOUT APPR.
DIAM. OF
HEAD

SNOUT TILTS
UPWARD A
LITTLE

THREE HAIRS-
MIDDLE
LONGEST

CHIN WELL
BACK

A LITTLE
STOMACH

ADAMS APPLE
USED ONLY
WHEN CON-
VENIENT

EARS FASTEN
A LITTLE BELOW
THE CENTER
OF THE HEAD

EARS
CONNECT
FLAT
AGAINST
THE HEAD

THIS IS THE NATURAL, RELAXED ATTITUDE OF THE GOOF-
SLOUCHED BACK, PROTRUDING STOMACH AND BENT KNEES
NOTE HOW HIS CLOTHES HANG LOOSELY AND HOW THE
CROTCH OF HIS PANTS HANGS. WELL BELOW HIS BODY

Don Towsley 8/4/37
© W.D.P.

WALT DISNEY PROD. LTD.

THE SHOES ARE
TOO LONG FOR HIS
FEET SO THEY
TURN UP AT THE
ENDS

THERE IS A SLIGHT
SUGGESTION OF
A SOLE

M-131-A

COMPARATIVE SIZES

Methods of Constructing a Drapery Drawing

As stated before, it is always best to conceptualize the drapery you are drawing in its broadest terms before concerning yourself with depicting individual folds or groups of folds. Here are a few techniques that may help you lay out the basic fold patterns on your drawing paper. Note that these are not meant to be done in any particular order, and, in fact, they need not be done at all; certainly they are not meant to

supersede any of the good and useful drawing practices that you may already employ.

The first method, shown in figure 7.4, involves drawing a set of construction lines that represent those that run through the nodes of the folds in the drapery you are drawing. Doing so not only provides you with a grid for transferring the visual information that you see onto your paper, but it also harmonizes the rendering of the

drapery into a set of reasonably divided planes, which is, after all, exactly how drapery reacts in real life.

▼ Construction lines. You can sketch lines to align the nodes with each other. A line can also be used to demarcate a plane break.

FIGURE 7.4

You could additionally (or instead) choose to draw a set of construction lines that run in the opposite direction to these, as shown by the blue vertical lines in the drawing on the left of figure 7.4. These lines follow the plane breaks of the form influencing your drapery.

The construction method in figure 7.5 is somewhat different from that of figure 7.4. You could use this technique in addition to that of the previous figure or instead of it. Here, construction lines have been added to either side of each fold's ridges. These are areas that naturally tend to be described by lines, because the planes of the fold turn away from the source of direct light in the picture. At each intersection, you can place a circle or hemispheric symbol to indicate the position, size, and even height of the node.

▼ Circles and lines. You can use circles to quickly demarcate the positions and sizes of the nodes and double lines running between them to demarcate the folds' ridges.

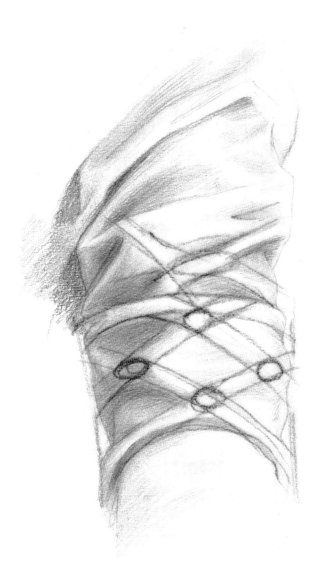

FIGURE 7.5

Last, as shown in figure 7.6, you might use an X shape as a device to quickly indicate the position and shape of a "pyramid" of intersecting folds. Any visual method that makes it easier to copy what you see before you is beneficial. I must, however, warn you against mistaking the letter form that a fold or group of folds appears to resemble when seen in a particular light *for its essential nature*. One might just as easily distinguish Ss and Ys and Zs in a sky full of clouds, but that would not help explain the clouds' fundamental character.

▼ X shape. Using an X shape can help you establish the position and form of an intersection of folds.

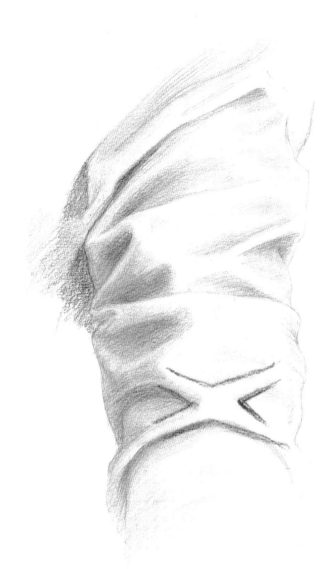

FIGURE 7.6

Shortcuts

Figures 7.7 through 7.19 each contain a pair of drawings. The drawing on the right shows a mark or simple set of marks commonly used to express a certain fold or group of folds. The full rendering on the left shows the origin of the shortcut, marked in red lines.

The importance of understanding the structural form and mechanics of drapery in your drawing is stressed throughout this book. Many of these shortcuts, however, find their basis more in the way that light and shadows fall on the cloth than in the cloth's shape. Drawing form and drawing the play of light on that form are often treated as separate concerns in art. In the same way, when you draw drapery, you will have to use your artistic judgment as to which of the two to emphasize at any given place in your drawing.

As shown in figure 7.7, two shallow curves, one right side up and the other, below it, upside down and pointing toward the one above, can give the feeling of a compression band. The line that describes the edge of the band closer to the viewer should be stronger, giving a hint of the perspective at play.

A light source coming from above will leave the bottom side of the ridge of a horizontal fold in shade. Therefore, two roughly parallel curves, one darker than the other, can be used to convey this effect, as seen in figure 7.8. You can even add a small cast shadow.

◀ Parallel curves.

▶ U-shaped curves.

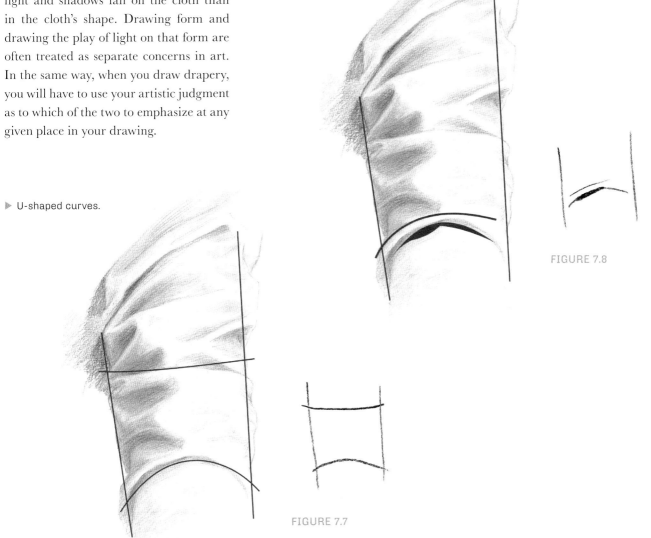

FIGURE 7.8

FIGURE 7.7

Figure 7.9 shows a quick squiggle dividing the light and dark sides of a compression pattern. You might use looser, more carefree curving lines to indicate such a formation, but a careful serpentine line that closely follows the rhythm of light falling over a compression band can be both a beautiful and sophisticated means of conveying a wealth of information to the viewer.

A looping line like that at the bottom in figure 7.10 can be used on its own to convey both the bottom of a ridge and its own cast shadow, quickly giving a feeling of dimension. The concave line mirroring it above adds to the illusion.

▼ Squiggle.

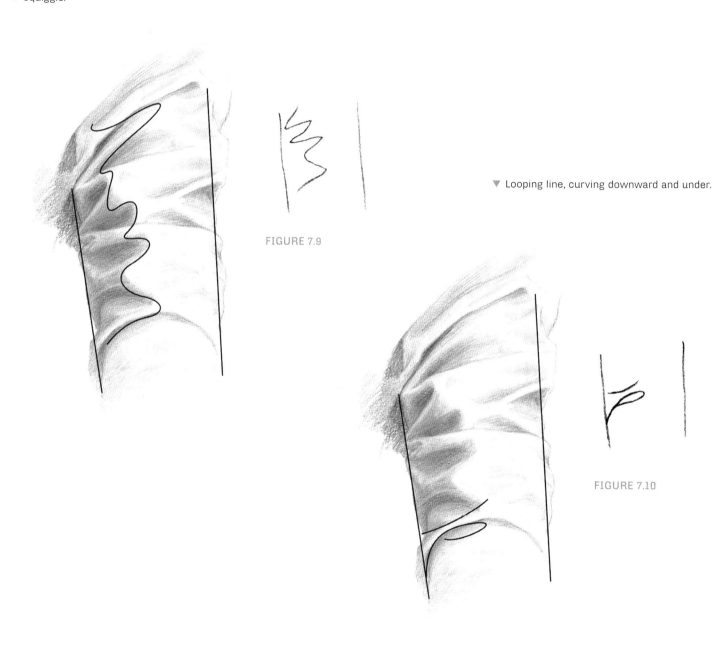

FIGURE 7.9

▼ Looping line, curving downward and under.

FIGURE 7.10

The technique shown in figure 7.11 is similar to that in figure 7.10, but now the line curves upward and over to meet itself instead of downward and under. In doing so, it first describes the upper edge of a ridge and then the lower edge of the ridge above it.

Compression bands can project out a significant distance away from the median position of the cloth at rest. The curved bump in figure 7.12, breaking through the line describing the general extent of the cloth, achieves that effect succinctly.

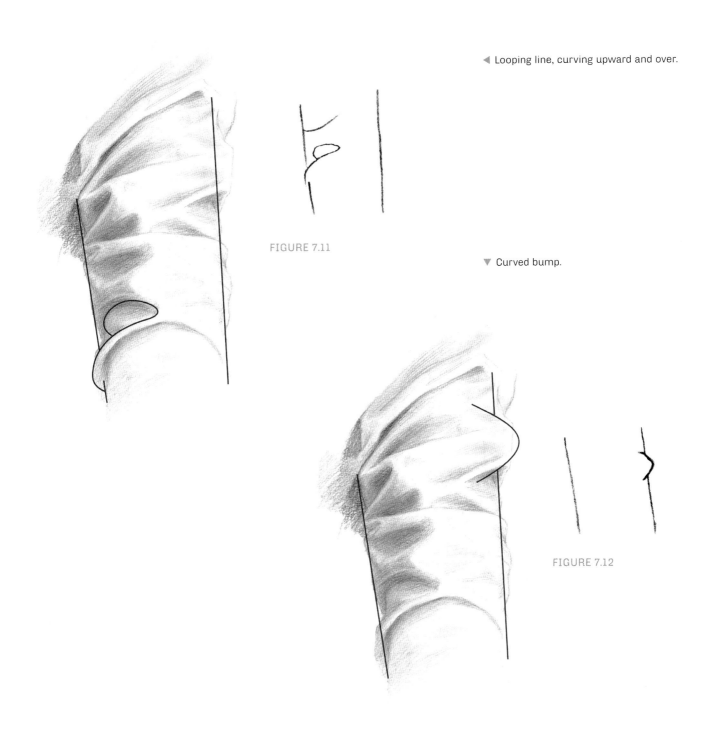

◀ Looping line, curving upward and over.

FIGURE 7.11

▼ Curved bump.

FIGURE 7.12

In figure 7.13, two lines, one above and one below, suggest a branching. The addition of an elongated C-shaped line between them accentuates the impression. When drawing such lines, try to "feel" the movement of the compression pattern, which will add subtlety and expression to your lines.

A series of gently curved lines such as those depicted in figure 7.14 is one of the most common and effective ways of conveying the idea of a compression pattern, especially if it is more compressed on one side than on the other. Note how the lines are staggered: Each is of a different length, and, measuring from left to right, none ends at the same spot as another.

▼ Branching lines.

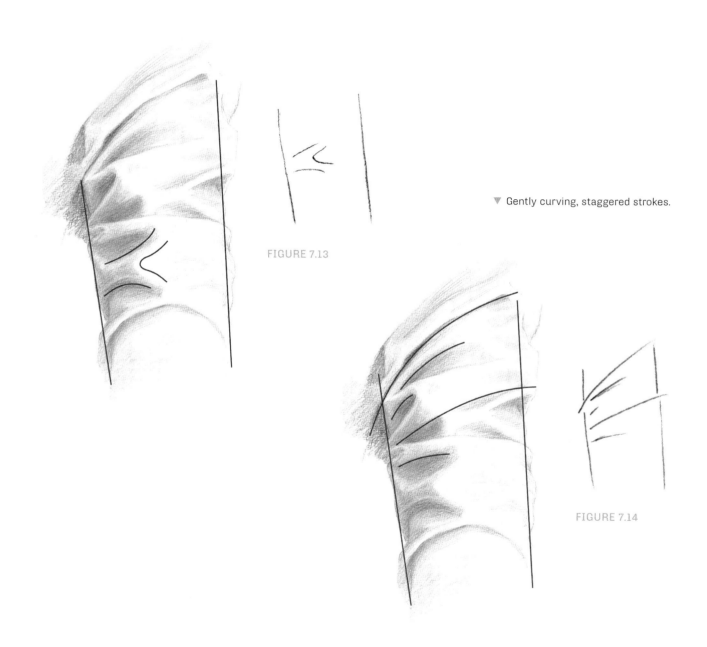

▼ Gently curving, staggered strokes.

FIGURE 7.13

FIGURE 7.14

The treatment seen in figure 7.15, somewhat extreme in its representation, shows the most recessed part of the compression pattern "taking a bite" out of the form.

These lines in figure 7.16, meant to represent the conical folds that descend from a single anchor, softly diverge from one another. Note the implication of a pure vertical line in the center, which would correlate to the pull of gravity.

▶ "Bite."

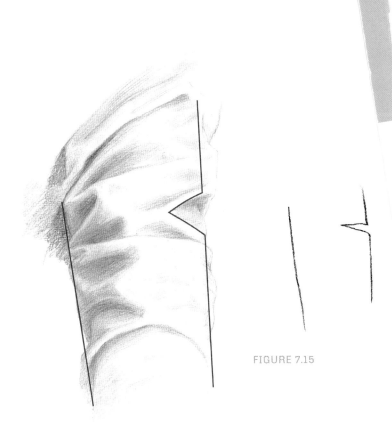

FIGURE 7.15

▼ Diverging lines.

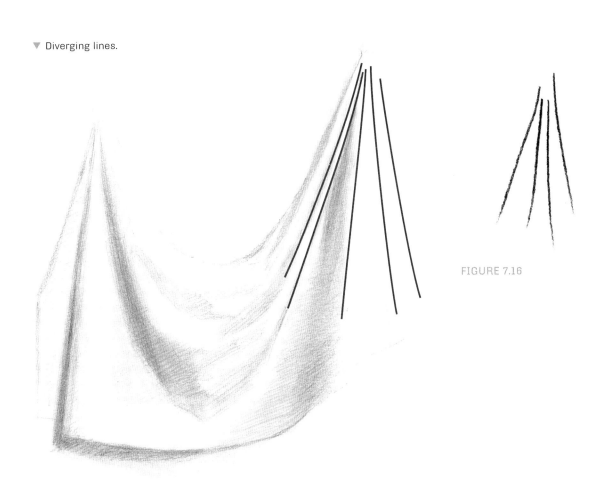

FIGURE 7.16

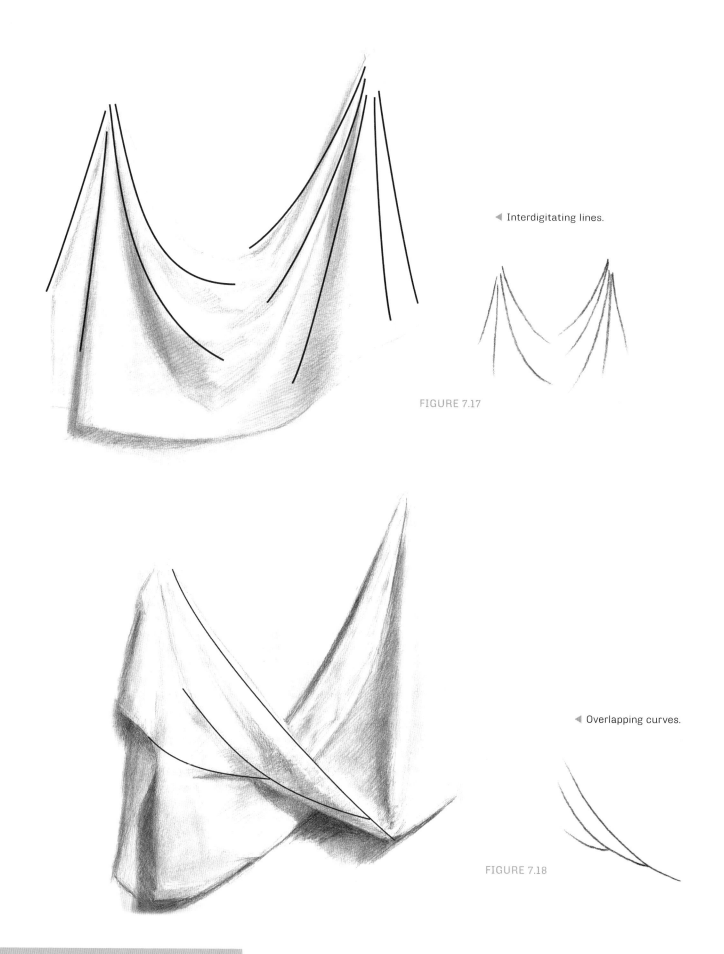

◀ Interdigitating lines.

FIGURE 7.17

◀ Overlapping curves.

FIGURE 7.18

The Artist's Guide to
Drawing the Clothed Figure

Because each of the descending folds of cloth in figure 7.17 takes light on its top plane, followed by shadow on its downward plane, the lines used in this drawing interdigitate with each other. Note how at the top, at the site of the anchors, the converging lines do not touch.

In any fabric that has a twist in it, it is easy to find instances where a series of folds have their originating points hidden from the viewer. In figure 7.18, each curve that runs into another implies that the fold it describes is partially hidden behind another.

An S curve (or backwards S curve) can be used to signify the edge of a cloth that hangs in a series of conical forms. The extreme edges of the curvy line should hit any straight line that describes the limit of these cones.

◀ S curve.

FIGURE 7.19

LEVITOW

(Warner Bros. Looney Tunes)

Abe Levitow was one of the talented animators who worked under Chuck Jones at the *Looney Tunes* studio. Levitow went on to become a director himself, and this drawing is from one of his theatrical shorts, entitled *A Witch's Tangled Hare*.

Here, we see the lead character, Bugs Bunny, dressed as Romeo in Renaissance garb. Because production concerns demanded that the line work for drawing for each frame be kept to a minimum, the use of line is minimal. But it is also extremely sophisticated—subtly but quickly communicating a large amount of information.

Note, for example, the gentle curve of the line at *A*, where Bugs's hat meets his head. It communicates both the tilt and the shape of his cranium. At *B*, the sleeve drops toward the ground in a conical formation, as expected. But note the addition of the small line at *C*, which tells us that the sleeve is being compressed inside the natural depression, below the biceps muscle, at the bend of the arm. The vertical direction of line *D* expresses the force of gravity's pull on the sleeve.

Because the lines at *E* and *F* are so long, they let us know that the material in Bugs's footwear is very supple; the material lacks the internal expansiveness that would push these folds into the full pyramidal form that usually occurs in a compression pattern. Their long, slightly wiggly shape also lends a comic element to the drawing, as do the lines at *G* that describe the fold that appears when the material is compressed between the instep and toes of the foot.

▶ Abe Levitow (1922–75) for Warner Bros. *Looney Tunes*, animation drawing for *A Witch's Tangled Hare.* Pencil on paper, 10³/₄ x 7³/₄ inches (27.3 x 19.7 cm), c. 1959. Reproduction courtesy of Van Eaton Galleries

INDEX